PSALMS OF PROMISE
Exploring the Majesty and Faithfulness of God

by E. Calvin Beisner

NAVPRESS ◑®
A MINISTRY OF THE NAVIGATORS
P.O. BOX 6000, COLORADO SPRINGS, COLORADO 80934

The Navigators is an international Christian organization. Jesus Christ gave His followers the Great Commission to go and make disciples (Matthew 28:19). The aim of The Navigators is to help fulfill that commission by multiplying laborers for Christ in every nation.

NavPress is the publishing ministry of The Navigators. NavPress publications are tools to help Christians grow. Although publications alone cannot make disciples or change lives, they can help believers learn biblical discipleship, and apply what they learn to their lives and ministries.

Cover art: Peter Pohle

Scripture quotations in this publication are from the *Holy Bible: New International Version* (NIV). Copyright © 1973, 1978, 1984, International Bible Society. Used by permission of Zondervan Bible Publishers. Other versions used are the *New American Standard Bible* (NASB), © The Lockman Foundation 1960, 1962, 1963, 1968, 1971, 1973, 1975, 1977; and the *King James Version* (KJV).

Printed in the United States of America

Contents

For David, my firstborn:
May he have the King's heart.

Author

E. Calvin Beisner is a graduate of the University of Southern California with a B.A. in Interdisciplinary Studies in Religion and Philosophy, and a graduate of International College with a M.A. in Society with a Specialization in Economic Ethics. A former editor of *Discipleship Journal*, published by The Navigators, he has also been a newspaper editor, and a radio commentator.

Beisner is national chairman of the economics committee of The Coalition on Revival, an organization of evangelicals that seeks to make clear the implications of the Christian world view in such fields as law, government, economics, politics, art, media, psychology, medicine, and education.

In addition to *Psalms of Promise*, Beisner has written *God in Three Persons*, *Answers for Atheists*, and *Poverty and Prosperity: The Compassionate Use of Resources in a World of Scarcity*. He has contributed articles to *Discipleship Journal, Christianity Today, Presbyterian Journal, World*, and is author and editor of *Paradym*, the monthly educational newsletter of Century III Foundation.

A lover of biblical, theological, historical, philosophical, and economic studies, Beisner also enjoys classical music, tennis, fish-

ing, and classical literature. He lives in the Ozark Mountains with his wife, Deborah, who is a respected portrait painter and artist, and their three children.

Foreword

The Church of Christ has ever been fascinated with the book of Psalms. Throughout its history, great men of God, from Augustine to Luther to Spurgeon and C.S. Lewis, have published their reflections on this collection of Hebrew poetry. Beisner's contribution to our understanding of Psalms is unique in that he approaches various psalms from the covenantal perspective. This enables him to show the overarching unity in the rich variety of experiences as portrayed by the psalmists.

The author makes numerous statements about God, His perfections and self-disclosure; about Christ, His person and work; about the Spirit, His presence and operations; about history, its movements and progress; and about man, his battles and prospects. But these statements do not present disjointed or, even worse, contradictory pieces of information that are confusing to the reader. No, they all contribute to the insight in the many realities of the one grand mosaic of life. In the end, this insight inspires confidence and hope, however sobering these realities may be.

But the recognition of the covenantal framework of the psalms has still another advantage. It rescues the reader from

viewing them as the all-too individual expressions of the all-too individual emotions of the several psalmists, which are totally and capriciously dependent upon circumstance and mood. While they would remain impressive as works of art, their truth value would diminish greatly.

No, they present us God, in the glory of His being, the sum total of His perfections and the majesty of His operations, and the principles and patterns of His dealings with man. They also present us man and the patterns of his response to God and of his interaction with his fellowman in a wide range of conditions, circumstances, and experiences.

Thus they furnish the Church of Christ with a model as to how life can and should be lived under God, with God, and for God in trials and in temptations, in war and in peace, in defeat and in victory, in times of stagnancy and progress, discouragement and encouragement, distress and confidence, whether in doubt or hope, sorrow or joy, and prayer or praise.

It is nothing short of amazing how in the book of Psalms things theological, christological, pneumatological, soteriological, ecclesiological, and eschatological combine to make life practically possible *and*, in the true sense of the word, worth living. We are indebted to Cal Beisner for bringing this out skillfully and effectively.

Henry Krabbendam
Professor of Biblical Studies
Covenant College

Acknowledgments

Many people deserve thanks for their help in bringing this book to completion. Don Simpson, editorial director at NavPress when I first got the idea for it, encouraged me to develop a formal proposal, which he later shepherded through to acceptance. Had he not believed in the project, I probably would have abandoned it from the start. Traci Mullins was a helpful and patient editor. She and Kathy Yanni stuck by their guns and persuaded me not to use an approach with which I was at first enamored but that I later saw was ill conceived. Their persistence made the book far better than it might have been.

Reverend L.C. Barnett, Arthur Melvin, John Kramer, and others read individual chapters and made helpful suggestions for revision. L.C. taught me much about waiting on God in prayer, a practice that helped me in writing. Jerry Bridges, vice president for corporate affairs with The Navigators and a man whose spiritual wisdom and insight I greatly admire, read every chapter and made particularly astute criticisms and suggestions leading to revisions.

The congregation of Gateway Chapel in Gateway, Arkansas, prayed for me from start to finish. They exhorted me to trust in God many times when I doubted whether I could do the work.

Their love and encouragement were invaluable.

My dear wife, Deborah, prayed for me, patiently encouraged me, pushed me when I needed pushing, and helped me to slow down when I needed to. She read the whole book and made many helpful suggestions—often before drafts went from computer to paper. Debby's wisdom and ability to identify unclear writing never led me astray.

Undoubtedly there are errors of interpretation in this book. I will be eternally grateful to those who point them out, explain them to me, and help me to correct my thinking.

God Himself has been my strength and stay. He has responded to my prayers for guidance. Anything good in this book is here because of Him, to whom be glory for ever and ever. *Soli Deo Gloria!*

[Josiah] went up to the temple of the LORD with the men of Judah, the people of Jerusalem, the priests and the prophets—all the people from the least to the greatest. He read in their hearing all the words of the Book of the Covenant, which had been found in the temple of the LORD. The king stood by the pillar and renewed the covenant in the presence of the LORD—to follow the LORD and keep his commands, regulations and decrees with all his heart and all his soul, thus confirming the words of the covenant written in this book. Then all the people pledged themselves to the covenant.

2 Kings 23:2-3

Introduction

Each chapter of this book can stand alone. Anyone can read and understand the last chapter before he's read any others. And that is as it should be, for the psalms themselves can stand alone; no one should insist that everyone read Psalms 1-149 before Psalm 150.

Yet there is a sense of progression in the psalms, apparent especially as we near their end, where the focus turns increasingly toward God and His coming Kingdom. So reading the psalms in order has its merits; we can learn progressively that way. This book, too, shows progression. While each chapter is independent, more or less, of those immediately before and after it, still all of them form a coherent whole, a larger framework designed to portray the progression of God's work in history from Creation to Consummation. So reading these chapters in order should be more rewarding than otherwise.

I have tried to be true to the text of each psalm, not reading into it ideas that aren't there or misconstruing those that are. But I have also arranged the chapters to show the progression I have described, and for that reason I have focused sometimes on elements within each psalm that fit its position in the book, while putting less emphasis on elements relatively unrelated to that

13

progression. Most of these studies, therefore, are not substitutes for verse-by-verse commentaries on the Psalms.

The following outline will make it easier to see why I have ordered the chapters as I have, and why I have highlighted some things and skirted others:

Chapter One, on Psalm 104, treats Creation and the order God has established in nature. Chapter Two, on Psalm 19, shows how in addition to creating a natural order God created a moral order in His Law. Chapter Three, on Psalm 90, discusses the Fall—that is, man's rebellion against God's moral order—and the resulting problems man faces, while Chapter Four, on Psalm 88, shows man lamenting the suffering that results from sin.

God responds to man's needs with the Covenant, in which He promises salvation to man and requires obedience from him. Chapter Five, on Psalm 74, focuses on God's promises in and faithfulness to the Covenant, while Chapter Six, on Psalm 50, focuses on man's duties under it. Chapter Seven, on Psalm 51, shows the repentance man must display if he is to enjoy the benefits of the Covenant, and the forgiveness he experiences consequent to repentance. Chapter Eight, on Psalm 107, discusses the thanks man ought to render in response to God's faithful fulfillment of His Covenant promises, and Chapter Nine, on Psalm 18, focuses on praise and adoration for God's protection provided under the Covenant.

Chapter Ten, on Psalm 15, describes the character of the faithful child of the Covenant, while Chapter Eleven, on Psalm 73, discusses the natural bewilderment of children of the Covenant when it seems that God abandons them to their enemies. Chapter Twelve, on Psalm 109, explores the use of imprecatory prayer in response to God's enemies who violate the Covenant, while Chapter Thirteen, on Psalm 85, discusses the role of intercessory prayer among God's Covenant people, and Chapter Fourteen, on Psalm 103, displays God's merciful responses to intercessory prayer in accord with His promises under the Covenant.

Chapter Fifteen, on Psalm 105, shows that God continually rules over history, drawing it toward the great end promised in the Covenant, namely, the Kingdom of God. Chapter Sixteen, on Psalm 101, shows how King David, whose life and reign prefigured the life and reign of Jesus Christ, understood his covenantal duties as ruler of God's people. Chapter Seventeen, on Psalm 22, observes the road Christ followed from Cross to throne in fulfilling the expectations of David for the Messiah. Finally, Chapter Eighteen, on Psalm 145, pictures the glorious fulfillment of God's promises and man's hopes under the Covenant, a fulfillment that is to be accomplished in the establishment of the Kingdom of God.

It should be clear from this outline that a central theme throughout this book is the Covenant between God and man. It was while preparing to write this book that I became increasingly convinced of the central importance of the Covenant to our understanding of all of Scripture—including the Psalms. Repeatedly the various elements of the Covenant, described in some detail in chapters 5-7, appear in the Psalms; and the better we understand the Covenant the more sense all of the psalms will make to us. The psalms I've treated here also represent all of the major types of psalms, which means that reading these expositions can help in understanding not only the psalms on which they focus but all the rest of that wonderful collection as well.

The Covenant is revealed primarily in the first five books of the Bible, particularly Exodus and Deuteronomy. Consequently, the more familiar we are with those books the better prepared we are to understand the rest of the Bible, all of which is an outworking of the covenantal idea. For that reason I have drawn heavily upon Exodus and Deuteronomy for background to the ideas central to most of these psalms.

Essential to the Covenant is its revelation of the character of God, a theme that arises time and again throughout the Psalms. A key text on God's character is Ex. 34:6-7, which tells us that when

God passed before Moses on Mount Sinai He declared Himself, "The LORD, the LORD, the compassionate and gracious God, slow to anger, abounding in love and faithfulness, maintaining love to thousands, and forgiving wickedness, rebellion and sin. Yet he does not leave the guilty unpunished; he punishes the children and their children for the sin of the fathers to the third and fourth generation." This theme appears in the New Testament repeatedly, perhaps most strikingly in the words of the Apostle Paul: "Consider therefore the kindness and sternness of God: sternness to those who fell, but kindness to you, provided that you continue in his kindness. Otherwise, you also will be cut off" (Ro. 11:22). Much of the message of the Psalms has to do with understanding this revelation about God's character and learning to think and live appropriately in response to Him.

In most of the chapters I have included suggestions for practical application of what is taught in the Psalms. But I haven't always done this, or always done it to the same extent. Some psalms are more practically oriented than others. Sometimes what we think or feel is more important than what we do—and when I have thought specific suggestions for practical application would obscure the effect of the psalm on our thinking or feeling, I've steered away from them. In the long run I think most people's lives are shaped more profoundly by incremental learning about the nature of God, the nature of man, the problem of sin, and the ways of salvation and sanctification than by "how-to" materials that might not address our hearts at the deep levels where real change must be rooted. As a man thinks within himself, so he is (Prov. 23:7). If reading this book causes anyone to appreciate God and His Word more, to stand in awe of Him, to worship Him, to long to be conformed to His will, then my highest hopes for it have been achieved.

God of Creation
PSALM 104

I will always remember my first trip through the Rocky Mountains, when I was ten years old. The rugged, towering mountains were beautiful, but their impact on our family was heightened by our repeated cries of "Oh! Look at that! Isn't it beautiful?" and "Look! Have you ever seen anything so awesome?" Had each of us kept his thoughts to himself, we might all have forgotten that drive by now. Instead, not only the vistas but also the original excitement remain forever imprinted in our minds. It is not for nothing that the Psalms so frequently urge God's people to sing, to shout, to clap, to make a joyful noise to the Lord.

Psalm 104 begins, "Praise the LORD, O my soul," and all that follows is a joyous expression of praise, until, in the last verse, the psalmist's longing for the fullness of righteousness bursts forth in a painful cry at the thought of the wicked—only to be drowned out by renewed praise.

How would he praise God? By telling both God and others of Jehovah's "splendor and majesty" (verse 1). In his excitement he spoke first to himself: "Praise the LORD, O my soul." Then he addressed God directly: "O LORD my God, you are very great; you are clothed with splendor and majesty." Then, unable to keep

17

the wonder to himself and God, he turned to anyone who would hear, saying, "He wraps himself in light as with a garment; he stretches out the heavens like a tent and lays the beams of his upper chambers on their waters" (verses 2-3). After that he alternated between addressing God and addressing others, like an actor on a stage who makes the audience part of the play. We can almost see him turning sometimes backstage, face lifted high as he speaks to God, then facing forward, hand thrown up behind him pointing to God, while he invites us to join him in praise. "Look!" he says. "This is the God I'm talking to! This is the God I've told you about!"[1]

What moved him to praise? He saw the world and was overwhelmed with its beauty in form and function. He stared with "wide-eyed, childlike astonishment at the marvelous, mystifying handiwork of the Lord" and gave the only fitting response. He saw the world as "the stunning theatre, workshop, playground, of our Father in heaven. . . ."[2]

The psalmist structured his praises roughly according to the days of Creation. He spoke of the first day, when God created the heavens, the earth, and light and darkness; of the second day, when God distinguished sky from earth; of the third day, when God separated seas and lakes from dry land, and created plant life; of the fourth day, when God separated night from day; of the fifth and sixth days, when God created creatures of sea, sky, and land—including man—blessed them, and told them to multiply; and finally of the seventh day, the day of God's rest.[3] He longed for the eternal Sabbath when God's glory would be perfectly proclaimed by all creation untainted by wickedness, when God would again look on everything He had made and declare it "very good" (Gen. 1:31).

Bearer of Messages

Why did the psalmist speak of all these things? Of light and clouds and wind, of sea and land and thunder, of mountains and valleys

and springs and rivers? Why did one who set out to praise God revel in thoughts of wild donkeys and goats, of birds and grass and cattle, of wine and oil and bread? Why did he speak so glowingly of the "trees of the LORD . . . the cedars of Lebanon" (Ps. 104: 16)? What did it matter that there "the birds make their nests; the stork has its home in the pine trees" (verse 17), or that coneys hide in the mountain crags? Why did he tell of moon and seasons, of sun and day and night?

Because these are God's works; they reveal His wisdom (verse 24). To speak in awe and wonder of them is to speak in yet more awe and wonder of their Creator. For the psalmist everything was sacred; everything had its story to tell about the Creator. (David testifies of the same thing in Ps. 19:1-6.)

Psalm 104, like Genesis 1 which it reflects, marks one of the great dividing lines between biblical religion and the nature worship of many other ancient peoples. Here we find a clear distinction between creature and Creator that permits unabashed admiration for the art as praise for the Artist.

> To say that God created Nature, while it brings God and Nature into relation, also separates them. What makes and what is made must be two, not one. Thus the doctrine of Creation in one sense empties Nature of divinity. . . .
>
> But in another sense the same doctrine which empties Nature of her divinity also makes her an index, a symbol, a manifestation, of the Divine. . . . It is surely just because the natural objects are no longer taken to be themselves Divine that they can now be magnificent symbols of Divinity. . . .
>
> By emptying Nature of divinity—or, let us say, of divinities—you may fill her with Deity, for she is now the bearer of messages.[4]

The psalmist saw the world as the bearer of messages. "He makes winds his messengers, flames of fire his servants" (Ps. 104:4).

Light tells of God's splendor, darkness of His mystery or anger (verse 29). Wind and flame display His power. The firmness of earth is founded on His steadfastness (verse 5), its orderliness on His order (verses 7-9). Springs of water that quench the thirst of wild donkeys reflect the living Holy Spirit on whom man and beast alike depend for every breath (verses 11-13; see also verses 29-30).

Grass that feeds cattle, plants that yield fruit and grain for man, and deep waters from which great trees drink their fill are marvels (verses 14-16), yet even these are but signs of the God to whom all living things look for their food (verse 27). Mountains and crags that provide safety for goat and coney picture the refuge man has in God (see Ps. 18:2,31). When the lion roars for his prey (Ps 104:21), God responds as if it had prayed, "Give us this day our daily bread." And the frolicking of the great sea monster is the merest hint of the joyful delight of the Creator in His creation (verse 26).

Beasts and birds that are "satisfied with good things" (verse 28) are living parables, shaming men for discontent and complaint. "Look at the birds of the air," said Jesus; "they do not sow or reap or store away in barns, and yet your heavenly Father feeds them. Are you not much more valuable than they? . . . So do not worry. . . . But seek first his kingdom and his righteousness, and all these things will be given to you as well" (Mt. 6:26,31,33).

Then, after all his meditation on creation, the psalmist turned again to the Creator: "May the glory of the LORD endure forever; may the LORD rejoice in his works" (Ps. 104:31). He did not forget that his purpose had been to praise God, to give Him glory, to exalt and extol Him.

As if to avoid worshiping things made rather than their Maker he recalled how puny and fragile they were in God's presence. The earth that could "never be moved" (verse 5) "trembled" at a mere glance from God; the mountains that sheltered donkey and goat smoked at His touch (verse 32).

The psalmist's song could not be confined to the works of God but had to reach to God Himself: "I will sing to the LORD all my life; I will sing praise to my God as long as I live" (verse 33). And to the God in whom the psalmist rejoiced and who rejoiced in His own works (verse 31), he prayed, "May my meditation be pleasing to him" (verse 34), as if to say, "May I give You as much joy as You give me."

Suddenly the thought of the wicked invaded the psalmist's reverie. The very existence of evil men stained the garment of Creation. Indignantly he cried, "But may sinners vanish from the earth and the wicked be no more" (verse 35)! For him, the wicked were a great contradiction. They rebelled against creation and creation's God. And so his longing for their destruction was a pure and righteous expression of his praise to God.

But the psalmist did not allow himself to be distracted long by thoughts of the wicked. No temporary trouble could shake his confidence in the ultimate goodness of God. Confident that the wicked *would* vanish from the earth, he concluded as he had begun: "Praise the LORD, O my soul. Hallelujah!"[5]

Learning to Praise God for the Creation

How can we capture the delight in God's creation that the psalmist had and learn to praise the Lord for His wonderful works? There are five steps we can take.

First, we must understand that the earth *is* the Lord's, that He *did* make it—that, rather than its being the result of random accidents, it is a glorious, never-ending display of His goodness and wisdom, His power and beauty.

Second, we can sharpen our skills of observation. While we can't all become amateur biologists, geologists, or artists, we can open our eyes to the brilliance of a bluebird, the miniature world of bugs treading through forests of grass, or the awesome majesty of a huge thunderhead glistening in the late afternoon sun. We can

train our ears to notice the cooing of doves, the singing of crickets, and the purring of a cat on our lap. When we learn to taste the wonder of cold, clear water on a hot day, to smell the sweetness of freshly mowed grass, to feel the springy softness of moss on the forest floor, and remember that each of these was planned and made by the hand of the Lord, then we can join the psalmist in praise to God the Creator.

But believing and seeing aren't enough by themselves. They must be coupled with a third thing: proclaiming. In our age of quiet, private, hide-it-in-your-heart religion, we often fail to realize the role proclamation can play in the life of faith. Yet like cheering at a football game or clapping at a child's first steps, outward expression can make indelible the writing on our hearts.

The fourth step toward enjoying creation to the utmost is learning to hate evil, to be deeply bothered by wickedness. "They will not love where they ought to love, who do not hate where they ought to hate," wrote the Christian statesman Edmund Burke. It is common to applaud someone who keeps his cool in the face of the greatest wickedness, the ugliest affront to all morality. But that was not the way of Jesus, who used whips to drive wicked men from His Father's house. If we do not react to evil with horror, we will not react to God's goodness and beauty with praise. Rather than turning the other way when confronted by evil, we must choose, each day, to confront it, to loath it, to do battle with it, and, by the blood of the Lamb and the Word of His testimony, to overcome it. We must share the psalmist's longing for the time when sinners will vanish from the earth and the wicked will be no more.

This leads naturally to the fifth step toward enjoying God's creation: developing a firm, unalterable faith that God *will* win the war against evil. If we believe, like atheistic physicists, that the universe is slowly and inexorably dying, our joy must always be mixed with melancholy resignation to the triumph of nothingness. But Scripture teaches us that the God who made everything and

declared it "very good" (Gen. 1:31) will one day remake every-thing, that the people of God will be made pure, that "there will be no more death or mourning or crying or pain, for the old order of things [will have] passed away" (Rev. 21:4) and been replaced with a new Heaven and a new earth in which righteousness reigns without interruption.

If we can believe that God made the earth and everything in it, learn to observe the beauty around us and proclaim it, truly loathe evil, and retain complete faith that God's will will be done one day on earth as it is in Heaven, then we can enjoy creation as God intends us to and find in it reason to say, "Praise the LORD, O my soul. Praise the LORD" (Ps. 104:35).

NOTES:

1. He addresses others in verses 2-5,10-19,21-23,32-33; God in 6-9,20,24-31,34-35; him-self in 35.

2. Calvin Seerveld, *Rainbows for the Fallen World: Aesthetic Life and Artistic Task* (Toronto, Ontario, Canada: Toronto Tuppence Press, 1980), pages 22-23.

3. For the first day, compare verses 2-5 of Psalm 104 with Gen. 1:1-5; for the second, verses 6-9 with Gen. 1:6-8; for the third, verses 10-18 with Gen. 1:9-13; for the fourth, verses 19-23 with Gen. 1:14-19; for the fifth and sixth, verses 24-30 with Gen. 1:20-31; for the seventh, verses 31-35 with Gen. 2:2-3. In this analysis I have followed Albert Barnes and others. But while Barnes sees only the first five creative days reflected, I think the parallel is complete, though not strict. See Albert Barnes, *Notes on the Old Testament: Psalms*, 3 volumes, ed. Robert Frew (Grand Rapids: Baker Book House, 1976), volume 3, pages 81-82.

4. C.S. Lewis, *Reflections on the Psalms* (London: Fontana Books, 1962), pages 69-71.

5. The closing "Praise the LORD" in the NIV is the single word *Hallelujah* in the Hebrew. This word of praise was associated with thoughts of the Messianic Kingdom (see Arno C. Gaebelein, *The Book of Psalms* [Wheaton, Ill.: Our Hope Press, 1939], pages 386-387). Thus Psalm 104, a song of Creation, points forward to Consummation.

God the Creator and Lawgiver

PSALM 19

When the Apostle Paul entered Athens on a missionary journey, he saw about him altars to various gods of the Greek pantheon. Among them was one dedicated "To an Unknown God." "Now what you worship as something unknown," he told the people on the Areopagus, "I am going to proclaim to you" (Acts 17:23). Then he reminded them that their own philosophers taught them of a Creator independent of the world.

But while the philosophers had insisted that the Creator was unknowable, Paul insisted that God had made Himself known not only by creation but also in a Law. For violations of that Law, Paul said, God "commands all people everywhere to repent. For he has set a day when he will judge the world with justice by the man he has appointed. He has given proof of this to all men by raising him from the dead" (verses 30-31).

Psalm 19 conveys a similar message: that ". . . nature and law witness to the same Divine Person. . . ."[1] When standing before that Law, every man must bow in humble repentance, plead for God's mercy, and fully consecrate himself to God's service.

God's Self-Revelation in Creation

"The heavens declare the glory of God; the skies proclaim the work of his hands" (Ps. 19:1). As David studied God's creation, he met God the glorious and mighty. The broad expanse of the sky, the innumerable stars, the rolling majestic clouds, all testified of One more powerful than man can imagine.

The sun by day and the moon and stars by night declare a Creator more glorious than they. "Day after day . . . night after night . . ." (verse 2) their testimony is unceasing. It is also universal. "There is no speech or language where their voice is not heard. Their voice goes out into all the earth, their words to the ends of the world" (verses 3-4). No man anywhere is without God's self-revelation through nature.

For David, the radiant sun shows the brightness, clarity, and penetrating power of God's self-revelation. It is ". . . like a bridegroom coming forth from his pavilion," proud and fulfilled and overflowing with joy; "like a champion rejoicing to run his course," strong and determined and confident of victory; ". . . nothing is hidden from its heat," for it lights up every corner of the earth. "It pierces everywhere with its strong, clean ardour."[2]

Pagan nations for thousands of years have worshiped the sun because of its greatness. But David resisted that temptation with these simple words: "In the heavens he has pitched a tent for the sun" (verse 4)! Though it is stronger than anything else David knew, and though in contrast with his own narrow walk in life the sun roams freely from one end of the heavens to the other (verse 6), still God is mightier: He has confined even the sun within a certain scope—it makes its steady circuit, it follows His perfect plan.

Thus from the majestic creation David learned of the glory and power of God the Creator. For him, creation spoke so clearly and powerfully of the Creator that only a fool would deny it (Ps. 53:1).

But is God merely the "Great Architect of the Universe"? Did He, as deism claims, merely design and build the machine, start it working, and then abandon it? Or does He take intimate personal interest in the affairs of men? Is He merely the first Cause, or is He also One in whom "we live and move and have our being" (Acts 17:28)? For David the answer was clear.

God's Self-Revelation in Law

"The law of the LORD is perfect, reviving the soul" (Ps. 19:7). Suddenly shifting focus, David considered not only what *is*, but also what *ought* to be. In considering creation (what is) he had met God the Creator; in considering Law (what ought to be), he met Jehovah the Covenanter. "Nature speaks in eloquent silence of the strong God, but has no witness to His righteous will for men or His love to them which can compare with the clear utterances of his law."[3] First he saw God's glory and power; then he saw God's holiness and love.

In the first six verses, where David wrote of *God* (Hebrew: *El*) the Creator, he used the term only once, as if to imply that when revealed by creation alone, God remained distant. But with the shift in focus came a shift in language: He wrote of *Jehovah*, a name connoting God's covenantal relationship with Israel, and he used the word six times in three verses, as if to emphasize the deeply personal nature of his relationship with God. David considered God's revelation of His Law a sign of His intensely intimate, covenantal relationship with His people.[4]

The giving of the Law, like a parent's wise instruction to his child, meant that God was committed to His people, that He cared about every moment and aspect of their lives. By His Law, God expressed His love: it showed the way to happiness. That is why David viewed the Law and all its parts as ". . . more precious than gold, than much pure gold . . . sweeter than honey, than honey from the comb" (verse 10). David believed that the Law

warned him away from danger; he expected reward for keeping it (verse 11).

How many modern Christians think so highly of the Law? How many of us could say to God, "I will always obey your law, for ever and ever. I will walk about in freedom, for I have sought out your precepts. I will speak of your statutes before kings and will not be put to shame, for I delight in your commandments because I love them. I reach out my hands for your commandments, which I love, and I meditate on your decrees" (Ps. 119:44-48)? Rare is the Christian who meditates on the Law "day and night" (Ps. 1:2).

Why did David value the Law so much? The answer lies in his descriptions of the parts of the Law and their effects on people who keep them (Ps. 19:7-9).

The *Torah*

"The law [Hebrew: *Torah*] of the LORD is perfect, reviving the soul" (verse 7).

The Hebrew word *Torah* comes from a root meaning "to project" or "to teach," and denotes whatever points out or indicates God's will to man.[5] It refers not merely to moral, civil, or ceremonial law, but to the whole teaching, instruction, or doctrine of Scripture. It is the most comprehensive term for God's instruction to man.

David called the *Torah* "perfect" (see also 2 Tim. 3:16-17), meaning that ". . . it lacks nothing in order to its completeness. . . . It is absolutely true; it is adapted with consummate wisdom to the wants of man; it is an unerring guide of conduct. There is nothing there which would lead men into error or sin; there is nothing essential for man to know which may not be found there."[6] This perfect *Torah* revives, or gives life to, the soul, by showing men paths that lead to physical and spiritual prosperity rather than to physical and spiritual poverty and death.

How can this be, since the Apostle Paul implicitly denied that

the Law "could impart life" (Gal. 3:21)? The answer is that David wrote of the Law's relationship to the believer, the person whose covenant relationship with God was already established (note that it is the Law's effect on God's "servant" [Ps. 19:11] that David described), while Paul wrote of its relationship to the unbeliever, who was outside the covenant.

The Law, though "holy, righteous and good" (Ro. 7:12), is powerless to free men from bondage to sin and make them also holy, righteous, and good (Ro. 8:2-3). But by sending Christ as an offering for sin, God broke sin's hold over those who submitted to Him ". . . in order that the righteous requirements of the law might be fully met in us, who do not live according to the sinful nature but according to the Spirit" (Ro. 8:4).

In other words, the believer is a new creature (2 Cor. 5:17) empowered by a new principle—the principle of righteousness instead of sin (see Romans 6). He can, by drawing on the power of the indwelling Holy Spirit and studying the Law prayerfully so as to understand and apply it, obey the Law more and more as he matures in Christ. His growing obedience will be an outward expression of the inward righteousness that is a gift from God to all who trust in Christ. Thus he not only will be declared righteous in God's sight because of God's covering over his sins[7] and crediting Christ's righteousness to him (see Romans 4:6-8,23-25), but also will become increasingly righteous in thought, word, and deed toward God and others.

That the Law of God is a blessing to His people and not a curse is clear from the way God introduced the Ten Commandments: "I am the LORD your God, who brought you out of Egypt, out of the land of slavery" (Ex. 20:2). Jehovah, the God of the covenant, first redeems His people from slavery, and then gives them a Law. Obedience to that Law brings God's favor on all their endeavors, and so preserves their liberty (Dt. 7:12-16, 28:1-14). That is why James calls the Law a "law that gives freedom" (Jas. 2:12).

Ultimately the *Torah* calls us to submit to and depend on God and instructs us in a way of life that leads to prosperity— prosperity in relationship with God, with self, and with others. The first, second, and third commandments, for instance—and all of the statutes, ordinances, precepts, and judgments that stem from them—tell us how to prosper in our relationship with God: by putting God first in everything, worshiping nothing along with Him, and honoring Him in all that we do. The fourth and tenth commandments tell us how to prosper personally: by working diligently six days a week and resting a seventh, and by refusing to burden our minds with discontent by coveting what belongs to others. The fifth through ninth commandments tell us how to prosper in our relationships with others: by honoring our parents, respecting others' lives and property, being faithful in marriage, and speaking only the truth.

So, for those empowered to live by it, the Law shows the way of life. That is why, after Moses had given Israel an extended commentary on the Law in Deuteronomy, he concluded with this exhortation:

> This day I call heaven and earth as witnesses against you that I have set before you life and death, blessings and curses. Now choose life, so that you and your children may live and that you may love the LORD your God, listen to his voice, and hold fast to him. For the LORD is your life. . . . (Dt. 30:19-20)

The *'eduwth*

"The testimony [Hebrew: *'eduwth*] of the LORD is trustworthy, making wise the simple" (Ps. 19:7).[8]

After writing of the *Torah*, David wrote of the "testimony," which probably referred to the two tablets summarizing the Law—i.e., the Ten Commandments—that were placed in the Ark as a testimony, or witness, to the Covenant between God and His

people (Ex. 25:16-22). The Law stated the conditions of the Covenant. The promises of blessing God made in covenanting with His people are conditioned on their obedience to it (Dt. 4:1, 5:1-33, 6:1, 8:1); curses are threatened if they disobey it (Dt. 8:19-20, 28:15-68).

This testimony is "trustworthy," or sure. It is neither unstable nor fallible. It is not like the shifting sands of contemporary mores, but is the solid rock of divine wisdom, and as such it makes the simple—people otherwise easily misled—wise.

It is sad to see the sheepish way many Christians think and speak of God's Law. Some are embarrassed by it, as if it were outdated, not suited to man's current needs. But Scripture declares otherwise. To Israel Moses said:

> See, I have taught you decrees and laws as the LORD my God commanded me, so that you may follow them in the land you are entering to take possession of it. Observe them carefully, for this will show your wisdom and understanding to the nations, who will hear about all these decrees and say, "Surely this great nation is a wise and understanding people." What other nation is so great . . . as to have such righteous decrees and laws as this body of laws I am setting before you today? (Dt. 4:5-8)

God's Law is so trustworthy, so perfectly suited to the fallen nature of man made in the image of God, that even unbelievers will recognize its wisdom if they see it lived out consistently. If the people of God have lost influence in society, might it be because they have ignored God's Law?

The *Piqqud*

"The precepts [Hebrew: *piqqud*] of the LORD are right, giving joy to the heart" (Ps. 19:8).

The third name David used for the Law is "precepts," or

"statutes," a word that literally refers to a "thing appointed" or a "charge"—usually instructions given on specific occasions. The Law of God consists not only of broad, general principles, but also of specific instructions and applications. As city maps are to state and national maps, so precepts or statutes are to the general instruction (*Torah*) and testimony (*'eduwth*) of God: They give the detailed information necessary for concrete situations.

For instance, the Sixth Commandment tells us we must not commit murder. This is based on the positive principle that we must respect and protect human life. One specific rule applying this principle appears in Dt. 22:8: "When you build a new house, make a parapet around your roof so that you may not bring the guilt of bloodshed on your house if someone falls from the roof." Modern laws requiring fencing of construction sites and backyard swimming pools—and many similar laws—apply the same biblical principle.

The Eighth Commandment forbids stealing. That too—like all the negative commandments—is based on a positive principle: We ought to respect and protect others' property. Again, there are specific applications: "If you see your brother's ox or sheep straying, do not ignore it but be sure to take it back to him. If the brother does not live near you or if you do not know who he is, take it home with you and keep it until he comes looking for it. Then give it back to him. Do the same if you find your brother's donkey or his cloak or anything he loses. Do not ignore it" (Dt. 22:1-3). The modern adage, "Finders keepers, losers weepers" doesn't stand up to the *piqqud* of God!

There are hundreds of such statutes or precepts in Scripture, and a careful study of them pays off in new confidence for the Christian faced with ethical dilemmas. Rather than depending on his own ability to extrapolate from broad, general principles to specific decisions for specific occasions, he often can find that God has done the extrapolating for him—if he'll take time to search for it. The difficulty many believers have applying the Ten Com-

mandments to daily life, particularly to ethically complex problems, stems not from imperfection in the Law but from lack of knowledge of God's precepts, the detailed applications of Law taught throughout Scripture, especially in Deuteronomy.

These precepts, David said, are "right"; they always direct God's people in the right way, the way that pleases God. Because of that, they give joy to the heart, for the one who knows and practices them need not fear accidentally choosing the wrong thing and bringing on himself the curses threatened for disobedience.

The *Mitsvah*

"The commands [Hebrew: *mitsvah*] of the LORD are radiant, giving light to the eyes" (Ps. 19:8).

David next wrote of the "commands" of God, using a word that applied to the general body of God's Law. It refers to things "set up" or "appointed."[9] These commands of God David called "radiant," or clear and lucid rather than dark and mysterious. As such, they enlighten everyone who commits himself to them. "Your word is a lamp to my feet and a light for my path," wrote another psalmist (Ps. 119:105).

While casual acquaintance with God's Law is not sufficient to inform the believer against unrighteousness, the Law will point out clearly the path of righteousness to anyone who meditates on it day and night (Ps. 1:2)—who makes it his constant study and tries honestly to apply it to every aspect of his life. Of course, one who is satisfied with the barest acquaintance with the Law can expect neither its enlightenment nor the benefits that apply to the one who delights in God's Law. Indeed, in Ps. 1:4, "the wicked" are presented as the opposite of those who delight in God's Law, which implies that those who do love God's Law are the righteous. Clearly Christians need to give the Law more than just passing notice; we need to study it carefully and diligently conform our lives to it.

The *Yirah*

"The fear [Hebrew: *yirath*, construct case] of the LORD is pure, enduring forever" (Ps. 19:9).

Next David wrote of the fear of Jehovah. While he may have referred here to personal fear of, or reverence for, God, the poetic parallelism makes it more likely that he meant to refer to parts of God's Law that evoke fear: passages that warn of curses on disobedience, that pronounce judgment, that depict God as angry at sin or burning in holiness. Such passages, and the fear of God that they inspire, are pure, holy, undefiled. We should not think of them as tainted by some sub-Christian idea of God as capricious or spiteful, like the gods of pagan mythology. Rather, because God is holy and just, He is a consuming fire (Heb. 12:29) into whose hands it is a dreadful thing to fall (Heb. 10:31). And just as God never changes, but remains always the same (Mal. 3:6), so also His Law—particularly the part that instills fear — never changes but endures forever. "The ceremonial law is long since done away, but the law concerning the fear of God is ever the same. Time will not alter the nature of moral good and evil."[10]

Obedience to the Law gives the believer endurance as well, for it enables him to discern the best ways to deal with all of life's relationships—with God, with self, and with others. This is why in Psalm 1 David called the man blessed who delights in God's Law, adding that,

> He is like a tree planted by streams of water,
> which yields its fruit in season
> and whose leaf does not wither.
> Whatever he does prospers.
> Not so the wicked!
> They are like chaff
> that the wind blows away.
> Therefore the wicked will not stand in the judgment,
> nor sinners in the assembly of the righteous.

The *Mishpat*

"The judgments [Hebrew: *mishpat*] of the LORD are sure and altogether righteous" (Ps. 19:9).[11]

Finally David wrote of God's "judgments," what we might call case-law applications of the testimonies, precepts, and commands of the *Torah* to specific situations. They are God's judgments of what must be done in case particular things happen.

In Exodus through Deuteronomy these are recognized by their conditional construction: "*If* this happens, *then* you must do that," or "*If* someone does this, *then* he must suffer that."[12] God's judgments declare both what is to be done when faced with evil, or with the opportunity to choose good or evil, and what punishments are to be meted out for sin. These judgments, David wrote, are "sure," or "true," and "altogether righteous," not the least likely to lead those who practice them into unrighteousness—into anything unbefitting the holy, good, and just character of God.

Is the Law for Christians?

One important question raises itself here: Does the Law apply, in all these aspects, to Christians? Or did Christ's work on the Cross release us from all obligation to the Law?

Yes, it applies to Christians. The ceremonial aspects of the Law, which prefigured the atoning work of Christ (the instructions about sacrifices, offerings, and holy days, for instance) or served to distinguish Israel from its neighbors (dietary restrictions are an example of this), had served their full purpose after Christ accomplished His sacrifice and broke down the barrier between Jew and Gentile (Col. 2:13-17, Eph. 2:11-22). They are no longer binding on Christians. But the moral aspects of the Law, which reflect the unchanging moral character of God, never change and are binding on all people everywhere. That is why Jesus said:

> "Do not think that I have come to abolish the Law or the Prophets; I have not come to abolish them but to fulfill

them. I tell you the truth, until heaven and earth disappear, not the smallest letter, not the least stroke of a pen, will by any means disappear from the Law until everything is accomplished. Anyone who breaks one of the least of these commandments and teaches others to do the same will be called least in the kingdom of heaven, but whoever practices and teaches these commands will be called great in the kingdom of heaven." (Mt. 5:17-19)

Far from salvation by grace freeing us from any obligation to the Law, it sets us free from slavery to sin so that we can "become slaves to righteousness" (Ro. 6:18), and the Law is the written model of righteousness.[13]

Man's Response:
Contrition, Repentance, and Consecration

No wonder David valued the Law more than pure gold, savored it more than the sweetest honey, thanked God for the warning it gave him against sin, and expected reward for keeping it! But gratitude and expectation were not his only responses to God's self-revelation in Law.

"Who can discern his errors?" David wrote. "Forgive my hidden faults. Keep your servant also from willful sins; may they not rule over me" (Ps. 19:12-13).

Isaiah, on seeing God in a vision, cried, "Woe is me! . . . I am ruined! For I am a man of unclean lips . . . and my eyes have seen the King, the LORD Almighty" (Is. 6:5). Through the Law David saw God's holiness—and his own sinfulness. The Law was so brilliant, so all-encompassing, that it left nothing in his life hidden—even faults hidden from himself were open in God's sight. So David, like Isaiah, was moved to confess his sin and to beg God for forgiveness and deliverance.

The richness, the detail, the fullness of the Law made viola-

tions inevitable for fallen men. David knew this. But rather than protesting against the Law, which he knew to be perfect, he admitted that the fault was in himself. It was not the Law, but the flesh, that was weak (see Ro. 8:1-4). Thus he sought God's forgiveness for sin.

But David was not satisfied with the idea that he should be forgiven. He wanted to be made actually righteous. So he asked God to keep him from sin. He recognized that the Law demanded obedience, and that the power for obedient living comes from God alone. He wanted to be made "blameless, innocent of great transgression" (Ps. 19:13). He wanted to be set free from sin and made a slave to righteousness, that is, a true servant of God whose every act conformed with God's Law (see Ro. 6:18,22).

When David then prayed, 'May the words of my mouth and the meditation of my heart be pleasing in your sight" (Ps. 19:14), he was offering himself as a sacrifice to God (see Ro. 12:1). "The sacrifices of God," David wrote in Ps. 51:17, "are a broken spirit; a broken and contrite heart, O God, you will not despise." David displayed such a heart after contemplating the majesty of God shown in creation and the holiness of Jehovah shown in His Law.

From that heart, David closed his prayer, using three names for God that emphasized his confidence in his covenant relationship with God, his experience of God's undergirding power in his life, and his knowledge of God's redemptive love:

> May the words of my mouth and the meditation of my
> > heart
> > be pleasing in your sight,
> > O LORD, my Rock and my Redeemer. (Ps. 19:14)

NOTES:

1. Alexander MacLaren, *The Psalms*, 3 volumes, in W. Robertson Nicoll, ed., *The Expositor's Bible* (New York: Hodder & Stoughton [1892?]), volume 1, page 187.

2. C.S. Lewis, *Reflections on the Psalms* (London: Fontana Books, 1962), page 56.

3. MacLaren, *The Psalms*, volume 1, page 190.

4. "The name *Jahweh* means the covenanting God, the God sustaining faithful relations with his people." William Dyrness, *Themes in Old Testament Theology* (Downers Grove, Ill.: InterVarsity Press, 1979), page 33.

5. This discussion of the meanings of the words for the Law in Ps. 19:7-9 is a mere introduction to these fruitful concepts. For further study, see the commentaries on the Psalms listed in the bibliography and Robert B. Girdlestone's *Synonyms of the Old Testament—Their Bearing on Christian Doctrine* (Grand Rapids: Eerdmans, 1976 rpt.), pages 206-213. A thorough study of Old Testament Law from a Christian perspective, with applications for modern life, is Rousas John Rushdoony's *The Institutes of Biblical Law* (Nutley, N.J.: The Craig Press, 1973).

6. Albert Barnes, *Notes on the Old Testament*, 16 volumes, ed. Robert Frew (Grand Rapids: Baker Book House, 1976 rpt.), *Psalms*, volume 1, page 171.

7. The root meaning of the word *atonement* in Hebrew is a "covering over."

8. The rendering "statutes" for *'eduwth* in Ps. 19:7 NIV obscures the meaning of the Hebrew. I have chosen the familiar "testimony," the rendering of the KJV and the NASB.

9. See Girdlestone, *Synonyms of the Old Testament*, page 207.

10. Matthew Henry, *A Commentary on the Old and New Testaments*, 3 volumes (New York: Robert Carter and Brothers, n.d.), volume 2, page 130.

11. Again I have chosen the rendering of the KJV and the NASB over the NIV.

12. See, *e.g.*, Ex. 21-22, two whole chapters consisting almost entirely of such "judgments."

13. This is not the place for a full defense of the idea that the moral law is still binding on Christians. For further discussion, see John Calvin, *Institutes of the Christian Religion*, 2 volumes, ed. John T. McNeill, trans. Ford Lewis Battles (Philadelphia, Pa.: The Westminster Press, 1977), Book II, chapter vii, sections 12-13; and Greg Bahnsen, *By This Standard—The Authority of God's Law Today* (Tyler, Tex.: Institute for Christian Economics, 1985).

To Number
Our Days
PSALM 90

I t hadn't been much. Just a momentary lapse. He had had every reason to be angry. His patience had worn thin with all the complaints, the fickleness, the cowardice. And when the people had taunted him for lack of water, he had simply lost control.

So he had hit the rock—once, then twice. And the water had gushed out, more than the people could ever have used. "There!" he had thought. "You have your water now, you faithless rebels! Drink till you drown!"

But then the Voice had come: "Because you did not trust in me enough to honor me as holy in the sight of the Israelites, you will not bring this community into the land I give them" (Num. 20:12).

"Didn't trust in You? I believed You'd bring water out of the rock, didn't I? That's more than these people ever believed! It's not fair! Yes, I was wrong to hit the rock. But they drove me to it! You've seen what they've done, complaining day after day. My patience just wore out. Surely one little slip doesn't warrant such punishment."

But the excuses hadn't worked, and God had not relented.

39

Moses would not enter the Promised Land.

He could have sulked and felt sorry for himself, and indeed he was terribly disappointed. But he didn't allow himself to wallow in self-pity. Instead, he meditated on how great God was:

> Lord, you have been our dwelling place
> > throughout all generations.
> Before the mountains were born
> > or you brought forth the earth and the world,
> > from everlasting to everlasting you are God.
> (Ps. 90:1-2)

As leader of a wandering, homeless people, Moses had come to know God as his true home. God had shown His presence in cloud and fire. Where God was, Moses was at home. And at last he had learned that it had always been that way. Through all the generations since Abraham had been called out of Ur, since Jacob had fled to Paddan Aram, since Joseph had been sold into Egypt, God Himself had been Israel's home. He understood now that land and houses and family and life itself were worth nothing without God, but that God was worth everything without them.

The Hardness of God's Judgment

But, oh, it had been a cruel lesson to learn! This great I AM, who had created Heaven and earth and everything in them, who had made man in His own image, seemed almost indifferent toward human life. It was nothing for God to punish Moses for one slight indiscretion by keeping him from the one great reward he strove for; to sentence over a million of His people to die during forty years in the desert merely because they had refused to fight obviously superior enemies (Numbers 14); to kill 14,700 of His people merely because they had rebelled against Moses and Aaron (Num. 16:41-50).

> You turn men back to dust,
>> saying, "Return to dust, O sons of men."
> For a thousand years in your sight
>> are like a day that has just gone by,
>> or like a watch in the night. (Ps. 90:3-4)

So severe was God's judgment on His people that Moses had begged Him to remember His covenant, to remember that if He destroyed them all, the Egyptians would conclude that He had been unable to carry them through the trials of the desert (Ex. 32:1-14).

But if judgment on Israel were so frightful, how much more frightful was it on God's enemies! Moses had watched spellbound as Pharaoh and all his army were swept away in the raging torrent of the sea.

> You sweep men away in the sleep of death;
>> they are like the new grass of the morning—
> though in the morning it springs up new,
>> by evening it is dry and withered.
> We are consumed by your anger
>> and terrified by your indignation. (Ps. 90:5-7)

Enemies, chosen people, closest friends—it seemed God hardly had a second thought about crushing any of them. Could He not control His temper? Hadn't He admitted that He had to stay away from His people sometimes lest He destroy them (Ex. 33:3,5)? Why was this God, who urged His people to be merciful and kind, so wrathful? Why was He as ready to destroy ten thousand people as one?

The Evil of Rebellion

From the very beginning it had been so. When the first couple had disobeyed, merely by eating a piece of fruit, God had cursed all

their descendants and the whole earth. When mankind had grown wicked through and through, God had swept everyone away in a flood—all but one small family. When men had foolishly thought that by building a tower they could reach the heavens and challenge the authority of the gods, Jehovah hadn't seen the humor of it, but had cursed them with divided languages. Sodom and Gomorrah had felt the heat of His anger. Why?

Moses knew. It was because there was no such thing as "mere disobedience." All sin was rebellion against God. God was not capricious. He would not kill the righteous with the wicked (Gen. 18:25). But because He was holy, He could not wink at sin (Ps. 50:21). Sin, not God, was the great enemy.

> You have set our iniquities before you,
> our secret sins in the light of your presence. (Ps. 90:8)

Indeed, God was so merciful that He allowed no one to come face to face with His awful holiness. It was too much for men. Moses well remembered the day when he had begged to see God's glory, and He had responded, "I will cause all my *goodness* to pass in front of you, and I will proclaim my name, the LORD, in your presence. I will have mercy on whom I will have mercy, and I will have compassion on whom I will have compassion. But . . . you cannot see my face, for no one can see me and live." And so God had hidden Moses in a cleft in the rock while He passed, and even there the brilliant light had hurt his eyes (Ex. 33:18-23).

But he had seen God's goodness and mercy, the love Jehovah had showered on His people by making a covenant with them. And all his doubts about God's goodness had been swept away in that one awesome encounter. There Moses had met "The LORD, the LORD, the compassionate and gracious God, slow to anger, abounding in love and faithfulness, maintaining love to thousands, and forgiving wickedness, rebellion and sin." Yet in that brilliant, searing moment he had also known that Jehovah "does not leave

the guilty unpunished" (Ex. 34:6-7).

Oh, would that man had never sinned! That that one man, in whom all sinned, had never sinned! Then there had been no death, no raging floods or consuming fire! But the deed was done, the seed planted, and it had borne fruit in every generation. God was too holy to overlook such rebellion.

The Root of Mortality

You have set our iniquities before you,
> our secret sins in the light of your presence.
All our days pass away under your wrath;
> we finish our years with a moan. (Ps. 90:8-9)

Here was the root of man's feebleness, his frailty, his mortality. Death stemmed from sin, not from God's capricious choice. Without sin man would have lived forever, but with it his life was cut short. And though God would punish no one for a sin in which he was not implicated (Dt. 24:16), still no one was utterly innocent.

Moses had written of the shortening of life. Hadn't Adam lived 930 years, and Seth 912, and Enosh 905? Methuselah's 969 years hadn't been much longer than normal for man before the Flood; after all, Jared before him had lived 962 years, and Mahalalel 895, and Kenan 910. And later Noah had lived 950 years. Of course even those vast lifetimes were in God's sight like mere watches in the night. But then the disease of sin had caught hold in earnest, and lifetimes had shrunk, from the 600 years of Shem to the mere 175 of Abraham, the father of the faithful.

The length of our days is seventy years—
> or eighty, if we have the strength;
yet their span is but trouble and sorrow,
> for they quickly pass, and we fly away. (Ps. 90:10)

If a thousand years in God's sight were like a watch in the night, what were seventy but a blink of His eye? No wonder He thought nothing of condemning the nation to forty years in the wilderness!

A God to be Feared

One who had existed before the mountains were born or the earth was brought forth, who was God from everlasting to everlasting, must be feared before He could be known. His judgment and punishment should evoke reverent submission and humble appeals for mercy. That is why Moses had committed his last days to reminding Israel of the covenant, of its requirements, and of the penalties for violating it. "Be careful not to forget the covenant of the LORD your God that he made with you," he had urged them; "do not make for yourselves an idol in the form of anything the LORD your God has forbidden. For the LORD your God is a consuming fire, a jealous God" (Dt. 4:23-24). Obedience to the covenant was essential! Obedience brought blessing, but disobedience, wrath.

> Who knows the power of your anger?
>> For your wrath is as great as the fear that is due you.
> (Ps. 90:11)

A God to be Trusted

Still, though Israel had forsaken God time and again since the Exodus, Moses knew God would not forsake them (Dt. 4:29-31). That is why, though the people had rebelled and forsaken the covenant in treason against their King, he could plead confidently with God to mold for Himself a faithful people whose hearts would be knit together with His, who would fear Him, who would keep His commands always, so that He could bless them (Dt. 5:29).

"Teach us to number our days aright, that we may gain a heart of wisdom" (Ps. 90:12). To number our days! That was a key to holy living. No one who knew the brevity of life, the fragility of breath, could live today as he had lived yesterday. If only God's people would remember that sin had deprived a whole generation of the Promised Land, they would guard against it in themselves. That was wisdom: humble acceptance of one's mortality and fearful submission to the sovereign will and judgment of God.

Moses had seen that wisdom in the new generation of Israel. Their fathers all buried, the children were men and women of better hearts. They were eager to enter the Promised Land. So Moses prayed:

> Relent, O LORD! How long will it be?
>> Have compassion on your servants.
> Satisfy us in the morning with your unfailing love,
>> that we may sing for joy and be glad all our days.
> Make us glad for as many days as you have afflicted us,
>> for as many years as we have seen trouble.
> May your deeds be shown to your servants,
>> your splendor to their children. (Ps. 90:13-16)

God's judgment was indeed something to be feared. Yet there remained God's promise, the covenant sealed with an oath, that there would be a rest for the people of God. Their wandering would cease. They would be no longer homeless. The unfailing love of Jehovah expressed in His covenant would triumph over the fickleness of man. Blessing would replace curse, life would defeat death, and gladness would rejoice over sorrow.

But only with God's favor. That was one lesson Israel most assuredly had learned. The simple turning of His favor had meant defeat where victory once had been assured (Num. 14:40-45). They must never presume on Him again, but must depend on Him

for guidance and strength, must go wherever He directed—and only there. So Moses concluded his prayer,

> May the favor of the Lord our God rest upon us;
> establish the work of our hands for us—
> yes, establish the work of our hands. (Ps. 90:17)

The Life of Dependence

This "prayer of Moses the man of God" is filled with lessons for the Christian life. Among the most clear is the lesson of dependence: We must depend on God for life and breath, for success and joy. Why? The psalm reveals three reasons.

The first reason why we must depend on God is our frailty. We are but dust enlivened by His breath. God's providential love for us is our only source of confidence, our only ground for hope. Without Him, we have no future. With Him, all things are possible.

The second reason is deeper, more fundamental, than the first. It is, in fact, the reason for the first. We die because of sin, not because of nature. "We are too apt to look upon death as no more but a debt owing to nature; whereas it is not so; if the nature of man had continued in its primitive purity and rectitude, there had been no such debt owing to it: it is a debt to the justice of God, a debt to the law."[1] The very thing that alienates us from God also requires us to cast ourselves on His mercy, for we can neither escape nor defeat His judgment. He knows our sins better than we do (Ps. 90:8, 1 Cor. 4:4-5), and because of them we deserve only His wrath (Ps. 90:9). Our only hope, then, is in pleading for mercy on the basis of His compassion and unfailing love. We can offer nothing good in ourselves to placate His wrath, but must trust solely in His provision in Christ's substitutionary death on the cross to pay the penalty for sin (Ro. 3:25).

And the third reason why we must depend on God? It is because God alone is "from everlasting to everlasting" (Ps. 90:2).

Nothing else—and no one else—will do. He alone can satisfy. He alone can comfort. He alone can make us secure.

Steps to Confident Living in God

How can we apply what we learn from Psalm 90? Though there are many applications, here are seven that can help us.

Focus on God

"Lord, you have been our dwelling place," Moses prayed. We are pilgrims on earth, journeying toward our permanent home. Here we have no abiding place, but we seek one that is to come. We ought, therefore, to focus on God, to live daily as residents of His house, to walk in the light as He is in the light (1 Jn. 1:5-7). This means that His Word, His judgments, His values should be ours. It means letting God's Word, not the world around us, shape our values and choices. "Blessed is the man who does not walk in the counsel of the wicked or stand in the way of sinners or sit in the seat of mockers. But his delight is in the law of the LORD, and on his law he meditates day and night" (Ps. 1:1-2).

We must not put down roots in this world, but be rooted and grounded in God Himself. Not our circumstances, but our Redeemer, must govern the way we think and live. We who are God's must set our hearts on things above, where our lives are "hidden with Christ in God" (Col. 3:3). This means putting to death every sinful desire by consciously refusing to obey it (Col. 3:1-17), and nurturing instead the life of holiness—distinction from the world by conformity to God's Law—by constant, purposeful, conscious obedience to His commands and grateful trust in His forgiveness provided in Christ. The life of faith is one of practiced obedience, wrote the Apostle John:

> My dear children, I write this to you so that you will not sin. But if anybody does sin, we have one who speaks to the

Father in our defense—Jesus Christ, the Righteous One. He
is the atoning sacrifice for our sins and not only for ours but
also for the sins of the whole world.

We know that we have come to know him if we obey
his commands. The man who says, "I know him," but does
not do what he commands is a liar, and the truth is not in
him. But if anyone obeys his word, God's love is truly made
complete in him. This is how we know we are in him:
Whoever claims to live in him must walk as Jesus did.
(1 Jn. 2:1-6; see also 3:4-10)

Live Each Moment for Eternity

Our lives, says Moses, "quickly pass, and we fly away" (Ps.
90:10). We will not live forever. Our time is short, so we must not
delay in bringing our sins before God in humble confession,
grasping onto the promise of forgiveness in Christ, and begging
Him for the power to live above conscious sin.

So also our works will endure only if God sets His favor on
them. We cannot make them permanent if they displease Him—
and surely would not wish to! He, not we, must establish them
(verse 17). When we boast in ourselves or our accomplishments,
or crave fame or recognition, or always insist on doing things our
way or seeing our efforts through to completion, we act as people
without faith, without a God who can bring to fruition all that He
intends. Instead, we act as if everything depended on us—when in
reality all depends on Him.

Wait on God

For God, "a thousand years . . . are like a day that has just gone
by, or like a watch in the night" (verse 4). He is not limited by time.
He might as well wait ten thousand years as act today. God's acts
are not urgent but deliberate. He does not hurry. We, likewise,
must act deliberately, in conscious obedience to His guidance, not
in frenzied urgency. We must learn to wait on God's instruction.

When we do, we find that obedience may as easily tell us to delay as to proceed (see Numbers 14).

Battle Against Sin

Sin alienates us from God. And because God alone is a stable, eternal, omnipotent dwelling place for us, sin alienates us from all that we need and long for. This means that sin is serious business. We dare not toy with it, but must overcome it by conscious battle as we rely on the Holy Spirit for instruction and power. We must flee sin and, with undivided hearts, pursue holiness in its place.

We cannot be casual about the battle. We must be thorough. Each day calls for careful self-examination, asking God to reveal to us sins that we have forgotten so that we can confess them and have them cleansed away by Christ's blood (1 Jn. 1:9). And even then we have not gone far enough, for there are sins so secret, buried so deeply in our hearts, that we cannot know them. But God knows them (Ps. 90:8), and even those secret sins, when not placed on the altar before Him to be burned away by His cleansing fire, separate us from Him. We need, therefore, to confess with Paul that a clear conscience does not make us innocent (1 Cor. 4:4), recognize that God is our Judge, and humbly ask His forgiveness even for sins He has mercifully hidden from us.

Rejoice in God's Mercy

Despite our sin, God loves us. That is a key message of this wonderful psalm. God does have compassion on His servants, His is an unfailing love, and we can therefore look forward confidently, when we depend on Him, to His making us glad, not only for as many days as we have suffered, but for all eternity (Ps. 90:14-15). Knowing this gives us grounds for joy today, even in the midst of difficulty. This life of sorrow will not last forever but will be replaced by a life of resplendent glory. And while we dwell here, He shows us His love by countless deeds on our behalf: giving us homes and clothing, food and drink, friends and families,

and—best of all—friendship with Him, without which all else is worth nothing and with which we could rejoice without all else.

Depend on God's Blessing

All our success in life—real success in the things that count with God—depends on God's blessing what we do (Ps. 90:17). It is, indeed, our work; we cannot sit idly by and expect God to do everything for us. But its fruitfulness—whether in meeting our physical needs, or in bringing the lost to salvation, or in building up the Body of Christ—rests on God's approval. This Paul taught when he wrote, "So neither he who plants nor he who waters is anything, but only God, who makes things grow. The man who plants and the man who waters have one purpose, and each will be rewarded according to his own labor. For we are God's fellow workers . . ." (1 Cor. 3:7-9).

Yes, we work, but ultimately it is God who works in us, enabling us to will and to act according to His good purpose (Phil. 2:12-13). All that is not done under His direction and in His power is done in vain, for "unless the LORD builds the house, its builders labor in vain" (Ps. 127:1). We must, then, listen for His guidance in Scripture and in prayer, act upon it, and trust Him for the results.

Number Your Days

The focus of Psalm 90 is verse 12: "Teach us to number our days aright, that we may gain a heart of wisdom." What is "a heart of wisdom"? It is no mere intellectual understanding, but moral perception and action. It comes only to those who call out for it, who cry for it to God, and it makes a man "understand what is right and just and fair—every good path." When wisdom enters the heart, it protects from evil and saves from the ways of wickedness (Prov. 2:2-12; see also Jas. 1:5-6).

Finally, what does it mean "to number our days aright"? It begins with contemplating hourly "the fleeting character and

brevity of our lifetime."[2] Such contemplation should remind us of God's eternity, our frailty, and the coming judgment on our sin. And that reminder, in turn, should lead us to what Matthew Henry once called "the practice of serious godliness"[3]—that is, to glorifying God through sincere obedience to all of His commands, loving Him and our fellowman, and following the example of Christ, who came not to be served but to serve (Mt. 20:28). Wasn't that the sort of life Moses lived?

NOTES:

1. Matthew Henry, *A Commentary on the Old and New Testaments*, 3 volumes (New York: Robert Carter and Brothers, n.d.), volume 2, page 250.
2. Franz Delitzsch, *Psalms*, trans. Francis Bolton, in C.F. Keil and Franz Delitzsch, *Commentary on the Old Testament*, 10 volumes (Grand Rapids: Eerdmans, 1976), volume 5, part 3, pages 57-58.
3. Henry, *A Commentary on the Old and New Testaments*, volume 2, pages 250-251.

A Psalm
of Lament
PSALM 88

One of the most frightening things that could happen to an individual today is to contract the AIDS virus. The damage the virus can do to the body is awful. Though it might remain dormant for years, once it begins to attack the immune system, the inevitable death can be a welcome escape from the dreadful illness that ensues as diseases pile atop one another. The fortunate die before AIDS dementia sets in; others experience the scary reality of losing their minds as their brain cells are killed.

Perhaps worse than the physical ravages of the disease are the psychological and social problems that accompany it. Just harboring the virus can make someone an instant outcast. Families have been known to turn against AIDS carriers. Because the virus is transmitted sexually, couples in which one spouse contracts the virus may end their sexual relationships. Some people are so frightened of getting AIDS—perhaps with good reason, though medical experts disagree about how AIDS can spread—that they refuse to live in the same house with someone who has AIDS. Schools and even churches sometimes refuse to admit AIDS carriers. In Florida a family with hemophiliac children who carry the AIDS virus saw its home destroyed by a fire that probably was

set by an arsonist who wanted the family out of the community.

There was no acquired immune deficiency syndrome in ancient Israel. But there was a disease that, in that day, was just as frightening and loathsome: leprosy. Based on his description of himself, the author of Psalm 88 may very well have been a leper. The extended lament is his response to his suffering. In it we see first how Heman approached God (verses 1-2); next his enumeration of his troubles (verses 3-9); then his argument in favor of God's saving his life (verses 9-12); and finally a recapitulation of his troubles (verses 13-18). Careful study of his lament can help us deal with troubles in our lives.

Heman's Approach to God

The brightest part of Psalm 88—almost the only bright part—is the opening:

> O LORD, the God who saves me,
> > day and night I cry out before you.
> May my prayer come before you;
> > turn your ear to my cry. (verses 1-2)

Heman begins by calling on the Lord, Jehovah, the God of the covenant, and calls Him "God of my salvation." His very use of the name Jehovah sounds a note of hope, for it indicates his faith that God has acted to deliver him from trouble. He believed that God had saved him and would make his salvation complete.

Were it not for his manner of addressing God, we might easily think, based on the rest of Psalm 88, that Heman had lost all faith. For from this point forward all is darkness. Though he prays day and night and begs God to hear his petitions (verses 1-2), he says that God rejects him and hides His face from him (verse 14). Heman gets no answer to his prayers—or at least has none when he writes this song. And the psalm itself shows no

comfort, promises no relief from torment.

Yet Heman is persistent in prayer. He asserts that he prays "day and night" (verse 1), "every day" (verse 9), and "in the morning" (verse 13). Though no answers appear, he does not give up. In fact, he prays despite God's apparent rejection and wrath. In him we hear echoes of Job, who said, "Shall we accept good from God, and not trouble?" (Job 2:10) and, "Though he slay me, yet will I hope in him . . ." (Job 13:15). Heman is a living example of Jesus' parable of the importunate widow (Lk. 18:1-8). He never lets his troubles discourage him from continuing to pray.

Heman also shows humility in prayer. We find here no assertion of "rights," no demands in his approach to God. Rather, he begs God to hear him (Ps. 88:2). He assumes a subordinate, submissive role in his deeply personal relationship with God; for him, God is Master and he is servant, God is King and he is subject.

"I've Had Enough!"

Heman tells God that he is "full of trouble" (verse 3). Literally translated the phrase is "satiated with trouble." It is as if he had said, "I've had enough! I can't take any more!"

He uses two images for his pitiful condition, death and confinement. He writes of death first:

> . . . my life draws near the grave.
> I am counted among those who go down to the pit;
>> I am like a man without strength.
> I am set apart with the dead,
>> like the slain who lie in the grave,
> whom you remember no more,
>> who are cut off from your care. (verses 3-5)

His leprosy, assuming that this was his affliction, is so far advanced that he believes himself on the verge of death. Appar-

ently his associates also think of him that way. His condition is so
weak and helpless that they have taken up his duties, as high
government officials will take up the duties of a king or president
lying on his deathbed.

Seen in context, this is the sense of the phrase "set apart with
the dead." Literally this phrase is "free among the dead." The
word for "free" here was used especially of those set free from
servitude.[1] While we might think this a good thing, Heman sees it
as tragic, for the servitude from which he is free is service to God in
the sanctuary, the highest privilege anyone can have. He sees
himself as so near death that he is of no more use in God's service
than "the slain who lie in the grave," on whom God no longer calls
and who, at least from Heman's standpoint, are no longer objects
of God's care.

Next Heman switches to the image of confinement—
confinement in the grave and in prison:

> You have put me in the lowest pit,
> > in the darkest depths.
> Your wrath lies heavily upon me;
> > you have overwhelmed me with all your waves. . . .
> You have taken from me my closest friends
> > and have made me repulsive to them.
> I am confined and cannot escape;
> > my eyes are dim with grief. (verses 6-9)

It is largely from these verses that it appears that Heman may
have been a leper.[2] For in ancient Israel, the Law of God required
that a leper ". . . must wear torn clothes, let his hair be unkempt,
cover the lower part of his face and cry out, 'Unclean! Unclean!'
As long as he has the infection he remains unclean. He must live
alone; he must live outside the camp" (Lev. 13:45-46)—that is,
banned from all the benefits of the community of God's people
and of the holy services of the sanctuary.

Heman first describes his confinement as akin to that of a body lying in a grave (Ps. 88:5). But the more poignant image is of imprisonment, for that conveys the loneliness, the involuntary restraint, that he suffers. It was common for the Jews to consider leprosy a sign of God's judgment, and God did, in some instances, inflict it as punishment for sin (see Num. 12:10; 2 Kings 5:27, 15:5; 2 Chron. 26:23). So it is natural for Heman to ascribe his affliction to God's wrath (Ps. 88:7), and to consider himself confined in prison (verse 8), cut off from society because of his uncleanness.

Heman never considers that his sufferings might be the result of chance. He is convinced that they come from God. "*You* have put me in the lowest pit. . . . *Your wrath* lies heavily upon me; *you* have overwhelmed me. . . . *You* have taken from me my closest friends. . . ." Far from a sign of unbelief, this is one of those little lights that shine through the darkness of this psalm. "It breathes not complaint but submission, or, at least, recognition of His hand; and they who, in the very paroxysm of their pains, can say, 'It is the Lord,' are not far from saying, 'Let Him do what seemeth Him good,' nor from the peace that comes from a compliant will."[3]

Though Heman faithfully attributes his suffering to God, he is not like the Greek Stoical philosophers, who thought one ought never to be stricken with grief. Rather, he is so overwhelmed with grief that his eyes are "dim"—whether physically, perhaps because he cries so much that his vision is obscured either by tears or by the sheer fatigue of the stress of weeping, or spiritually, because he cannot see the good God intends in his suffering.

Heman's Argument

Having described the extent of his afflictions, he turns now to an argument in favor of God's saving his life:

> I call to you, O LORD, every day;
> I spread out my hands to you.

Do you show your wonders to the dead?
 Do those who are dead rise up and praise you?
Is your love declared in the grave,
 your faithfulness in Destruction?
Are your wonders known in the place of darkness,
 or your righteous deeds in the land of oblivion?
But I cry to you for help, O LORD;
 in the morning my prayer comes before you.
Why, O LORD, do you reject me
 and hide your face from me? (verses 9-14)

Heman's argument runs like this: "I am about to die. But the dead see none of God's wonders; they do not praise God; they neither hear nor declare God's love or faithfulness; and they know nothing of His wonderful deeds of righteousness. By contrast, I honor God daily in prayer. So it makes no sense for Him to reject me." The implication is that if he dies, the praise given to God will be diminished, meaning it is to God's advantage to spare his life.

All of this, of course, assumes a view of death that is far from Christian. But Heman lived long before Jesus Christ became the firstfruits from among the dead, before His Resurrection became the guarantee of the resurrection of all the faithful. While glimmers of hope for a future conscious life in God's presence appear here and there in the Old Testament, the full understanding of it awaited Christ's coming. For Heman, the argument seems compelling. But it doesn't persuade God. Instead, Heman senses only rejection from God. At the moment of his greatest need, when grief overwhelms him and he is falling into utter despair, God hides His face from him (verse 14).

Recapitulation and Cry of Despair

Like most people, Heman finds arguing with God little comfort. It doesn't take him long to return to depicting his trials:

> From my youth I have been afflicted and close to death;
> > I have suffered your terrors and am in despair.
> Your wrath has swept over me;
> > your terrors have destroyed me.
> All day long they surround me like a flood;
> > they have completely engulfed me.
> You have taken my companions and loved ones from me;
> > the darkness is my closest friend. (verses 15-18)

Affliction is nothing new to Heman. Indeed, it is all he has known since his youth. And now he is so ill that he is "in despair" (verse 15). The literal sense here is that he is "distracted," that his mind is befuddled. He has trouble thinking straight. The intensity of his suffering, its constancy and power, like the unrelenting crashing of breakers on a beach (verse 7) or the sweeping waters of a flood (verse 17), are literally driving him crazy.

But the most devastating thing for Heman is not his sickness itself, but its effect on his friends and loved ones. They have abandoned him—no, more precisely, *God has taken them from him.* He finds no comfort with wife or children, with parents or brothers or sisters. He is cut off from his fellow musicians in the Temple, with whom he has served all his life. He finds no shoulder to cry on, no arms wrapped around him in love. He is alone, utterly and terribly alone. No friends. No family. No God. Only darkness and despair.

How to Respond to Personal Suffering

The picture Heman paints of his life is not pretty. There is no cheer in it. But that does not mean that it is unrealistic, or that it reflects a weak faith. Millions of people live in such despair every day, and in a fallen world we have no guarantee that we will not encounter troubles as deep as Heman's.

We can take courage from the presence of this lament in the

Psalms. From it we learn ". . . that such feelings are not necessarily inconsistent with true religion, and do not prove that even such a sufferer is not a child of God."[4]

In addition, there are some very practical lessons about handling suffering to be found in this psalm.

Persist in Prayer

From the opening of the psalm we can see that we need, in times of trouble, to approach God in prayer with confidence, humility, and persistence. Like Heman, we can call the Lord "God of my salvation" even when we see no displays of His love. Yet we must approach Him not as equals but as subjects under a King, pleading with Him for a hearing rather than demanding His response. And, like Heman, we need to persist in prayer, to come to God day and night until either we are satisfied that we have been heard, or we have died. "Though he slay me, yet will I hope in him . . ." (Job 13:15). If we follow Heman's example, we will persist in prayer even when it goes unanswered for days, or weeks, or years on end. We will ultimately triumph over despair at God's silence, and we will be able, with Heman, to call Him, "the God who saves me."

Accept Troubles as Sent from God

It is always tempting to believe that our trials come from anyone but God—from Satan, our enemies, even our friends, but not from God. In so thinking, we hope to preserve our faith in God's goodness. But the moment we come to that conclusion, we have demolished our faith in God's power, and regardless how good God is, if He hasn't the power to deliver us from trials, we are without hope.

If, on the other hand, we can believe that God is in complete control of our lives, that Satan can attack us only by His express permission and only within the limits that He sets, then we can hope that our troubles are not for our harm but for our good. This is part of the message of the Book of Job, and it is also Paul's

message when he writes that God ". . . works out everything in conformity with the purpose of his will, in order that we . . . might be for the praise of his glory" (Eph. 1:11-12). This is not to say that God's goodness guarantees our happiness. Far from it. As C.S. Lewis put it in his book *A Grief Observed,* "What do people mean when they say, 'I am not afraid of God because I know He is good?' Have they never even been to a dentist?"[5] Rather, it is to say God's goodness guarantees our ultimate healing—healing of hearts once fatally stricken by the disease of sin, conforming them increasingly in this life, and perfectly in the life to come, to the image of Christ (Ro. 8:29). And if that healing requires painful surgery and long recuperation, our faith in God's goodness and sovereignty will enable us to endure patiently without abandoning hope (Ro. 8:24-25).

Our willingness to see God's hand behind all our afflictions has a wonderful side effect: it means we won't blame our friends, or hold grudges against them, if they turn against us. If we are prepared to see them, too, as instruments in God's hands, we will be able to forgive them, or, better yet, not to count the offense against them in the first place. If we thank God for giving us friends, why should we not acknowledge His hand in taking them away? "Shall we accept good from God, and not trouble?" (Job 2:10).

Take Hope in Eternal Life

Though Heman had little knowledge of the life to come, we, who live after Christ, have been given great promises about eternal life. God assures us ". . . that our present sufferings are not worth comparing with the glory that will be revealed in us" (Ro. 8:18). Are our sufferings great? Our glory will be greater—greater beyond compare!

> But we have this treasure in jars of clay to show that this all-surpassing power is from God and not from us. We are

hard pressed on every side, but not crushed; perplexed, but not in despair; persecuted, but not abandoned; struck down, but not destroyed. We always carry around in our body the death of Jesus, so that the life of Jesus may also be revealed in our body. . . . For our light and momentary troubles are achieving for us an eternal glory that far outweighs them all. So we fix our eyes not on what is seen, but on what is unseen. For what is seen is temporary, but what is unseen is eternal. (2 Cor. 4:7-10,17-18)

Prepare for Trials Ahead of Time

There is a valuable lesson in Heman's saying that the torments he suffered made him "distracted," that is, that they were driving him out of his mind. It is entirely possible that anyone should suffer difficulties that will drive him to the brink of insanity. Keeping from going over the edge may well rest on our preparing for troubles before they come. The practice of constant prayer, self-denial, and thankfulness must become ingrained *before* we encounter desperate hardship, lest we meet the enemy unprepared. What we need, says Albert Barnes, ". . . to prepare us for sickness, is a strong faith, built on a solid foundation while we are in health; such an intelligent and firm faith that when the hour of sickness shall come we shall have nothing else to do *but* to believe, and to take the comfort of believing. The bed of sickness is not the proper place to examine the evidences of religion; it is not the place to make preparations for death; not the proper place to *become* religious. Religion demands the best vigour of the intellect and the calmest state of the heart; and this great subject should be SETTLED in our minds *before we are sick—before we are laid on the bed of death.*"[6]

Never Pretend Happiness

Another temptation Christians face, especially in the age of "positive thinking," "positive confession," "possibility thinking," and

"self esteem," is the desire to pretend happiness despite our sorrow. For those of us who are tired of faking it when times get rough, Heman's psalm, dark and dismal as it is, should be a breath of fresh air! It positively reeks with honesty! He makes no excuses for God. He hides none of his complaints. When he feels abandoned, he says so—whether abandoned by God, by friends, or even by his own good senses.

That willingness to admit grief and torment and even despair is an important step toward recovery—though God does not guarantee recovery for us in this life—for without it we will not cry to God for deliverance. So long as we don't succumb to the opposite temptation to wallow in self-pity, honest expression of sorrow is good. To acknowledge pain without complaint, and then to get on with our duties, will deliver us from the extremes of fooling and babying ourselves.

Hope in God

Finally, Heman exemplifies hope in God Himself. Though his friends fail him, his health deteriorates, and life itself is ebbing away, Heman still trusts in Jehovah, the covenant-making God whose love reaches out in saving deliverance to those who trust in Him.

At the end of C.S. Lewis's novel *Till We Have Faces*, the main character, Orual, who had accused God of being wicked and ugly, finally saw Him and was overwhelmed with His beauty. "I know now, Lord, why you utter no answer," she said. "You are yourself the answer. Before your face questions die away. What other answer would suffice? Only words, words; to be led out to battle against other words."[7]

There are, in fact, times when God must strip us of things or persons we rely on in order to remind us that He is our real life and hope.[8] When He does that, we must remember, as MacLaren puts it, that ". . . God never makes a solitude round a soul without desiring to fill it with Himself. . . . if God has made a heart or a life

empty of human love, it is that He may Himself fill it with His own sweet and all-compensating presence."[9]

Yet many people who suffer loss go on for years without experiencing God's "sweet and all-encompassing presence." What can we do to experience Him? There is no magic formula, no guaranteed method. We can remove the obstacles of unbelief and sin, but the timing is His. That, as much as anything, is the message of Psalm 88: keep hoping, keep waiting, keep trusting, keep praising despite all pains. God is our Master, not our slave. We cannot force our Lover to come, but we can be ready when He does.

NOTES:
1. It is used also in Ex. 21:2,5-6,27; Dt. 15:12-13,18; 1 Sam. 17:25; Job 3:19, 39:5; Is. 58:6; Jer. 34:9-11,14,16. Always, except in 1 Sam. 17:25 (where it refers to a household exempt from taxation), it refers to a servant (or, as in Job. 39:5, a beast of burden) released from service.
2. "All these details suggest leprosy, which, if referred to here, is most probably to be taken, as sickness is in several psalms, as symbolic of affliction. The desertion by friends is a common feature in the psalmists' complaints. The seclusion as in a prison-house is, no doubt, appropriate to the leper's condition, but may also simply refer to the loneliness and compulsory inaction arising from heavy trials." Alexander MacLaren, *The Psalms*, 3 volumes, in W. Robertson Nicoll, ed., *The Expositor's Bible* (New York: Hodder & Stoughton, n.d. [1892?]), volume 2, pages 482-483.
3. MacLaren, *The Psalms*, volume 2, page 482.
4. Albert Barnes, *Notes on the Old and New Testaments: Psalms*, 3 volumes, ed. Robert Frew (Grand Rapids: Baker Book House, 1976), volume 2, page 362.
5. C.S. Lewis, *A Grief Observed* (New York: Bantam Books, 1976), pages 50-51.
6. Barnes, *Notes on the Old and New Testaments: Psalms*, volume 2, page 368, emphases original.
7. C.S. Lewis, *Till We Have Faces* (Grand Rapids: Zondervan, 1966), page 308.
8. Many of the lessons of Psalm 88—especially this one—are conveyed powerfully in Lewis's novel *Till We Have Faces*. I hope readers who want to delve more deeply into these insights will read that wonderful book.
9. MacLaren, *The Psalms*, volume 2, pages 483, 486.

God of the Covenant

PSALM 74

I n ancient Judah, the southern of the two kingdoms of God's chosen people, life for the faithful revolved largely around the sanctuary, the magnificent Temple in Jerusalem. There the believers brought their sacrifices to atone for sin, to offer a soothing aroma to an offended God, to purify themselves from uncleanness that otherwise would cut them off from fellowship and worship. There they enjoyed feasts and holy days. There they worshiped in song and prayer.

The Temple was filled with pageantry—pageantry prescribed by God Himself to display His glory and holiness. Its walls were covered with exquisite carvings, tapestry, and gold leaf. It was the most splendid structure the people ever saw, and it was the center of their religious life. There God's special presence dwelt, always reassuring God's people that they were His, that He had chosen them from among all the peoples of the world, that He had betrothed Himself to them. No matter the danger, no matter the ruin that might come upon home and community, the Temple was there to remind the people that God was unshakable.

Imagine the trauma the faithful Jew would suffer if that Temple were pillaged, desecrated, and destroyed! For him such an

event would be a revolution against the foundations of reality. It would call into question the truth of his faith, the power and authority of his God, the honor of his Divine King.

Just such an event is the background of Psalm 74, in which the psalmist presents the ruin of the Temple as the greatest calamity God's people could suffer and as an affront to the honor of God Himself. The psalm might have been written after the destruction of the Temple by Nebuchadnezzar's armies in 587 BC, or perhaps after its desecration by Antiochus IV Epiphanes in 168 BC—the text does not specify.[1] Whichever it was, the event shook the psalmist[2] to his core.

Is God Unfaithful?

The key to the passage is verse 20, where the psalmist pleads with God, "Have regard for your *covenant*, because haunts of violence fill the dark places of the land." Why is this the key? Because it tells us the substance of the whole psalm: It is an appeal to a Covenant, or contract, between God and His people and, if we may go so far, a complaint that God has ignored that contract.

Ancient covenants, or "suzerainty treaties," typically involved an agreement between a conquering king, or "suzerain," and local rulers, princes, or kings whom he subdued. In return for their submission, tribute, allegiance, and service, the suzerain promised protection from invasion. Such a Covenant God made with the nation of Israel when He delivered it from Egypt and brought it into the Promised Land. And though that Covenant included a warning that if Israel committed treason its enemies would defeat it and carry its people away, it also included this great promise:

> But if from there you seek the LORD your God, you will
> find him if you look for him with all your heart and with all
> your soul. When you are in distress and all these things
> have happened to you, then in later days you will return to

the LORD your God and obey him. For the LORD your
God is a merciful God; he will not abandon or destroy you
or forget the covenant with your forefathers, which he con-
firmed to them by oath. (Dt. 4:29-31)

Similarly Moses told the nation of Israel shortly before it crossed
into Canaan:

. . . the LORD has declared this day that you are his people,
his treasured possession as he promised, and that you are to
keep all his commands. He has declared that he will set you
in praise, fame and honor high above all the nations he has
made and that you will be a people holy to the LORD your
God, as he promised. (Dt. 26:18-19)

Psalm 74 then, written during the height of Judah's humilia-
tion either under the Babylonians or under Antiochus IV, is an
urgent appeal to God to honor the provisions of His covenant, to
observe that His people suffer contrary, it seems, to those provi-
sions, and to respond by delivering them. The outcome of every-
thing the psalmist prays for hangs on God's faithfulness to His
promises.

Just like the ancient Jews, Christians stand in covenantal
relationship with God, and the New Covenant includes the same
fundamental idea as the Old: in return for our surrender and
submission to His rule in our lives, God promises our salvation,
". . . if you confess with your mouth, 'Jesus is *Lord*,' and believe in
your heart that God raised him from the dead, you will be saved.
For it is with your heart that you believe and are justified, and it is
with your mouth that you confess and are saved. As the Scripture
says, 'Everyone who trusts in him will never be put to shame'"
(Ro. 10:9-11). When we understand this, we can learn valuable
lessons from Psalm 74 about how to pray when calamity over-
whelms us.[3]

The psalmist begins by calling to God's attention the desperate condition of His people (verses 1-8). Next he sets forth an urgent plea for God's response, coupled with an expression of surprise at God's prior inattention (verses 9-11). Then he comforts himself by remembering God's greatness proved by His past works of redemption and creation (verses 12-17). Finally he resumes his appeal for deliverance based on God's honor and covenant (verses 18-23).

Why Have You Rejected Us?

For a nation that believed it always lay under God's protecting hand, the calamity of conquest by a pagan enemy, particularly when that enemy desecrated and destroyed the very throne of God on earth, the Temple, communicated but one thing: God had forsaken His people. That is why, in verse 1, the psalmist attributes the difficulties directly to God's doing. It is not merely that the enemy hates Judah, but that God Himself is angry with Judah for its sin—this must be the case, for no enemy could touch the sheep of His pasture unless the Shepherd failed to protect them. In response to God's apparent anger against His people, the psalmist, speaking for a righteous remnant, presents three arguments.

Three Grounds for Confidence

First he draws a powerful image, juxtaposing God's smoldering anger with "the sheep of your pasture." Sheep are peaceable, gentle, tender creatures, defenseless against their natural predators. God is supposed to protect His sheep, but His wrath boils and smokes against them like lava in a volcano. By this contrast the psalmist appeals to God's tenderness and compassion toward the meek and defenseless.

Second, he argues that God has already committed Himself to these sheep. They are "the people you purchased of old, the tribe you redeemed as your inheritance" (verse 2).[4] The psalmist's

confident expectation of rescue rests on a past redemption. He argues as Moses does when God threatens to destroy a rebellious Israel and raise up a new nation through him: "If you put these people to death all at one time, the nations who have heard this report about you will say, 'The LORD was not able to bring these people into the land he promised them on oath; so he slaughtered them in the desert'" (Num. 14:15-16; see also Exodus 32). Paul argues the same way in Ro. 8:32: "He who did not spare his own Son, but gave him up for us all—how will he not also, along with him, graciously give us all things?" As Paul appeals to the great work of redemption in Christ, so the psalmist appeals to God's redeeming work for the nation. (That this is a powerful concept for him appears from the fact that he later uses four verses [12-15] developing it.)

The verb "redeemed" (*ga'al*) conveys a wonderful lesson. It is used especially of acts of the *goel*, the "kinsman redeemer" of Mosaic Law. The *goel* had responsibility to buy back for his kin any land that the kin sold in emergency to survive, and even to buy his kin out of slavery if the latter's circumstances became so desperate that he had to sell himself (Leviticus 25, Jer. 32:7-12). He also acted as *goel had-dam*, "avenger of blood," in case his kin were murdered (see Deuteronomy 19). The tender care Boaz exercised for Ruth and Naomi was as kinsman redeemer (Ruth 4:3-12), and in taking Ruth as wife, he called on the elders of the town to be "witnesses," a normal part of establishing a covenant— in this case, marriage. Covenant is fundamental to the idea of the *goel*. In the familiar verse, "I know that my Redeemer lives" (Job 19:25), Job calls God his *Goel*. By using *ga'al* then, the psalmist represents God as the *Goel*, the covenantal Kinsman of His people who both redeems them from slavery and visits vengeance on their murderers. In so doing he proves both God's duty and God's authority to deliver His people from distress.[5]

Third, he argues that Judah—particularly the Temple—is God's dwelling place on earth, a place that He treasures and the

honor of which He should defend. He asks God to remember "Mount Zion, where you dwelt" (verse 2). In a much earlier psalm God had been depicted as laughing at those who vainly tried to oppose Him, saying, "I have installed my King on Zion, my holy hill" (Ps. 2:6). And David had instructed his people to "Sing praises to the LORD, enthroned in Zion; proclaim among the nations what he has done. For *he who avenges blood* [the *Goel* again[6]] remembers; he does not ignore the cry of the afflicted" (Ps. 9:11-12). Thus this reference in Ps. 74:2 to Mount Zion is a particularly strong ground for the psalmist's plea. It ties together in a single image the ideas of God's kingly reign, honor, glory, and responsibility for protecting, redeeming, and avenging His people.

Judah's Desperate Condition

Immediately after appealing to God on the grounds of His mercy and tenderness and the people's vulnerability, of His covenantal relationship as Kinsman Redeemer, and of His honor pictured as Mount Zion, the psalmist describes the calamity that has come upon them. He calls on God to take notice of the destruction they have suffered, emphasizing its extent and intensity by referring to it as "everlasting" (verse 3).

But notice the destruction on which the psalmist focuses. When Judah was overwhelmed, both by the Babylonians in the sixth century BC and by Antiochus in the fourth, villages were ransacked and burned, homes destroyed, livestock and crops devastated. Thousands upon thousands of people were killed or enslaved. But those are not the psalmist's focus. Instead he writes, "Pick your way through these everlasting ruins, all this destruction the enemy has brought on the *sanctuary*." His primary concern is for God's honor, not for himself or his people and their possessions:

> Your foes roared in the place where you met with us;
> they set up their standards as signs.

> They behaved like men wielding axes
> to cut through a thicket of trees.
> They smashed all the carved paneling
> with their axes and hatchets.
> They burned your sanctuary to the ground;
> they defiled the dwelling place of your Name.
> They said in their hearts, "We will crush them completely!"
> They burned every place where God was worshiped in
> the land. (verses 4-7)

What a surprise! Which would I be more grieved at: a fire that destroyed my house, or one that destroyed the sanctuary in which I worshiped? "The desolation of God's house should grieve us more than the desolation of our own houses," wrote Matthew Henry, "for the matter is not great what comes of us and our families in this world, provided God's name may be sanctified, his kingdom may come, and his will be done."[7] This great concern for the things of God over the things of ourselves comes when we set our "minds on things above, not on earthly things" (Col. 3:2). It comes from our realizing that we have died, and our ". . . life is now hidden with Christ in God" (verse 3). When we have offered up everything we have as a sacrifice to God and committed ourselves to His Kingdom rather than our own, we will find ourselves deeply anguished at any harm to the Body of Christ, but we will face great personal loss without collapsing into inconsolable grief.

Why Do You Hold Back Your Hand?

While my father was in dangerous open heart surgery, the surgical team thoughtfully arranged for a nurse to call my family in the waiting room at regular intervals to report on progress. I remember how relieved we all were after each of those calls. Without them, sitting there hour after hour, we would have

wondered over and over, "What's taking them so long? Are they losing him? Has he died on the table?" The calls helped sustain our hopes.

But the author of Psalm 74 has no such advantage. I think what eats most deeply into his heart might be that, through all the time of the enemy's outrages against Judah and the sanctuary, there is no indication that God cares. There are no "signs" of God's continuing faithfulness to the covenant.[8] No prophets foretell a coming vindication and deliverance by God, "and none of us knows how long this will be" (verse 9). The people's trauma would be more bearable if there were just some end in sight, but the psalmist sees no light at the end of the tunnel. In desperation he cries out:

> How long will the enemy mock you, O God?
>> Will the foe revile your name forever?
> Why do you hold back your hand, your right hand?
>> Take it from the folds of your garment and destroy
>> them! (verses 10-11)[9]

Here again, despite the psalmist's despair for the people, he is more concerned for God's honor. It is *God* whom the enemies mock and whose name they revile. The writer wants God to avenge *Himself* more than to avenge His people. I cannot help being reminded of Christ's question to Saul on the road to Damascus, "Saul, Saul, why do you persecute *me*?" (Acts 9:4). There Jesus claimed His people's sufferings as His own. Just so here the psalmist prays as if Judah's sufferings were God's, and God's dishonor were his own. That is as it should be in a covenant. Each party must hold the other's affairs more important than his own. That same Saul, when he had become the Apostle Paul, displayed that attitude when he wrote, ". . . I consider everything a loss compared to the surpassing greatness of knowing Christ Jesus my Lord, for whose sake I have lost all things" (Phil. 3:8).

You Bring Salvation Upon the Earth

As if in answer to his own despair, the psalmist now writes, "But you, O God, are my king from of old; you bring salvation upon the earth" (Ps. 74:12). It seems that his mind now is drawn naturally from pleading for God to destroy His enemies to reminiscing on another time when God's people were threatened and God delivered them. The psalmist wasn't putting a good face on bad circumstances. Instead, when he looked at God, he couldn't help being encouraged.

Seven times in verses 13-17, the psalmist (as if to emphasize God's perfection) speaks to God saying, "*You, You* did this or that." The repeated pronoun, like a great bell pealing from the top of a cathedral, emphasizes the contrast between the awesome God and the contemptible scoundrels who dared to insult Him. Alexander MacLaren's translation brings out the majesty of these verses:

> Thou, Thou didst divide the sea by Thy strength,
> Didst break the heads of monsters on the waters.
> Thou, Thou didst crush the heads of Leviathan,
> That Thou mightest give him [to be] meat for a
> people—the desert beasts.
> Thou, Thou didst cleave [a way for] fountain and torrent;
> Thou, Thou didst dry up perennial streams.
> Thine is day, Thine also is night;
> Thou, Thou didst establish light and sun.
> Thou, Thou didst set all the bounds of the earth;
> Summer and winter, Thou, Thou didst form them.[10]

In effect, the psalmist changes his focus—from all the destruction and turmoil that have befallen his land, to the omnipotent God—and his repeated "Thou, Thou" drives home the lesson that nothing can challenge God's power. He takes comfort in his God

and in remembering His ancient deeds.

Again a passage comes to mind in which a New Testament writer uses cadenced repetition to drive home his point. In assuring Christians of their complete security in God's love, Paul writes, "For I am convinced that neither death nor life, neither angels nor demons, neither the present nor the future, nor any powers, neither height nor depth, nor anything else in all creation, will be able to separate us from the love of God that is in Christ Jesus our Lord" (Ro. 8:38-39). Paul and the psalmist both take refuge in the great power of God's love to preserve His people against all threats.

The psalmist's reference to God as King hints again at the covenant that underlies his whole way of thinking. This King who has covenanted with the descendants of Abraham, Isaac, and Jacob has brought "salvation upon the earth." How? He fulfilled His promises under the covenant with Abraham (Gen. 17:3-8) by bringing Israel out of slavery in Egypt and into the Promised Land. First the author considers the deliverance from Egypt: in it God divided the Red Sea, crushed Pharaoh's army, including its highest officers ("heads of the monster") and Pharaoh himself ("Leviathan"[11]), and then provided water in the desert by splitting open rocks for them. Second he looks at how God ushered Israel into Canaan: He "dried up the ever flowing rivers"—in other words, He held back the waters of the Jordan River while Israel passed through.

We might find it confusing that the psalmist now turns to God's rule over day and night, sun and moon, the boundaries of the earth, and summer and winter. Again the idea of Covenant enlightens us. In a sense Creation itself was a covenanting act by God in which He declared His rule, demanded submission, and promised blessing for obedience and cursing for disobedience. Jeremiah (33:19-26) refers to creation as a covenantal act of God.[12] Like the psalmist, Jeremiah refers to regularity in creation as a sign of God's dependability to uphold the Covenant:

"This is what the LORD says: 'If you can break my covenant with the day and my covenant with the night, so that day and night no longer come at their appointed time, then my covenant with David my servant—and my covenant with the Levites who are priests ministering before me—can be broken and David will no longer have a descendant to reign on his throne.'" (Jer. 33:20-21)

The psalmist is perplexed by the apparent collapse of the Covenant between God and His people. But, using the Covenant with creation to illustrate, he takes comfort in the fact that none of God's covenants collapses, that God upholds them all. It is as if he were saying, "You don't see night and day, summer and winter ceasing regular alternations, do you? Then take heart. God covenanted to sustain the order of creation and will sustain His people also." Or, more simply, "It's not the end of the world, you know!"

There is another lesson implied here: If it is by God's design that day follows night and summer follows winter, so also both prosperity and suffering follow God's design. If He rules the universe and sustains the order of nature, can anything happen by chance, without His design? Then He must have power to control our lives and circumstances. So, what have we to worry about?

Rise Up, O God, and Defend Your Cause

Having told God of the devastation caused by the enemy and comforted himself with the assurances of the covenant, the psalmist now returns in earnest to plead for God to respond. The focus is still on preserving or vindicating God's honor against those who mock and revile Him (verse 18), but the psalmist also remembers the need of the people, begging God not to forget them or hand over their lives to the "wild beasts"—the invaders (Ps. 74:19).

There is a poignant play on words in verse 19. In the NIV, we read, "Do not hand over the *life* of your dove to *wild beasts*."

Surprisingly, "life" and "wild beasts" here represent the same Hebrew word, which might be translated "congregation" in the first instance and "horde" in the second. At bottom, the people of God and the people of the world are the same. What, then, makes the difference between them? Only their relationship with God: either they are members of the covenant, or they are not. For ancient Israel this would be a reminder that "the LORD did not set his affection on you and choose you because you were more numerous than other peoples, for you were the fewest of all peoples. But it was because the LORD loved you and kept the oath he swore to your forefathers [i.e., the covenant] that he brought you out with a mighty hand and redeemed you from the land of slavery, from the power of Pharaoh king of Egypt" (Dt. 7:7-8). Just so Paul describes Christians' covenantal relationship with God: "But when the kindness and love of God our Savior appeared, he saved us, not because of righteous things we had done, but because of his mercy. He saved us through the washing of rebirth and renewal by the Holy Spirit . . ." (Titus 3:4-5).

The whole basis for hope of deliverance is found in God's gracious choice made known in the covenant. The psalmist never claims righteousness for the people of Judah, though he does picture them as helpless, tender, and vulnerable. In beginning by attributing the violence of the enemy to God's anger, he acknowledges the people's sinfulness. They deserve judgment. Nevertheless, as God promised again and again in His covenant to receive them back if they would turn in repentance, so now the psalmist calls on God to be faithful to that promise:

> Have regard for your covenant,
>> because haunts of violence fill the dark places of the
>> land.
> Do not let the oppressed retreat in disgrace;
>> may the poor and needy praise your name.
> (Ps. 74:20-21)

At last he returns to what has been his chief focus all along, God's honor and glory in the face of blasphemers who insult Him with their wickedness. He never specifically describes the punishment he hopes God will inflict (the closest he comes is asking God to take His right hand from His garment and destroy them, verse 11). Why? Perhaps because he knows that a Holy God cannot long overlook evil without punishing those who commit it. That is why it is enough that he concludes by praying:

> Rise up, O God, and defend your cause;
>> remember how fools mock you all day long.
> Do not ignore the clamor of your adversaries,
>> the uproar of your enemies, which rises continually.
> (verses 22-23)

It is enough for the psalmist to know that God will observe, that He will not hide His face from the evil that has befallen Judah and the sanctuary. Knowing this, he knows that ultimately justice will come, the Covenant will be honored, God will be glorified.

If the key to the psalm is the appeal to the covenant in verse 20, the essence is verse 22, where the psalmist begs God to plead *His own cause*. Not man's comfort but God's honor and glory are the right purpose of all creation, all life, all religion, and all prayer. The great musician Johann Sebastian Bach wrote at the end of each of his compositions, *Soli Deo Gloria*, Latin meaning, "To God alone be glory." Is that our conscious purpose today, this moment?

NOTES:

1. For arguments both ways see Albert Barnes, *Psalms*, 3 volumes, ed. Robert Frew (Grand Rapids: Baker Book House, 1975), volume 2, page 263; Alexander MacLaren, *The Psalms*, 3 volumes, in W. Robertson Nicoll, ed., *The Expositor's Bible* (New York: Hodder & Stoughton, n.d.), volume 2, pages 349-350; and other commentaries on Psalm 74.

2. The title might mean his name was Asaph, but it might also have meant simply that he was a descendant of Asaph or that the psalm was written to be sung by the descendants of Asaph. I will refer to him simply as "the psalmist" or "the author," or similar terms.

3. The covenant is one of the richest concepts in Scripture, but sadly one of the most ignored. It lies at the heart of our understanding of salvation and sanctification and is the foundation on which the role of God's people in family, Church, and society flows. It is also the key to understanding many passages of Scripture. For further study of the covenant, see Meredith G. Kline, *By Oath Consigned* (Grand Rapids: Eerdmans, 1968) and *The Structure of Biblical Authority* (Eerdmans, 1978), and Ray R. Sutton, *That You May Prosper—Dominion By Covenant* (Fort Worth, Tex.: Dominion Press/ Institute for Christian Economics, 1987).

4. Fruitful implications could be drawn from the two terms for the people. "The people" equals "the congregation," or the religious institution, while "the tribe" refers to the civil institution. Our understanding of the relationship of Church and state could be affected by how we view this passage.

5. See A.R.S. Kennedy, "Goel," in James Hastings, ed., *A Dictionary of the Bible*, 5 volumes (New York: Charles Scribner's Sons, 1906), volume II, pages 222-224.

6. MacLaren, *Psalms*, volume 1, page 84.

7. Matthew Henry, *Commentary on the Old and New Testaments*, 3 volumes (New York: Robert Carter & Sons, n.d.), volume 2, page 222.

8. The "signs" in verse 9 are probably not miraculous works but the regular ordinances performed in the Temple that constantly renewed and portrayed the covenant. The Temple being destroyed, those ordinances ceased until it was rebuilt. The psalmist contrasts the lack of these signs with the setting up of (probably military) standards as signs in the Temple by the invaders (see also verse 4). See Franz Delitzsch, *Psalms*, in C.F. Keil and Franz Delitzsch, *Commentary on the Old Testament*, 10 volumes (Grand Rapids: Eerdmans, 1976), volume 5, part 2, page 331.

9. We won't delve into the question here whether Christians can join in a prayer for vengeance against their enemies. But we will encounter that problem in Chapter Fourteen, when we study the imprecatory Psalm 109.

10. MacLaren, *Psalms*, volume 2, pages 349-350.

11. "Leviathan" probably denotes the crocodile, which the Egyptians worshiped as god of the Nile. Because the Pharaohs claimed to be incarnations of the gods, and the god of the Nile was at various times the most important of the Egyptians' gods, the psalmist would have used Leviathan to represent Pharaoh. Repeated mention of "heads" being broken or crushed may well have hinted at Messianic hope, based on the promise in Gen. 3:15 that Messiah would crush the serpent's head.

12. The general structure of the suzerainty treaty, or covenant, can be discerned repeatedly in the first three chapters of Genesis. See Sutton, *That You May Prosper—Dominion By Covenant*, pages 24ff.

A Covenant
Lawsuit
PSALM 50

We are seated in a courtroom, vast and deep and awful in its holiness. Its walls, ceiling, and floor are the boundaries of the universe. And now the Holy One of Israel sweeps in among us (upon us!) brilliant with the light of righteousness, full of power and mystery, beautiful to behold. And He is enraged! He is fairly bubbling over with rage. He has been patient long enough. He *will not* hold His peace any longer. Flame blazes forth from His judicial robes, whipped about by whirlwinds intensified by the flame's own heat. His thundering voice commands Heaven and earth to witness the trial of His people and proclaim His righteousness.

> The Mighty One, God, the LORD,
>> speaks and summons the earth
>> from the rising of the sun to the place where it sets.
> From Zion, perfect in beauty,
>> God shines forth.
> Our God comes and will not be silent;
>> a fire devours before him,
>> and around him a tempest rages.

79

He summons the heavens above,
> and the earth, that he may judge his people:
"Gather to me my consecrated ones,
> who made a covenant with me by sacrifice."
And the heavens proclaim his righteousness,
> for God himself is judge. *Selah* (Ps. 50:1-6)

A complaint is to be heard, a verdict reached, a fate settled. In this case the Almighty is Plaintiff (verse 7): He brings an indictment charging high crimes against the covenant. The same righteous God is also Judge (verse 6): He considers the evidence and declares the verdict. The courtroom is the whole earth (verse 1); the witnesses—in this case, not those who testify, but those who view the proceedings—are the whole of Heaven and earth (verse 4). And the defendants? They are God's chosen people, consecrated to Him by a Covenant ratified with sacrifices (verse 5).

What are these high crimes against the Covenant? There are two: contempt for worship, and thus for the God who is the only proper object of worship (verses 7-15), and contempt for fellowmen, demonstrated by violation of God's laws for human relations (verses 16-21). God will charge His people with empty formalism on the one hand, and lawless hypocrisy on the other.

Now He orders the miserable defendants brought before the bar. It is time for judgment to begin at the House of God.

First Charge: Empty Formalism

"Hear, O my people, and I will speak,
> O Israel, and I will testify against you:
> I am God, your God.
I do not rebuke you for your sacrifices
> or your burnt offerings, which are ever before me.
I have no need of a bull from your stall
> or of goats from your pens,

for every animal of the forest is mine,
 and the cattle on a thousand hills.
I know every bird in the mountains,
 and the creatures of the field are mine.
If I were hungry I would not tell you,
 for the world is mine, and all that is in it.
Do I eat the flesh of bulls
 or drink the blood of goats?
Sacrifice thank offerings to God,
 fulfill your vows to the Most High,
and call upon me in the day of trouble;
 I will deliver you, and you will honor me."
(verses 7-15)

What is the offense? Is it that Israel has forgotten the sacrifices God required? No, the sacrifices are there, day after day, constantly repeated. But they are empty, vain, profaned by insincerity. The worshipers—if they may be called that—bring cattle and goats and birds, but no hearts. They honor God with their lips, but their hearts are far from Him (Is. 29:13). They offer form without substance, sound without power, words without meaning.

Israel brings the sacrifices regularly enough, but not faithfully. The people treat the offerings like magic formulas that work automatically. They act as if they had succumbed to the pagan idea of a finite god who—like a foreign conqueror—needs tribute to sustain his rule. In so doing they violate the sense of the first three commandments, against worshiping other gods, making idols and worshiping them, and taking God's name in vain.

The perfect picture of Israel's wanton disregard for the spirit of the sacrificial system is Solomon's portrait of the prostitute who says to the young man she hopes to entice, "I have peace offerings at home; today I fulfilled my vows. So I came out to meet you. . . . Come, let's drink deep of love till morning; let's enjoy ourselves

with love!"¹ (Prov. 7:14-15,18). She believes her offerings buy
God's forgiveness for sins yet to be committed. She treats them as
superstitious people in pre-Reformation times treated indul-
gences, buying them to pay for sins in advance so they need fear no
penalty. She has no desire for holiness; she wants wickedness with
impunity.

But empty formalism can never please God. What can? Not
ignoring the forms of worship, but using them with thankful
hearts, honest consecration and dedication, and sincere appeals to
God for mercy and deliverance.

Second Charge: Hypocrisy

But to the wicked, God says:
"What right have you to recite my laws
 or take my covenant on your lips?
You hate my instruction
 and cast my words behind you.
When you see a thief, you join with him;
 you throw in your lot with adulterers.
You use your mouth for evil
 and harness your tongue to deceit.
You speak continually against your brother
 and slander your own mother's son.
These things you have done and I kept silent;
 you thought I was altogether like you.
But I will rebuke you
 and accuse you to your face." (Ps. 50:16-21)

Here are people who boast in their treaty with Jehovah, but
who brazenly violate its conditions. Just as they think the sacri-
fices are magic, so they think their Covenant, of which the sacri-
fices are tokens, is magic. As if the mere mention of it would turn
away God's judgment! But they are as mistaken as were the

hypocrites of Judah shortly before the Babylonians destroyed the Temple, who refused to believe that it could fall because it was God's dwelling place on earth. To them Jeremiah said:

> This is what the LORD Almighty, the God of Israel, says: Reform your ways and your actions, and I will let you live in this place. Do not trust in deceptive words and say, "This is the temple of the LORD, the temple of the LORD, the temple of the LORD!" If you really change your ways and your actions and deal with each other justly . . . then I will let you live in this place, in the land I gave your forefathers for ever and ever. But look, you are trusting in deceptive words that are worthless.
>
> Will you steal and murder, commit adultery and perjury, burn incense to Baal and follow other gods you have not known, and then come and stand before me in this house, which bears my Name, and say, "We are safe"—safe to do all these detestable things? (Jer. 7:3-10)

No temple or sacrifices or covenant can protect those whose hearts are far from God, for they exclude themselves from the blessings of the Covenant and nullify the sacrifices by their unrepentance. The Covenant is no guarantee of God's blessing to everyone, but a promise of blessings on covenant-keepers and curses on covenant-breakers (Deuteronomy 28). It is a treaty between the Sovereign Lord of all creation and a needy people. If they trample on their duties, God will cause their enemies to trample on them (Dt. 28:15-68). All their pious recitations of the Ten Commandments only make them the more guilty if they scoff at them in daily life.

"But we have lived this way for years," say the people, "and God hasn't rejected us. We're people of the Covenant! We're His children! Sure, we've bent the rules a little here and there, but He's never done anything about it." Oh, foolish people, who think that

God is like them! That He merely pays lip service to His Law, that He winks at violations of treaties, that He approves of thievery and adultery and slander and false witness. What a shock awaits them! "The LORD is slow to anger, abounding in love and forgiving sin and rebellion. *Yet he does not leave the guilty unpunished*; he punishes the children for the sin of the fathers to the third and fourth generation [of those who hate him]" (Num. 14:18; see also Ex. 20:5).

That shock is now, here, in this courtroom! They stand before the bar indicted, tried, found guilty. What awaits them?

The Sentence—with an Offer of Mercy

"Consider this, you who forget God,
 or I will tear you to pieces, with none to rescue:
He who sacrifices thank offerings honors me,
 and to him who considers his way
 I will show the salvation of God."[2] (Ps. 50:22-23)

Like fruitless branches of the Vine, fit only to be lopped off, thrown aside to wither and dry, and cast into the fire (Jn. 15:1-6), so the hypocritical, formalistic Israelites deserve only God's wrath. If they do not repent, He will tear them in pieces, and no foreign god will be able to rescue them.

If they do not repent! But if they do . . . if they do, then there is hope! If they will turn their hearts to Jehovah in thanksgiving, and order their lives according to His Law, then they will see His salvation. His anger will cease, they will be acquitted in judgment, and rather than suffering His punishment they will enjoy His favor.

What of the New Covenant?

God's charges against Israel under the Old Covenant were two: empty formalism and hypocrisy. The people went through the

motions of worship, but without sincerity. They mouthed the Law, but didn't live it. How does this covenant lawsuit apply to believers under the New Covenant?

New Covenant, Old Substance

Precisely the same way, I believe, that it applied under the Old. For the substance of the New Covenant is the same as that of the Old:[3]

> "The time is coming," declares the LORD, "when I will make a *new covenant* with the house of Israel and with the house of Judah. It will not be like the covenant I made with their forefathers when I took them by the hand to lead them out of Egypt, because they broke my covenant, though I was a husband to them," declares the LORD.
>
> "This is the covenant I will make with the house of Israel after that time," declares the LORD.
>
> "I will put my law in their minds and write it on their hearts. I will be their God, and they will be my people. . . ." (Jer. 31:31-33, emphasis added)

Promises, Obligations, Signs

How does the New Covenant differ from the Old? The Old is written on tablets of stone (Dt. 5:22), the New on the heart. The covenants differ, then, in how they are prescribed. Yet they are the same in substance; they have the same promises, threats, and obligations.

The *promise* is, "I will be their God, and they will be my people," a promise made more specific in God's commitments to protect His people, to give them prosperity when they obey Him, and to forgive their sins when they repent and seek Him with heartfelt sincerity (Deuteronomy 28-30, Acts 16:31). Under both covenants, this promise is received by faith (Ro. 4:16).

The *threat* is, ". . . if you do not obey the LORD your God

and do not carefully follow all his commands and decrees I am giving you today, all these curses will come upon you and overtake you. . . . The LORD will send on you curses, confusion and rebuke in everything you put your hand to, until you are destroyed and come to sudden ruin because of the evil you have done in forsaking him" (Dt. 28:15,20).

The *obligations* are the requirements of God's moral Law revealed in the Ten Commandments and summarized in the two Great Commandments (Lev. 19:18, Dt. 6:5, Mt. 22:37-40; see also Ro. 13:8-10). Under the Old Covenant, Moses declared these obligations when he "told the people all the LORD's words and laws," and the people committed themselves to them when "they responded with one voice, 'Everything the LORD has said we will do'" (Ex. 24:3; see also Deuteronomy 29, where the covenant was renewed before entry into the Promised Land).

In ushering in the New Covenant, Jesus reaffirmed these promises, threats, and obligations simultaneously when He said:

> "Do not think that I have come to abolish the Law or the Prophets; I have not come to abolish them but to fulfill them. I tell you the truth, until heaven and earth disappear, not the smallest letter, not the least stroke of a pen, will by any means disappear from the Law until everything is accomplished. Anyone who breaks one of the least of these commandments and teaches others to do the same will be called least in the kingdom of heaven, but whoever practices and teaches these commands will be called great in the kingdom of heaven. For I tell you that unless your righteousness surpasses that of the Pharisees and the teachers of the law, you will certainly not enter the kingdom of heaven." (Mt. 5:17-20)

The New Covenant believer commits himself to these obligations when he confesses, "Jesus is Lord" (Ro. 10:9; see Mt. 7:21-23)

and professes to love Him, for Jesus said, "If you love me, you will obey what I command" (Jn. 14:15).[4]

Both covenants are entered into, or ratified, by sacrifices (see Ps. 50:5). Under the Old Covenant the chief sacrifice was the killing of the Passover lamb in Egypt, whose blood protected Israel's firstborn from the angel of death (Exodus 12), an act commemorated each year at Passover (Ex. 12:14). Under the New Covenant, the chief—and only—sacrifice was the killing of the Son of God on the cross, whose blood protects all who believe in Him from death (Jn. 1:29, 6:53), an act commemorated in baptism (Ro. 6:3-4) and Communion (note that Communion was instituted at the Passover supper shared by Jesus and the disciples, Lk. 22:7-20). Indeed, the Passover sacrifice of the Old Covenant, like all the other sacrifices, was but a picture of Christ's ultimate Passover sacrifice (1 Cor. 5:7).

Thus the believer under the New Covenant has the same moral obligations as one under the Old—namely, to love God with all his heart, soul, mind, and strength and to love his neighbor as himself. He learns from the moral Law how to do these two things (Ro. 13:8-10). And he, like the Old Covenant believer, enjoys promises in response to obedience and faces threats in response to disobedience (Mt. 7:24-27). And while the Old Covenant prescribed sacrifices as *signs* of the covenant, the New Covenant prescribes baptism and Communion.

How, then, does the covenant lawsuit pictured in Psalm 50 apply to New Covenant believers?

Believers under the New Covenant may equally turn worship—particularly baptism and the Lord's Supper—into empty formalism, and we, mirroring Israel's hypocrisy, may disobey God's Law while claiming a covenantal relationship with Christ. Our doing so is just as offensive to our Holy God as Israel's formalism and hypocrisy were. It should not surprise us, then, that in the New Testament we find warnings against both formalism and hypocrisy.

Formalism Under the New Covenant

It is easy for many Protestants to presume that we have no "forms" of worship analogous to the sacrifices of Israel. Our services, typically, are not full of liturgy and ritual. But in fact we have forms of worship that parallel those of the Old Covenant.

One is Communion. The Apostle Paul went out of his way to warn believers not to profane that ceremony:

> . . . whenever you eat this bread and drink this cup, you proclaim the Lord's death until he comes.
>
> Therefore, whoever eats the bread or drinks the cup of the Lord in an unworthy manner will be guilty of sinning against the body and blood of the Lord. A man ought to examine himself before he eats of the bread and drinks of the cup. For anyone who eats and drinks without recognizing the body of the Lord eats and drinks judgment on himself. That is why many among you are weak and sick, and a number of you have fallen asleep. But if we judged ourselves, we would not come under judgment. (1 Cor. 11:26-31)

In ancient times, parties establishing a covenant conducted a ceremony in which they cut an animal in half. Then they walked between the halves of the animal, acting out a self-maledictory oath. It was as if they said, "May the same end come to me as to this animal if I rebel against this covenant." What that ceremony was to ancient covenants, Communion is to the New Covenant. When we commemorate Christ's death in this way, we as much as say, "May what He suffered come on me if I rebel against this covenant." Taking Communion should be a most serious matter. When we commune without first examining our hearts and presenting ourselves in renewed commitment to God and sincere intention to obey and serve Him, we profane it just as formalistic Israelites profaned their sacrifices.[5]

Are we not guilty of formalism every time we sit among God's people in worship but let our minds wander to the distractions of daily life without concentrating on God Himself and what He has done on our behalf, or when we sing hymns without attending to their words? Do we not dishonor God every time we mouth words of table grace without believing that all we have really and truly comes solely from His gracious hand? Do we not profane the forms of worship when we recite the Lord's Prayer without consciously intending obedient submission to God's will and committing ourselves to the struggle for God's Kingdom, or without living up to that frightful clause, "Forgive us our debts, as we also have forgiven our debtors," and its even more frightful explanation, "For if you forgive men when they sin against you, your heavenly Father will also forgive you. But if you do not forgive men their sins, your Father will not forgive your sins" (Mt. 6:12,14-15)?

Hypocrisy Under the New Covenant

Just as it is easy for us to forget that we, like Israel, have forms of worship that we may make empty and profane by acting them out while our hearts are elsewhere, so also we may forget that the same moral Law that bound Israel binds us. When we do, we are guilty of hypocrisy.

When we make the wonderful doctrine of salvation by grace through faith an excuse for carelessness toward God's Law, we become hypocrites. For Paul expressly explains that we are saved by grace through faith ". . . to do good works . . ." (Eph. 2:10). This is why James wrote of those who rejected good works, "What good is it, my brothers, if a man claims to have faith but has no deeds? Can such faith save him? . . . As the body without the spirit is dead, so faith without deeds is dead" (Jas. 2:14,26). We know that we must not allow grace to become an occasion to sin (Romans 6), but do we remember that ". . . sin is lawlessness" (1 Jn. 3:4), and therefore that grace must not become an occasion for

us to act as if God's Law did not bind us?

In fact, Jesus made explicit the implicit high standards of the Law when He taught that not mere outward action but inward intention is its real aim (Mt. 5:21-44). Never did He abrogate the requirement of the Law (see Mt. 5:17-20). Instead, He pointed to the Law's real intent, which is to make our hearts reflect God's heart, so that we are known not for anger but for patience and charity; not for adultery but for purity of mind and conduct as well as of body; not for divorce but for marital faithfulness; not for broken oaths but for truthfulness even in our most casual conversation; not for exacting revenge to the maximum extent permitted by the Law, but for forgiveness; not for hatred of our enemies, but for reconciling love for them.

So then, am I innocent of theft merely because I don't steal my neighbor's book or money or time, even though I envy what he possesses? Is not a pastor guilty of theft if he envies another pastor's successful ministry? Is not a man guilty of adultery even if he only looks longingly on a woman other than his wife? Am I not guilty of slander if, refusing to forgive, I pass on ugly gossip, whether true or not?

A church member once told me that a man in our congregation was stealing water from a municipal water system. She hadn't talked to him about it. Neither had she gone to the proper authorities. She didn't expect me to stop the thefts. Apparently her only motive was to tear down a brother in the Lord. God's charge against the hypocrites of Israel would apply to her action: "You speak continually against your brother . . ." (Ps. 50:20).

If we allow our standing in grace to become an excuse for ignoring or violating the Law, we make ourselves exactly like the hypocrites condemned in Psalm 50. For we pretend that the grace shown in Christ's death on the cross will apply to us regardless of our hypocrisy, just as the hypocrites then claimed protection because of the grace pictured in the regular sacrifices of the Temple. To such impudent presumption God replies, "These

things you have done and I kept silent; you thought I was altogether like you. But I will rebuke you and accuse you to your face" (Ps. 50:21).

Our knowledge of the finished work of Christ on the cross makes our sin not less but, if possible, more obnoxious in God's sight than it was in our ignorance. That is why the writer to the Hebrews urged us:

> If we deliberately keep on sinning after we have received the knowledge of the truth, no sacrifice for sins is left, but only a fearful expectation of judgment and of raging fire that will consume the enemies of God. Anyone who rejected the law of Moses died without mercy on the testimony of two or three witnesses. How much more severely do you think a man deserves to be punished who has trampled the Son of God under foot, who has treated as an unholy thing the blood of the covenant that sanctified him, and who has insulted the Spirit of grace? For we know him who said, "It is mine to avenge; I will repay," and again, "The Lord will judge his people." It is a dreadful thing to fall into the hands of the living God. (Heb. 10:26-31)

Grace Under the New Covenant

After His angry warning in Ps. 50:21, God holds out the promise of gracious forgiveness when He says:

> "Consider this, you who forget God,
> or I will tear you to pieces, with none to rescue:
> He who sacrifices thank offerings honors me,
> and to him who considers his way
> I will show the salvation of God."[6] (verses 22-23)

The Reformer John Calvin grasped the glorious weight of this great promise when he wrote:

. . . what a remarkable proof have we of the grace of God
in extending the hope of mercy to those corrupt men, who
had so impiously profaned his worship, who had so auda-
ciously and sacrilegiously mocked at his forbearance, and
who had abandoned themselves to such scandalous crimes!
In calling them to repentance, without all doubt he extends
to them the hope of God being reconciled to them, that they
may venture to appear in the presence of his majesty. And
can we conceive of greater clemency than this . . . ? Great
as it is, we would do well to reflect that it is no greater than
what we have ourselves experienced. We, too, had aposta-
tized from the Lord, and in his singular mercy has he
brought us again into his fold.[7]

So also, after the stern warning in Heb. 10:26-31, we read
this gracious promise: "For in just a very little while, 'He who is
coming will come and will not delay. But my righteous one will
live by faith. And if he shrinks back, I will not be pleased with
him.' But we are not of those who shrink back and are destroyed,
but of those who believe and are saved" (Heb. 10:37-39).

The message of Psalm 50 is the same. When we go to God
with thankful hearts, intent on allowing Him to work His will in
us, He shows us the way of salvation. Faith that pleases God is not
trust in empty ritual, though it may use God-ordained symbols to
enhance understanding. It is not mere lip service to God's holy
Law, though it sings the praises of that Law (Ps. 19:7-11). Rather,
it is a humble accepting of God's forgiveness and an earnest
commitment to walking in obedience to Him.

The prophet Micah described another covenant lawsuit
brought by God against His people in which the charges were
much the same as those in Psalm 50. Micah represented the
repentant defendant as asking, "With what shall I come before the
LORD and bow down before the exalted God? Shall I come before
him with burnt offerings, with calves a year old? Will the LORD be

pleased with thousands of rams, with ten thousand rivers of oil? Shall I offer my firstborn for my transgression, the fruit of my body for the sin of my soul?" To these questions Micah replied, "He has showed you, O man, what is good. And what does the LORD require of you? To act justly and to love mercy and to walk humbly with your God" (Mic. 6:6-8).

God asks us to present ourselves, not bulls and goats, as living sacrifices for His service (Ro. 12:1). The beasts on a thousand hills are His already, as are all things that we might imagine giving to Him. But our hearts are far from Him if we do not voluntarily bring them to Him as thank offerings for all His goodness to us. "To obey is better than sacrifice," Samuel told Saul (1 Sam. 15:22), and that is what God invites when He says, "He who sacrifices thank offerings honors me, and to him who considers his way I will show the salvation of God"[8] (Ps. 50:23).

NOTES:

1. NIV marginal translation.

2. I have chosen the marginal translation in the NIV. It appears more accurate and makes better sense contextually.

3. See A.B. Davidson, "Covenant," in James Hastings, ed., *A Dictionary of the Bible*, 6 volumes (New York: Charles Scribner's Sons, 1905), volume 1, page 514.

4. That receipt of promises and commitment to obligations are fundamental aspects of the Covenant, see Gleason L. Archer, "Covenant," in Everett F. Harrison, ed., *Baker's Dictionary of Theology* (Grand Rapids: Baker Book House, [1960] 1975), page 142. That threatening is also an essential aspect of the covenant, see Ray Sutton, *That You May Prosper—Dominion By Covenant* (Fort Worth, Tex.: Dominion Press/Institute for Christian Economics, 1987), pages 77ff. That New Covenant believers have the same obligations to obey the moral Law Old Covenant believers had, see Mt. 5:17-19 and John Calvin, "Three Uses of the Law," *Discipleship Journal*, Issue 21 (May/June 1984), pages 23-25 (condensed from his *Institutes of the Christian Religion*, ed. John T. McNeill, trans. Ford Lewis Battles [Philadelphia, Pa.: Westminster Press, 1977], Book II, Chapter vii, sections 6-13 [volume I, pages 354-362]). Greg Bahnsen's *By This Standard—The Authority of God's Law Today* (Tyler, Tex.: Institute for Christian Economics, 1985) is a good popular level defense of the applicability of the moral Law to modern Christians. For an excellent practical exposition of the Ten Commandments, see Martin Luther, "A Brief Explanation of the Ten Commandments, the Creed, and the Lord's Prayer" (1520), in *Works of Martin Luther*, Philadelphia Edi-

tion (Grand Rapids: Baker Book House, 1982), pages 354-367.

5. There are additional significances to Communion also. For excellent discussions of its meaning and use, see Sutton, *That You May Prosper—Dominion By Covenant*, Appendix 9, "Covenant By the Spirit (New Covenant Sacraments)," pages 299ff, and Samuel Johnson, "An Oath of Fidelity," *Discipleship Journal*, volume 6, Number 2, March 1, 1986, pages 32-35, adapted from Johnson's Sermon IX, on 1 Cor. 11:28, in *The Works of Samuel Johnson*, 9 volumes (Oxford: Talboys and Wheeler, 1825), volume 9, pages 369ff.

6. NIV marginal translation.

7. John Calvin, *Commentary on the Book of Psalms*, 3 volumes, trans. James Anderson (Grand Rapids: Baker Book House, [1846] 1984), volume 2, page 279.

8. NIV marginal translation.

Longings of a Broken Heart

PSALM 51

S everal years ago a woman who was a member of a small church in Oklahoma had an adulterous affair with a man in her town. Despite urging by church leaders, she refused to repent. At last, following the procedure for church discipline in Mt. 18:15-18, the elders and pastor announced her sin to the congregation and excommunicated her. The woman was outraged. She sued for invasion of privacy and defamation of character. She claimed that her private life was none of the church's business. She showed no remorse for her sin—she didn't even acknowledge that it was sin.

What a far cry from the response of King David to the prophet Nathan's rebuke after he had committed adultery with Bathsheba and arranged for Uriah's death (2 Samuel 11-12)! When Nathan shows him the heinousness of his act, David's eyes are opened and he confesses, "I have sinned against the LORD." Immediately Nathan pronounces forgiveness: "The LORD has taken away your sin" (2 Sam. 12:13). Then, in stark contrast with the Oklahoma woman's response, David confesses and repents *publicly* by writing a psalm "for the director of music" in the sanctuary—that is, for use in the most public place, where every-

one in the kingdom will learn of his wickedness (Psalm 51, title).

In Psalm 51 David reveals his brokenness of heart, his true penitence, his sorrow for sin. He pleads with God for forgiveness and cleansing (verses 1-9), begs God to strengthen him in righteousness (verses 10-12), and commits himself to purity and obedient service (verses 13-17).

David's Prayer for Pardon

Have mercy on me, O God,
 according to your unfailing love;
according to your great compassion
 blot out my transgressions.
Wash away all my iniquity
 and cleanse me from my sin.
For I know my transgressions,
 and my sin is always before me.
Against you, you only, have I sinned
 and done what is evil in your sight,
so that you are proved right when you speak
 and justified when you judge.
Surely I have been a sinner from birth,
 sinful from the time my mother conceived me.
Surely you desire truth in the inner parts;
 you teach me wisdom in the inmost place.
Cleanse me with hyssop, and I will be clean;
 wash me, and I will be whiter than snow.
Let me hear joy and gladness;
 let the bones you have crushed rejoice.
Hide your face from my sins
 and blot out all my iniquity. (Ps. 51:1-9)

These verses reveal what David thought of God, of sin, and of himself as a sinner subject to God's judgment.

God of Mercy

To David, God is merciful, unfailing in love, and great in compassion (verse 1). This forms the foundation on which David stands before God, hopeful despite the knowledge that his sin deserves punishment. He argues nothing in himself, but appeals to God for forgiveness solely on the basis of God's nature.

Man of Sin

His view of sin shows us why he can argue nothing in himself. At first he refers to "transgressions," using the plural (verse 1). He views his sins as separate, isolated events. But instantly he changes and speaks of his "iniquity" and "sin," each word singular (verse 2). Those seemingly isolated events are mere symptoms, exhibitions of the monolithic structure of his whole character. Sins manifest sin; they are parts of a whole. But the whole is greater than the sum of its parts. His problem is not merely that he has sinned now and again, but that he is _sinful_, full of sin in his very essence. Had only his individual sins separated him from God, they could be wiped away in a moment; but he himself, because of his moral corruption, is an abomination to God.

What Is Sin?

The three words David uses for sin are rich in instruction. First, sin is "transgression" (verse 1)—it is, as Alexander MacLaren defines it, "rebellion, the uprising of the will against rightful authority— not merely the breach of abstract propriety or law, but opposition to a living Person, who has right to obedience. The definition of virtue is obedience to God, and the sin in sin is the assertion of independence of God and opposition to His will."[1] David sees his sin not as a mere slip, an inadvertent mistake, but as an angry, contemptuous shaking of his fists in the face of the gracious God who has anointed him to be king, who has given him all his victories, who has blessed him with salvation and joy and honor and power.

Second, sin is "iniquity," or "distortion" (verse 2). It is a twisting of the soul, a corrupting of the character. There is, writes MacLaren, "a straight line to which men's lives should run parallel. . . . But this man's passion had made for him a crooked path, where he found no end. . . ."[2] The phrase translated, "I have been a sinner from birth" (verse 5) is literally "I was shapen in sin," and the word David chooses to describe his shaping is poignantly picturesque. It is the Hebrew *hhool*, and means "to turn around, to twist, to whirl," and then "to twist oneself with pain, to writhe." Hence it was used for childbirth.[3] But for David, in this context, it must have had special significance: he declares that he is a man of iniquity, disordered, misshapen, twisted, "bent" as C.S. Lewis described it in his novel *Out of the Silent Planet*. And that twisting had begun at birth—no, even before that, at his very conception (verse 5).

Finally David uses the word "sin" (verse 2), what MacLaren describes as "missing an aim." But it is no unimportant target that is missed. It is ". . . either the Divine purpose for man, the true Ideal of manhood, or the satisfaction proposed by the sinner to himself as the result of his sin. In both senses every sin misses the mark."[4]

The Horror of Sin

With these three words, David paints a picture of himself as wretched in God's sight. But he is not finished depicting how horrible sin—and therefore he himself—is. He now shows that sin's horror is fivefold.

Sin Torments the Mind

True penitence is a present, constant, painful recognition of one's sin and the mess it makes of one's relationship with God. It is not a mere intellectual awareness that one has sinned, but the awful realization that one's sin grips him and drags him down into the flood of God's wrath. The man convicted of sin cannot escape its

torment until he has experienced reconciliation with God. David feels that. That is why he insists, ". . . I know my transgressions, and my sin is _always_ before me" (verse 3).

Sin Is Against God Himself

The acts for which David feels so penitent injured Bathsheba, Uriah, and the members of his army who suffered with Uriah in the plot to have him killed. Why, then, does David now write, "Against you, you only, have I sinned and done what is evil in your sight" (verse 4)? There are several reasons.

First, the common notion in the ancient Near East was that a king could do whatever he pleased with his people. Yet Israel had a Law, given by God, that applied even to kings (Dt. 17:14-20). When Nathan confronted him with God's judgment, David must have remembered that he, like everyone else in Israel, must answer to God. Second, David was admitting that while he had hidden the sin from everyone else, God knew of it—had observed him in the very act. Third, David understood that sin itself is, ultimately, only against God. We may commit crimes against our fellowmen, but God defines sin as transgression of _His Law_ (1 Jn. 3:4). Sin therefore, in this strictest sense, can only be against God. Fourth, in David's days, a king who had done what he had would have been exonerated by all his subjects. But it was not man's judgment, but God's that he faced. No assurance of man's approval could outweigh his dread of that condemnation.

Finally, might not the author of that great prophecy of the atoning crucifixion of the Messiah (Psalm 22) have had some sense that whatever injury he does to men he ultimately does to God Himself? Jesus declared that in the day of judgment He would say to the righteous, "I tell you the truth, whatever you did for one of the least of these brothers of mine, you did for _me_," and to the guilty, ". . . whatever you did not do for one of the least of these, you did not do for _me_" (Mt. 25:40,45). When He confronted Saul, the great persecutor of the early Christians, on the

road to Damascus, He asked not, "Why do you persecute My people?" but ". . . why do you persecute *me*?" (Acts 9:4). Those who know God's grace but persist in rebelling against Him ". . . are crucifying the Son of God all over again and subjecting him to public disgrace" (Heb. 6:6), and if anyone under the Old Covenant knew God's grace, it was David. Our sins may injure our fellowmen once, but they injure the Lord of glory twice—once by contempt for Him and His Law, and once by His bearing them in punishment on the Cross.

Sin Is Against a Righteous Judge

David reveals another horror of sin when he confesses that God is always right and just in condemning and punishing sinners (Ps. 51:4). Here David as much as says, "No matter how stringent the punishment, even to the point of everlasting suffering, I deserve it all." He makes no excuses, presents no extenuating circumstances. He admits his guilt and God's justice in judgment.

The Apostle Paul was so convinced of God's righteousness in the face of every conceivable objection from man that he wrote, "Let God be true, and every man a liar." Then he cited David's declaration of God's righteous judgment:

> As it is written: "So that you may be proved right in your words and prevail in your judging."
>
> But if our unrighteousness brings out God's righteousness more clearly, what shall we say? That God is unjust in bringing his wrath on us? (I am using a human argument.) Certainly not! If that were so, how could God judge the world? Someone might argue, "If my falsehood enhances God's truthfulness and so increases his glory, why am I still condemned as a sinner?" Why not say—as we are being slanderously reported as saying and as some claim that we say—"Let us do evil that good may result"? Their condemnation is deserved. (Ro. 3:4-8)

No matter what excuses we might conjure up for our sins, the fact remains that we are sinners and God is holy; His judgment is just, and in His sight, apart from His grace, we stand condemned.

Sin Infests Man's Very Heart

Yet again, sin is horrible because it is so deeply imbedded in David's heart—and in the heart of every man, for all, like him, are conceived in sin. When David confesses, "Surely I have been a sinner from birth, sinful from the time my mother conceived me" (Ps. 51:5), he does so not to excuse himself, but to emphasize how filthy he is. David is not merely covered with sin, but saturated with it. He would be in enough trouble if God required only the appearance of holiness, for he bears instead the appearance of iniquity. But God requires _inner_ holiness (verse 6), and David is even more wicked in reality than in appearance. No external show will restore his relationship with God.

The Wonder of Grace

Yet he does not despair. Rather, he calls on God to "blot out" his rebellion, to "wash away" his corruption, and to "cleanse" him from error. To three pictures of his corruption (transgressions, iniquity, and sin) he opposes three pictures of God's grace in action.

His request that God "blot out" his transgressions (verse 1) views forgiveness as erasing charges or debts. David knows that his individual acts of rebellion separate him from God, and he longs for them to be stricken from the record, that fellowship might be restored.

But that, as we have seen, is not enough. For not the sins alone, but sin itself, staining the warp and woof of his person, makes him repugnant to God. So he asks God to "wash away" all his iniquity (verse 2). This could be translated literally as "multiply to wash" or "wash thoroughly."

Here again the Hebrew is richly pictorial. The word means

more than a mere outward rinsing, as one might wash a plate. It means "washing by kneading or beating." Before modern detergents and washing machines, clothes were washed by wringing them by hand and beating them against rocks, forcing water through every fiber, carrying away the dirt (a method used among the poor even today). It is as if David prayed, "Wash me, beat me, tread me down, hammer me with mallets, dash me against stones, do anything with me, if only these foul stains are melted from the texture of my soul."[5]

And finally David pleads, "cleanse me from my sin" (verse 2). The word *cleanse* is used for a priestly declaration of ceremonial cleanness. David understands that his iniquity makes him unworthy to commune with God. Until *declared* clean, he is excluded from the wonderful rituals of the sanctuary depicting God's gracious acceptance of His people. Thus, until "cleansed" he must believe himself rejected by God. He is like the New Covenant believer who cannot in good conscience take Communion until he has confessed his sin and made restitution to the one he has offended (1 Cor. 11:28-32). So he longs to be readmitted to communion with God and His people.

This is why David prays, "Cleanse me with hyssop, and I will be clean; wash me, and I will be whiter than snow" (Ps. 51:7). In the ritual of cleansing for the healed leper, the priest dipped hyssop into water mixed with blood from a slain bird, symbolizing the leper dying in his uncleanness, and then sprinkled the solution over the man, symbolizing his cleansing. Then he pronounced him clean and, at the same time, released a living bird, symbolizing the leper healed by God, to fly freely "over the open field," symbolizing his freedom from his quarantine before his healing (Lev. 15:1-7). What a picture of the freedom God gives to the pardoned sinner! (And can any Christian not see in this a vivid picture of Christ's shedding blood mixed with water on the Cross to wash away sins?) No wonder David's mind flies from the ceremonial cleansing to pray, "Let me hear joy and gladness; let the bones you

have crushed rejoice" (Ps. 51:8)! For being declared clean in such a gripping ceremony and restored to free fellowship with God's people is a joyous occasion.

Significantly, ceremonial cleansing for the leper always *followed* his healing. He sought not healing in the ritual, but declaration—to himself and others—that the healing was accomplished. Just so, David's request for the ritual of cleansing follows his request for God to blot out his transgressions and scrub away his iniquity. He knows that God will make that declaration only after the condition it depicts is made real. And so he looks forward to it as reassurance of forgiveness and reconciliation with God.

This great cleansing would be David's if only God would hide His face from his sins and blot out his iniquity (verse 9). And on the basis of God's mercy, love, and compassion, David is confident that God will do just that. But why, when he has already devoted so much energy to begging God for pardon, does he repeat the same request? Does he lack faith? No, his initial description of God proves otherwise. Why then this repetition? Is it vain? No. It is rooted in the gravity with which David feels the weight of sin.

> All repetitions are not 'vain repetitions.' Souls in agony
> have no space to find variety of language: pain has to con-
> tent itself with monotones. David's face was ashamed with
> looking on his sin, and no diverting thoughts could remove
> it from his memory; but he prays the Lord to do with his sin
> what he himself cannot. If God hide not his face from our
> sin, he must hide it for ever from us; and if he blot not out
> our sins, he must blot our names out of his book of life.[6]

What a wonderful threefold by threefold picture we have in Ps. 51:1-9: a God of mercy, love, and compassion responds to a penitent man of transgression, iniquity, and sin by blotting out, washing, and declaring clean!

David's Prayer for Renewal and Purity

Create in me a pure heart, O God,
 and renew a steadfast spirit within me.
Do not cast me from your presence
 or take your Holy Spirit from me.
Restore to me the joy of your salvation
 and grant me a willing spirit, to sustain me.
(Ps. 51:10-12)

Here David ". . . passes from the subject of the gratuitous remission of sin to that of sanctification."[7] No longer does he pray for pardon, for justification, for removal of sin, but now for the practical inworking of righteousness. It is not enough that he should be forgiven; he must also be changed. He must be not merely ". . . swept clean and put in order," but made the abiding place and throne of the Holy Spirit, lest "seven other spirits more wicked than [the one cast out] . . . go in and live there" and he is more miserable in the end than in the beginning (Mt. 12:44-45). And so David prays for three things.

A New Heart

After reading his description of his own utter corruption, we should not be surprised that David asks God to *create* in him a pure heart (Ps. 51:10). Nothing short of the creative act of omnipotence will suffice! It must not be a matter merely of changing what is there, but of replacing it with something new. He expresses the same thought the Apostle Paul had when he wrote, ". . . if anyone is in Christ, he is a new creation; the old has gone, the new has come!" (2 Cor. 5:17).

 Real salvation involves a complete and permanent remaking of a man, not a temporary glossing over of his faults. The sixteenth-century Puritan Henry Smith described well what this involves:

It is the repairing of the image of God, until we be like Adam when he dwelt in Paradise. As there is a whole old man, so there must be a whole new man. The old man must change with the new man, wisdom for wisdom, love for love, fear for fear; his worldly wisdom for heavenly wisdom, his carnal love for spiritual love, his servile fear for Christian fear, his idle thoughts for holy thoughts, his vain words for wholesome words, his fleshly works for sanctified works.[8]

In the end, not all the claims or confessions or professions or pious sounding prayers in the world, but real sanctification—a new life of purity, separate from sin and wedded to righteousness— is the only proof of justification. "No one who lives in [Christ] keeps on sinning. No one who continues to sin has either seen him or known him" (1 Jn. 3:6).

Continued Fellowship

By praying that God will not take His Holy Spirit from him (Ps. 51:11), David confesses his utter dependence on God, not only for pardon and renewal, but also for continuance in new life. Who, in the face of this, can still believe that the Old Covenant was of human works but the New of divine? For here is an exemplary believer under the Old Covenant, and what does he trust? Himself and his own efforts? No! Should the Holy Spirit leave him, he would be cast from God's presence. His only hope of his spirit's being steadfast (verse 10) and of continued fellowship with God is for God's Spirit to remain in him.

Does David fear that the Spirit *has* departed? Perhaps. He had known God's Spirit to have left Saul because of unrepentant sin (1 Sam. 16:14), so such a fear would be natural. But the fear itself proves the opposite: the Spirit was there in him, convicting him of sin. As Saint Augustine put it, ". . . when one is angry with himself, and is displeasing to himself, then it is not without the gift of the Holy Spirit"[9]

Restored Joy

David's third request is for restoration of the joy that accompanies salvation by God (Ps. 51:12). Such joy David lost when caught up in sin, and it should be no surprise, for practical righteousness is the sign of salvation, and the practice of sin is a sign that a soul may be lost (1 Jn. 3:4-10). How, then, should even the saved, so long as he is caught in the web of sin, know the joy that comes with salvation, since the visible evidence says he is lost?

This explains why David immediately requests a willing—or free and spontaneous—spirit (Ps. 51:12). It is the prerequisite of joy. "If God's Spirit dwells in us [a fact for which David has just prayed], obedience will be delight. To serve God because we must is not service. To serve Him because we had rather do His will than anything else is the service which delights Him and blesses us. . . . Such obedience is freedom."[10] Sustained joy for the child of God depends on willing, spontaneous, free obedience to God. "If you obey my commands," said Jesus, "you will remain in my love, just as I have obeyed my Father's commands and remain in his love. I have told you this so that my joy may be in you and that your joy may be complete" (Jn. 15:10-11).

David's Commitment to Service

And now David looks to the future. He promises that if God will pardon his sin, cleanse him, renew him, and sustain him in fellowship, he will serve God by leading others to repentance and by sincere personal worship.

> Then I will teach transgressors your ways,
> and sinners will turn back to you.
> Save me from bloodguilt, O God,
> the God who saves me,
> and my tongue will sing of your righteousness.
> O Lord, open my lips,

and my mouth will declare your praise.
You do not delight in sacrifice, or I would bring it;
 you do not take pleasure in burnt offerings.
The sacrifices of God are a broken spirit;
 a broken and contrite heart,
 O God, you will not despise. (Ps. 51:13-17)

It is no betrayal of humility and contrition for David to think that, despite his great sin, God could still use him to bring others to repentance (verse 13). When Jesus predicted Peter's denials, He added, "But I have prayed for you, Simon, that your faith may not fail. And when you have turned back [literally "been converted"], strengthen your brothers" (Lk. 22:32). Paul made the example of God's forgiveness of his own great sins a premise for arguing that no sinner was beyond the reach of God's grace (1 Tim. 1:15-16).

David's determination to turn sinners to God was, in fact, one more proof of the sincerity of his love for God, and of the reality of God's love shown to him. "We love because he first loved us," wrote John. "If anyone says, 'I love God,' yet hates his brother, he is a liar. For anyone who does not love his brother, whom he has seen, cannot love God, whom he has not seen. And he has given us this command: Whoever loves God must also love his brother" (1 Jn. 4:19-21). And what greater love can a forgiven sinner show his brother than to lead him to repentance?

David promises that if God will save him from bloodguilt—guilt for murder—he will sing of God's righteousness to others. If God will open his lips, David will declare His praise (Ps. 51:14-15). "We cannot," wrote Albert Barnes, ". . . by penitence recall those whom we have murdered; we cannot restore purity to those whom we have seduced; we cannot restore faith to the young man whom we may have made a sceptic; but we may do much to restrain others from sin, and much to benefit the world even when we have been guilty of wrongs that cannot be repaired."[11]

And finally he vows sincere worship, the presentation of

himself in all his humble brokenness as a sacrifice, confident that God will always accept his offering (verses 16-17). He does not conclude by this that the sacrificial offerings prescribed in the Law are of no value, but only that they are worthless when unaccompanied by a penitent heart.[12]

What is a "broken and contrite heart"? Calvin has expressed the idea well: "The man of broken spirit is one who has been emptied of all vain-glorious confidence, and brought to acknowledge that he is nothing. The contrite heart abjures the idea of merit, and has no dealings with God upon the principle of exchange."[13]

David's Prayer for the Kingdom

Finally David turns to a wholly new subject. He prays for the prosperity of God's people and Kingdom.

> In your good pleasure make Zion prosper;
> > build up the walls of Jerusalem.
> Then there will be righteous sacrifices,
> > whole burnt offerings to delight you;
> > then bulls will be offered on your altar. (Ps. 51:18-19)

The change of subject seems abrupt. But anyone who understands what grips the heart of a repentant man finds it perfectly natural. What grips him? Two things: First, that somehow he may make amends for the wrong he has done. David's sin damaged the nation for generations (2 Sam. 12:10,14). Can anyone truly penitent not feel with him the longing for God to help those whom he has injured? Second, the coming of the Kingdom of God. That should be a matter dear to the heart of every believer, for we all are taught to pray, ". . . your kingdom come, your will be done on earth as it is in heaven" (Mt. 6:10). "There is surely no grace in us if we do not feel for the church of God, and take a lasting interest in its welfare," wrote Spurgeon.[14]

Following David's Example

I groan at the realization that I cannot make explicit here all the practical instruction I have found in this psalm, let alone what I must have missed. But here are nine practical lessons all Christians can learn from David's example:

First, no one is too holy to fall. David was a man of outstanding virtue and deep dedication to God. He ". . . had done what was right in the eyes of the LORD and had not failed to keep *any* of the LORD's commands *all* the days of his life—except in the case of Uriah the Hittite" (1 K. 15:5). Yet his was among the most heinous sins recorded in the Old Testament and brought suffering to generation after generation of his family and nation. Is it any wonder, then, that Paul wrote, "So, if you think you are standing firm, be careful that you don't fall!" (1 Cor. 10:12)? Holy living requires constant vigilance against sin.

Second, we may learn from David the right way to receive reproof and correction from others. Will we mimic the woman in Oklahoma who refused correction, or like David, who when confronted immediately confessed and fell on his face in contrition? Pride must not stand in the way of repentance. "An exalted king heard a prophet, let His humble people hear Christ."[15]

Third, we can share David's estimation of God's judgment. It mattered not to him what men thought. They might acquit him, but if God held him guilty, he knew he must repent or be cast forever from God's presence. Are we prepared, with him, to say, ". . . you are proved right when you speak and justified when you judge" (Ps. 51:4)?

Fourth, we can share David's horror at sin. We can learn to see it not only as isolated acts, but as the warp and woof of our nature, to think of it not as trivial but as the ugly, monstrous rebellion and corruption that it really is. Like David, we can refuse to make excuses for it, but rather acknowledge that it is an offense against God. We will never see sin rightly until we are over-

whelmed with grief at the thought that each sin lays another stripe across Christ's back, drives another nail through His wrist, pulls another of His bones out of joint.

Fifth, we can join David in making confession, repentance, and (insofar as it is possible) restitution *public*. What reason have we to hide our sins but pride? And is that not sin itself? So long as we remain prideful, do we not cling to sin and to the disease of soul (and sometimes of body) that it causes? Surely this is why James wrote, "Therefore confess your sins to each other and pray for each other so that you may be healed" (Jas. 5:16). If David's confession and repentance (like Paul's, 1 Tim. 1:15) has instructed us, will not ours instruct others, if we are sincere?

Sixth, we can learn from David never to despair of forgiveness. No one is so sinful that he will not find pardon and cleansing if he goes to God with a broken and contrite heart. If anything, we have more reason than David had to hope for forgiveness. For while he rested in the promise of God's merciful redeeming act to come, we have the privilege of looking at that act accomplished by Christ on the cross.

Seventh, David's example teaches us that *assurance* of forgiveness is not always easily gained, but must sometimes be sought long and hard. John Calvin explains why:

> However rich and liberal the offers of mercy may be which God extends to us, it is highly proper on our part that we should reflect upon the grievous dishonour which we have done to his name, and be filled with due sorrow on account of it. Then [too,] our faith is weak, and we cannot at once apprehend the full extent of the divine mercy; so that there is no reason to be surprised that David should have once and again renewed his prayers for pardon, the more to confirm his belief in it. . . . our faith cannot take in his overflowing goodness, and it is necessary that it should distil to us drop by drop.[16]

One means of gaining assurance of forgiveness that David exemplifies for us is the sincere use of ceremonies prescribed by God to declare His grace.[17] Laying aside our fears of appearing too like our more sacramentalist brethren, might not many evangelicals find great comfort in a right use of the Lord's Supper after honest confession and repentance?

Eighth, we must never be satisfied with pardon alone, but must press on toward practical righteousness—day-by-day conformity with God's moral Law. And we will be helped toward that by remembering our sins so that we may be humbled by them, and by asking God daily to renew a steadfast and willing spirit within us. A cleansed heart must remain contrite lest it be soiled anew.

Finally, David let God's grace bestowed on him stir him to bring that grace to others. Will we do the same?

NOTES:

1. Alexander MacLaren, *The Psalms*, 3 volumes, in W. Robertson Nicoll, ed., *The Expositor's Bible* (New York: Hodder & Stoughton, n.d.), volume 2, page 129.

2. MacLaren, *The Psalms*, volume 2, page 129.

3. Albert Barnes, *Psalms*, 3 volumes, ed. Robert Frew (Grand Rapids: Baker Book House, 1975), volume 2, page 85.

4. MacLaren, *The Psalms*, volume 2, page 129.

5. MacLaren, *The Psalms*, volume 2, pages 129-130.

6. Charles Spurgeon, *The Treasury of David*, 3 volumes (McLean, Va.: MacDonald, n.d.), volume 1, page 404.

7. John Calvin, *Commentary on the Book of Psalms*, 3 volumes, trans. James Anderson (Grand Rapids: Baker Book House, [1846] 1984), volume 2, page 298.

8. Henry Smith, in Spurgeon, *The Treasury of David*, volume 1, page 418.

9. Augustine, *Expositions on the Book of Psalms*, in Philip Schaff, ed., *A Select Library of the Nicene and Post-Nicene Fathers of the Christian Church*, First Series, volume VIII, trans. A. Cleveland Coxe (Grand Rapids: Eerdmans, 1979), page 195.

10. MacLaren, *The Psalms*, volume 2, page 139, bracketed material added.

11. Barnes, *Psalms*, volume 2, page 90.

12. See the discussion of formalism in Ps. 50:7-15 in Chapter Six.

13. Calvin, *Commentary on the Book of Psalms*, volume 2, page 306.

14. Spurgeon, *The Treasury of David*, volume 1, page 407.

15. Augustine, *Expositions on the Book of Psalms*, page 191.

16. Calvin, *Commentary on the Book of Psalms*, volume 2, pages 296-297.

17. See Ps. 51:7 and the earlier discussion of the significance of cleansing with hyssop.

Give Thanks to the Lord

PSALM 107

Ten years ago, when I worked with a ministry in California, a woman who had been a missionary in Europe for years came to our office seeking counseling. Her once vibrant, joyful relationship with God had, in the last three years, become dry and joyless. After hours of conversation, it became clear that the change was rooted not in what one would first guess—some habitual sin to which she had succumbed—but in something she had come to believe.

She had been taught, as part of a system called "Moral Government Theology," that God is good not by nature but by choice. He could, both theoretically and actually, choose at any time to do evil. Though this didn't square with what she had grown up believing as a Christian, the teacher who had taught it to her in Switzerland had been highly persuasive. So in time she had come to accept the idea, along with other doctrines in the system of "Moral Government Theology."[1]

At first the new doctrine had little effect on her life. But slowly she stopped trusting God. Why should she trust Him? After all, He could turn bad tomorrow. Might He not already be evil? Might He not be playing some terrible joke on her and all

113

Christians, having devised the whole gospel as a trick to make us trust in Christ instead of in ourselves for happiness? How could she know if He were tricking her? At last she lost all peace and joy in relationship with God.

But when, after several weeks of counseling, she had learned that God is good by nature, not by choice, and can never change (Mal. 3:6, Jas. 1:17), her whole understanding of Him changed. Here was a God she could trust without reservation! And not only that, but she saw in a whole new light the greatness of God's grace in receiving her on the ground of Christ's sacrifice. It was not, as she had been taught by "Moral Government Theology," that God had denied His justice by not punishing her sin, but that He, in His infinite goodness and love, had paid the penalty for her sin as her substitute. As these wonderful truths sank into her, she began to praise and thank Him for His goodness and love toward her, and to appreciate more than ever before what He had done on her behalf.

What she discovered is the message of Psalm 107, which exhorts God's people to thank and praise Him for His goodness and unfailing love. The psalm has a simple structure: a preface calling on God's people to give thanks for His goodness (verses 1-3); four choruses, each describing a group of people in distress and the display of God's goodness in delivering them, then calling on them to thank Him (verses 4-9,10-16,17-22,23-32); a summary chorus describing how God demonstrates His justice in His providential control of human history (verses 33-41); and a conclusion urging all of God's people to rejoice because of His providence and to learn from it the greatness of His love (verses 42-43).

The Goodness of God

Give thanks to the LORD, for he is good;
 his love endures forever.

Let the redeemed of the LORD say this—
> those he redeemed from the hand of the foe,
those he gathered from the lands,
> from east and west, from north and south.
(Ps. 107:1-3)

The psalmist begins by urging the people of God to thank Him, not for any specific favor, but simply for His goodness and unending love. He calls God Jehovah, using the name that stresses God's eternal, unchanging nature, conveying the idea that God's goodness is eternal and unchangeable.

One of the great distinctions between God and man is His goodness. Thus Jesus answered the rich young man who addressed Him as "good teacher": "Why do you call me good? . . . No one is good—except God alone" (Mk. 10:17-18). And the distinction holds not only between God and sinful man, but also between God and man in his original created state of innocence. Before Adam and Eve ever sinned, they were distinguished from God by His goodness, which is vastly different from the goodness of any created thing.

The seventeenth-century Puritan Stephen Charnock, in his magnificent study of the attributes of God, points out four chief senses in which God's goodness differs from man's:

> 1. [Only God is] originally good, good of himself. All created goodness is a rivulet from this fountain, but Divine goodness hath no spring; God depends upon no other for his goodness; he hath it in, and of, himself: man hath no goodness from himself, God hath no goodness from without himself: his goodness is no more derived from another than his being. . . .
> 2. [Only God is] infinitely good. A boundless goodness that knows no limits, a goodness as infinite as his essence, not only good, but best; not only good, but goodness itself,

the supreme inconceivable goodness. . . .

3. [Only God is] perfectly good, because only infinitely good. He is good without indigence, because he hath the whole nature of goodness, not only some beams that may admit of increase of degree. . . . As nothing hath an absolute perfect being but God, so nothing hath an absolutely perfect goodness but God. . . . The goodness of God is the measure and rule of goodness in everything else.

4. [Only God is] immutably good. Other things may be perpetually good by supernatural power, but not immutably good in their own nature. Other things are not so good, but they may be bad; God is so good, that he cannot be bad.[2]

This great truth of God's unchanging goodness and love should be a cause of praise and thanksgiving for all whom He has "redeemed."[3] Do we, privately and in congregation with others, focus often enough simply on God's goodness seen in itself? Or do we think mostly of ourselves and the benefits of God's goodness to us? There is nothing wrong, of course, with thanking God for what He has done for us—indeed, the psalmist shortly gives some examples of benefits for which the people should thank Him—but do we not reach higher in worship when, leaving aside every thought of ourselves, we praise God solely for what He is in Himself?

God's Goodness Shown in Cursing and Blessing

Next the psalmist describes four kinds of people who owe God special thanks for delivering them from distress. First (Ps. 107:4-9) he writes of those who were wandering homeless and suffering from hunger and thirst. To their cry for help, God responded by leading them "by a straight way to a city where they could settle" and by satisfying their hunger and thirst (verses 7,9). Second

(verses 10-16) are those who were chained up in prison at hard labor, at whose cry the Lord "brought them out of darkness and the deepest gloom and broke away their chains" (verse 14) and the gates and bars that had confined them (verse 16). Third (verses 17-22) are fools who suffered illness so severe that they "loathed all food and drew near the gates of death" (verse 18); when they cried, God "sent forth his word and healed them; he rescued them from the grave" (verse 20). Last (verses 23-32) are those who despaired of their lives in a great storm at sea; in response to their cry, the Lord stilled the storm and led them to a safe harbor (verses 29-30).

"Then they cried out to the LORD in their trouble, and he delivered them from their distress" (verses 6, also 13,19,28) is one of two recurring themes in these four choruses, or stanzas, of the psalm.[4] The other is, "Let them give thanks to the LORD for his unfailing love and his wonderful deeds for men" (verses 8,15,21,31). All of these groups faced grave danger and cried out to God; He delivered them all; and they all are exhorted to thank God for His deliverance.

All of the groups also apparently had rebelled somehow against God. The second group "rebelled against the words of God and despised the counsel of the Most High" (verse 11) and the third "became fools through their rebellious ways and suffered affliction because of their iniquities" (verse 17). The psalmist names no specific rebellion in describing the first and fourth groups, but it seems most likely that they, too, suffered because of their sin. What tells us this? Of the fourth group, the sailors, the psalmist emphasizes that _God_ sent the danger: "For he spoke and stirred up a tempest . . ." (verse 25), implying that He was punishing them for something, apparently pride, since the psalmist concludes the chorus by urging them to "_exalt [God]_ in the assembly of the people . . ." (verse 32).

But what of the first group, the homeless and hungry? Nothing in the passage clearly tells us that they suffered punish-

ment or chastisement from God. Yet I cannot conclude otherwise, for two reasons. First, the psalmist's description fits perfectly the Israelites' wandering in the desert after refusing to enter the land of Canaan (see Dt. 1:26-2:1), and it seems impossible to avoid the impression that he intends readers to think, at least in part, of them. Second, the words reflect clearly the threats of punishment that God spoke to Israel in Dt. 28:15-68. There God warned that because of Israel's disobedience to the Law and refusal to serve Him joyfully,

> . . . in hunger and thirst, in nakedness and dire poverty, you
> will serve the enemies the LORD sends against you. . . .
> Then the LORD will scatter you among all nations, from
> one end of the earth to the other. . . . Among those nations
> you will find no repose, no resting place for the sole of your
> foot. There the LORD will give you an anxious mind, eyes
> weary with longing, and a despairing heart. You will live in
> constant suspense, filled with dread both night and day,
> never sure of your life. (verses 48,64-66)

When we compare this with Ps. 107:4-5 the correlation becomes clear: "Some wandered in desert wastelands, finding no way to a city where they could settle. They were hungry and thirsty, and their lives ebbed away."

Indeed, the whole psalm seems designed to recall the threats of curses in response to disobedience to the covenant, and the promises of blessing in response to obedience, that make up Deuteronomy 28 and 30. We have seen this in the first four choruses, and it appears again in the fifth (Ps. 107:33-41), where the psalmist alternates between the two principles. "He turned rivers into a desert," he writes, "flowing springs into thirsty ground, and fruitful land into a salt waste, because of the wickedness of those who lived there" (verses 33-34), echoing Deuteronomy:

. . . if you do not obey the LORD your God and do not
carefully follow all his commands and decrees I am giving
you today, all these curses will come upon you and over-
take you. . . . The LORD will strike you with . . . scorching
heat and drought. . . . The sky over your head will be
bronze, the ground beneath you iron. The LORD will turn
the rain of your country into dust and powder; it will come
down from the skies until you are ruined. (Dt. 28:15,22-24)

Next the psalmist describes God's blessing on the faithful:
"He turned the desert into pools of water and the parched ground
into flowing springs; there he brought the hungry to live, and they
founded a city where they could settle. They sowed fields and
planted vineyards that yielded a fruitful harvest; he blessed them,
and their numbers greatly increased, and he did not let their herds
diminish" (Ps. 107:35-38). Again he echoes Moses:

If you fully obey the LORD your God and carefully follow
all his commands I give you today, the LORD your God . . .
will send a blessing on your barns and on everything you
put your hand to. The LORD your God will bless you in the
land he is giving you. . . .
 The LORD will grant you abundant prosperity—in the
fruit of your womb, the young of your livestock and the
crops of your ground—in the land he swore to your fore-
fathers to give you.
 The LORD will open the heavens, the storehouse of his
bounty, to send rain on your land in season and to bless all
the work of your hands. (Dt. 28:1,8,11-12)

Again considering the rebellious, the psalmist writes, "Then their
numbers decreased, and they were humbled by oppression, calamity
and sorrow; he who pours contempt on nobles made them wander
in a trackless waste" (Ps. 107:39-40), echoing God's warning:

> If you do not carefully follow all the words of this law,
> which are written in this book, and do not revere this glor-
> ious and awesome name—the LORD your God—the LORD
> will send fearful plagues on you and your descendants,
> harsh and prolonged disasters, and severe and lingering
> illnesses. . . . You who were as numerous as the stars in the
> sky will be left but few in number, because you did not
> obey the LORD your God. Just as it pleased the LORD to
> make you prosper and increase in number, so it will please
> him to ruin and destroy you. (Dt. 38:58-59,62-63)

And at last when the psalmist writes of those who have
turned to the Lord in repentance and cried out for His help, he
says, "But he lifted the needy out of their affliction and increased
their families like flocks" (Ps. 107:41). These words, too, echo the
Lord's promise through Moses:

> When all these blessings and curses I have set before you
> come upon you and you take them to heart wherever the
> LORD your God disperses you among the nations, and
> when you and your children return to the LORD your God
> and obey him with all your heart and with all your soul
> according to everything I command you today, then the
> LORD your God will restore your fortunes and have com-
> passion on you and gather you again from all the nations
> where he scattered you. . . . Then the LORD your God will
> make you most prosperous in all the work of your hands
> and in the fruit of your womb, the young of your livestock
> and the crops of your land. The LORD will again delight in
> you and make you prosperous, just as he delighted in your
> fathers, if you obey the LORD your God and keep his com-
> mands and decrees that are written in this Book of the Law
> and turn to the LORD your God with all your heart and
> with all your soul. (Dt. 30:1-3,9-10)

If this is true—if the psalm is designed to recall the curses God threatened for disobedience and the blessings He promised for obedience—then two truths appear: First, the distress that each group of people found itself in was a punishment for the people's sin, and deliverance must have come as God's response to *repentant, humble* cries for help. Second, the psalmist must intend by describing the four groups of people in distress, and by describing God's curses and blessings, to further his chief design, which is to depict God's goodness in His dealings with His people and to urge His people to be thankful for it (verses 1-3,43).

Both cursing and blessing, then—both the distress in which His people found themselves, and the deliverance He wrought in response to their cries—demonstrate God's goodness and love. This is the same lesson Solomon taught when he wrote, "My son, do not despise the LORD's discipline and do not resent his rebuke, because the LORD disciplines those he loves, as a father the son he delights in" (Prov. 3:11-12).

Punishing sin is, in other words, as much an act of grace as pardoning and saving the repentant, for it can move sinners to repentance, which is a necessary prerequisite to pardon. This is why, after describing both God's curses and blessings, the psalmist writes, "The upright see and rejoice, but all the wicked shut their mouths" (Ps. 107:42). Righteous people—regenerate people whose lives are conformed increasingly to the moral image of God expressed in His Law—rejoice at both judgment and mercy because both declare the goodness and love of God. In so writing, the psalmist says what the prophet Habakkuk did when he wrote, "Your eyes are too pure to look on evil; you cannot tolerate wrong" (Hab. 1:13).

Let the Wise Heed These Things

The psalmist, then, first urges God's people to thank and praise Him for His goodness and unfailing love (Ps. 107:1-3); then

illustrates His goodness and love in His discipline and saving of His people (verses 4-42); and finally exhorts the wise to "heed these things and consider the great love of the LORD" (verse 43). What lessons are there in this psalm for the wise to heed?

There are interesting contrasts in the needy people the psalmist describes. The first are homeless and wandering, while the second are confined in prison; the former want limits, while the latter want liberty. The third are sick and weak, while the fourth are healthy and strong. The sick and weak might think that, if they were healthy and strong, all would be well, but others have learned that health and strength are no guarantee of safety. No matter what our condition, then, we must depend on God's merciful provision for even the most basic things in life—home, liberty, food, drink, health, strength, and life itself.

And what is the underlying cause of their suffering? It is sin—sin seen particularly as rebellion against the words of God, sin that provokes God's wrath in punishment. Might we be too quick to assume that anyone who suffers—particularly any nation—suffers unjustly and so needs pity, not repentance? Some suffering is not punishment for sin, as Job's life demonstrates, but might we not benefit from remembering that God promises blessing on those who obey Him with their whole hearts, and curses on those who rebel?

Look yet again at each of the four examples of people delivered by God. How did their deliverance come about? First God punished them for sin, making them suffer so severely that at last they despaired of helping themselves. Only then were they ready to cry in sorrow for God's mercy. Should we not then, when we suffer, ask God whether our distress is chastisement for sin, and if it is, put no confidence in ourselves but cling wholly to God's mercy for deliverance?

How does the psalmist view righteousness and wisdom, on the one hand, and wickedness and foolishness on the other? Rebellion against God's Word is foolishness (verse 17), meaning

that wickedness is the opposite of wisdom, which is the possession of the righteous (compare verses 42-43). In Scripture, wisdom and foolishness have more to do with morality than with intellect. Can anyone be wise who rejects the Word of God? And is rejection of the Word confined only to conscious, overt opposition to the whole Bible, or might we rebel against the counsel of God when we ignore or avoid some parts of it, for whatever reason?

This psalm also reveals how to understand history. The rise and fall of nations and families and the fertility and barrenness of lands are not accidents but examples of the unfettered rule of God over all creation. This should give God's people great confidence that He *is* accomplishing His eternal plan. But it should also impress on us the sobering realization that our community, our nation—no matter what it is—is no exception to God's sovereignty. If it strays far enough and long enough from God's Law, it too will suffer His punishment. Doesn't this imply that Christians have some responsibility to call their societies to account, to warn them of the judgment to come not only on individuals but on whole nations, and to show them the way of righteousness?

The central theme of the psalm remains this: "Give thanks to the LORD, for he is good . . ." (verse 1). Thanksgiving should be one of the chief traits of God's people. It should be often on our lips, always in our hearts. In every circumstance, we should think, "What is there here for which I can thank God?" And we should not rest until we have identified it and rendered thanks to Him.

Are the people of God troubled, cast down, or weary? Are they lifted up in prosperity, full of energy and joy? Are they free or confined, ill or healthy? No matter their condition, "Let them give thanks to the LORD for his unfailing love and his wonderful deeds for men."

NOTES:

1. For an excellent biblical critique of "Moral Government Theology," examining both the doctrines and their practical effects on the Christian life, see Alan W. Gomes, *Lead*

Us Not into Deception—A Biblical Examination of Moral Government Theology, third edition (P.O. Box 1464, La Mirada, Calif., 90637-1464, published by the author).

2. Stephen Charnock, *The Existence and Attributes of God*, 2 volumes (Grand Rapids: Baker Book House, 1979), volume 2, pages 210-211.

3. This word comes from the Hebrew *goel*, used for the kinsman redeemer under Mosaic Law. For what it means that God is *goel* to His people, see the discussion of Ps. 74:2 in Chapter Five, page 69.

4. The Hebrew phrase describing God's response differs slightly in two of the choruses. In verse 6 God is said to "bring [them] out" [*yatsa'*] of their trouble. In verses 13 and 19, He is said to "save" [*yasha'*] them. And in verse 28 He is said to "snatch them away" [*natsal*] from their difficulty—a vivid picture of His delivering sailors in the midst of a storm. But the idea is so similar in all four instances that we will not focus on the slight distinctions here.

A God Worthy of Praise

PSALM 18

The northern climes of Michigan normally would still have been light enough for reading at 10:30. Not this night.

My wife and I sat huddled together, staring in rapt attention past the whipping curtains into unending blackness. Only the howling wind betrayed a world beyond. Instantly that world lit up like day—instantly it was gone. We held our breaths. One. Two. Three. Four. Five. The house shook before we heard the rumble, the roar, the crash, and finally the rumble again, fading, fading . . . shattered by the next bright flash—dark silence—trembling again. Black clouds rushed at us from the north, and with them came rain, then pounding hail. We clung to each other, glorying and shuddering before a storm that dwarfed us. We tasted awe.

A storm reveals God-in-action. Though we praise God for His attributes—wisdom, justice, goodness, perfection—abstract considerations make little impression on our hearts. It is God-in-action who moves us to humble adoration.

His action displays His power—power to crush and restore, power to humiliate and exalt, power to capture and deliver (see Dt. 32:39). Before such power, wrote Edmund Burke,

. . . we shrink into the minuteness of our own nature, and
are, in a manner, annihilated before him. And . . . no con-
viction of the justice with which it is exercised, nor the
mercy with which it is tempered, can wholly remove the
terror that naturally arises from a force which nothing can
withstand. If we rejoice, we rejoice with trembling; and
even whilst we are receiving benefits, we cannot but
shudder at a power which can confer benefits of such
mighty importance.[1]

David, in Psalm 18, uses a poetic description of a storm to
portray God's power exercised on his behalf. There he introduces
us to the God of strength and salvation (verses 1-3), of deliverance
(verses 4-19), of justice and vindication (verses 20-28), of prepara-
tion, provision, and perfection (verses 29-42), and of promise and
fulfillment (verses 43-50). His consideration of this God drives
him to praise, which he expresses throughout the psalm by telling
who God is and what He has done—or will do—for him.

God of Strength and Salvation

"I love you, O LORD, my strength." With these words of praise,
David, probably nearing his death,[2] embarks on a poetic autobi-
ography, beginning with a proclamation of faith in God's protection.

He piles figure upon figure to convey confidence in God's
strength: God is his rock, fortress, deliverer, refuge, shield, horn
(like the mighty horn of the rhinoceros), and stronghold. For a
military man, these were evocative terms. For months, David had
survived in the impregnable rocks and crags of rugged mountains
while Saul and his armies sought his life. But he believed it was
God, not the mountain fastnesses, who had saved him.

Nothing about David's proclamations of love and praise was
feigned. Repeatedly he had found that when he called to the Lord,
he was "saved from [his] enemies" (verse 3). He had experienced a

God worthy of love, dependence, trust, and exaltation. We, too, can experience such a God when we learn, as Peter put it, to cast all our cares on Him who cares for us (1 Pet. 5:7).

God of Deliverance

David's praises quickly gave way to describing the perils from which God had delivered him. In contest with Saul, he had found himself constantly near death. The "cords of death entangled me, the torrents of destruction overwhelmed me" (Ps. 18:4).

He didn't exaggerate his troubles. Twice in one day, Saul had hurled his spear at him (1 Sam. 18:8-11). Next Saul had tried to get David killed with a challenge to kill a hundred Philistines—an improbable task (1 Sam. 18:24-25). Not long after, though he'd sworn that he wouldn't kill David, Saul had tried again to pin him to the wall with a spear; missing again, he had told his men to catch David at his house and kill him (1 Sam. 19:9,11). And these were but the beginning of David's troubles.

"In my distress I called to the LORD," David wrote in Ps. 18:6; "I cried to my God for help." Until we know what it is to face calamity, we rarely pray sincerely. We waste many prayers said in distraction. But nothing cures distraction so quickly as imminent danger. David's call for help was genuine, and he quickly learned what God meant when He said, "Because of the oppression of the weak and the groaning of the needy, I will now arise I will protect them from those who malign them" (Ps. 12:5). His prayer was not wasted. God heard. God responded. And all Heaven and earth broke loose!

> The earth trembled and quaked, and the foundations of the mountains shook; they trembled because he was *angry*. Smoke rose from his nostrils; consuming fire came from his mouth, burning coals blazed out of it. He parted the heavens and *came down*; dark clouds were under his feet. He

mounted the cherubim and flew; he soared on the wings of the wind. He made *darkness his covering*, his canopy around him—the dark rain clouds of the sky. Out of the brightness of his presence clouds advanced, with hailstones and bolts of lightning. The LORD thundered from heaven; the voice of the Most High resounded. He shot his arrows and scattered the enemies, great bolts of lightning and routed them. The valleys of the sea were exposed and the foundations of the earth laid bare at your rebuke, O LORD, at the blast of breath from your nostrils. (Ps. 18:7-15)

Here in magnificent poetry David unveils a God whose power shakes the earth and rends the skies! Whose anger rages at His child's peril! Who, for all His greatness, responds with fatherly care the moment His beloved is endangered. God condescends to hear and answer. And when He comes down, it is with majesty and mystery: He rides in swift splendor on the most powerful of all creatures. He hides His glory in darkness, yet unleashes it in awful bursts that smite His foes right and left.

In the midst of His furious outbreak, God remembers His child: "He reached down from on high and *took hold* of me; he drew me out of deep waters. He rescued me from my powerful enemy, from my foes, who were too strong for me" (verses 16-17). The Hebrew translated "took hold" here has the sense of *seizing*. The deliverance was all of God, none whatever of David.

Having delivered His child from danger, God sets him in "a spacious place" (verse 19), where he is free at last, no longer bound to run and cower and hide. No wonder David began, "I love you, O LORD, my strength."

God of Justice and Vindication

Had God broken forth in fury against innocent David instead of against corrupt Saul, we might have feared Him; but we should

have been stirred to contempt as well. What made this fearsome God praiseworthy was His *justice*:

> The LORD has dealt with me according to my righteous-
> ness; according to the cleanness of my hands he has
> rewarded me. For I have kept the ways of the LORD; I have
> not done evil by turning from my God. All his laws are
> before me; I have not turned away from his decrees. I have
> been blameless before him and have kept myself from sin.
> (verses 20-23)

Not that David was sinless. Far from it. We know his history. But, unlike Saul, he was a man after God's own heart. He rejected a perfect opportunity to kill Saul, then called out to him:

> Why do you listen when men say, "David is bent on harm-
> ing you"? This day you have seen with your own eyes how
> the LORD delivered you into my hands in the cave. Some
> urged me to kill you, but I spared you. . . . Now understand
> and recognize that I am not guilty of wrongdoing or rebel-
> lion. I have not wronged you, but you are hunting me down
> to take my life. May the LORD judge between you and me.
> And may the LORD avenge the wrongs you have done to
> me, but my hand will not touch you. (1 Sam. 24:9-12)

David discovered in his battles with Saul that God is a shield to the righteous and a vindicator of the innocent. He discovered that God is just—that He renders to everyone his due. If we believe this, we can gain new confidence to stride into the battles God sets before us—battles against wickedness in our own hearts, in our families and churches, and in our society.

The same "storm" that wrought David's salvation crushed his enemies. God's justice is that way, Augustine saw: ". . . as by hail, the hard hearts are bruised, [still] . . . if a cultivated and genial

soil, that is, a godly mind, receive them, the hail's hardness dissolves into water . . . the terror of the lightning-charged, and as it were frozen, reproof dissolves into satisfying doctrine; and hearts kindled by the fire of love revive."[3]

Thus David wrote, "To the faithful you show yourself faithful, to the blameless you show yourself blameless, to the pure you show yourself pure, but to the crooked you show yourself shrewd. You save the humble but bring low those whose eyes are haughty" (Ps. 18:25-27).

God of Preparation, Provision, and Perfection

God's acts on David's behalf didn't stop at deliverance from his enemies. David saw God's work for him as all-encompassing.

David believed that God had *prepared* him for everything he faced. "*You*, O LORD, keep my lamp burning; my *God* turns my darkness into light" (verse 28). "It is *God* who arms me with strength and makes my way perfect. *He* makes my feet like the feet of a deer; *he* enables me to stand on the heights. *He* trains my hands for battle . . ." (verses 32-34). No one can truly praise God while boasting in himself, for praise is boasting about someone or something else. "'Isn't it lovely? Wasn't it glorious? Don't you think that magnificent?' The Psalmists in telling everyone to praise God are doing what all men do when they speak of what they care about," wrote C.S. Lewis.[4] Because David humbly believed that God was the ultimate Source of all his abilities, he praised Him for them.

David saw, too, that God not only prepared him but also *provided* for him in all his needs: "You give me your shield of victory, and your right hand sustains me; you stoop down to make me great. You broaden the path beneath me, so that my ankles do not turn" (verses 35-36).

David understood that everything lies under God's control, that God causes all things to serve His children (Ro. 8:28). He saw

the rocks, the mountains, the storms, the winds and floods—everything in nature that helped him—as sent by God.

There is an obstacle to our seeing things this way, and if we are to praise God with undivided, unhesitating hearts, it must be removed. It is our way of seeing the world. Modern scientism (not science) tells us that the world is a mere mechanism that goes and goes without interruption or direction. If we agree, the biblical doctrine of the providence of God is nonsense.

For biblical writers, everything was pregnant with God's presence. For them, thunder was God's voice, lightning His arrows, wind His breath. (We might find storms more exciting, and less frightful, if we thought of them that way ourselves.) For them, God "laid the earth's foundation . . . marked off its dimensions . . . stretched a measuring line [the horizon] across it." They believed that God had "shut up the sea behind doors . . . made the clouds its garment . . . fixed limits for it . . . [and] said, 'This far you may come and no farther; here is where your proud waves halt.'" They understood that God gave "orders to the morning" so that the dawn would "shake the wicked" out of the earth (Job 38:4-13).

The New Testament conveys this world view, too: All things in Heaven and on earth "hold together" solely because our Lord and God Jesus Christ holds them together, consciously sustaining their order and existence (Col. 1:15-17).

Oh, we know that God uses intermediate forces. But because they are _intermediate_, there must be an _Ultimate_. To God Himself we must credit every benefit. When we do that, we, like David, praise Him; when we refuse, we withhold praise.[5]

David also saw God—and all His acts—as _perfect_. "As for God, his way is perfect; the word of the LORD is flawless. . . . For who is God besides the LORD? And who is the Rock except our God?" (Ps. 18:30-31).

God never does anything partway. What He begins, He completes (Phil. 1:6). And what God does completely He also

does flawlessly (Ps. 18:30).

Imagine life governed by this truth! God works all things together for our good. God completes everything He starts. God never makes a mistake. What a great reason for praise! Believing this, we can rejoice confidently with Paul, "Who shall separate us from the love of Christ? Shall trouble or hardship or persecution or famine or nakedness or danger or sword? . . . No, in all these things *we are more than conquerors through him who loved us*" (Ro. 8:35-37, emphasis added)!

God of Promise and Fulfillment

Not all of David's reasons for praise required reminiscence. The future held as much hope as the past did satisfaction.

This living God (Ps. 18:46)—the same yesterday, today, and forever—who had already done so much for David, promised more. David saw God's promises as so certain, so absolutely beyond doubt, that he spoke of them as already fulfilled: ". . . he shows unfailing kindness to his anointed, to David *and his descendants forever*" (verse 50, emphasis added).

We cannot know the extent to which David was aware of the import of what he wrote. We do know that the whole Church since the time of Jesus has understood this promise to be fulfilled in Christ's reign in the Church. Here, more than anywhere else in this psalm, David's words speak more than he might have intended. They picture a God more gracious and bountiful, more powerful and sovereign, than He was described by anything yet said. The whole future is in God's hands, and His salvation is not only temporal but eternal.

When we look carefully at our own lives, we find that God, who is the same yesterday, today, and forever, is to us everything He was to David. Our circumstances may not be so dramatic as David's (not many are called to be kings over God's chosen people, after all!), but we, like him, are involved in spiritual

warfare against sin in our hearts and against God's enemies both human and demonic. And wherever we stand in the line of battle, God prepares us and provides all the weapons we need (Eph. 6:10-18). He is our strength and salvation, as He was David's (2 Cor. 12:9). He delivers us from sin and ultimately from death. We have God's promise that He works all things together for our good (Ro. 8:28). He justifies us and will one day vindicate us from all condemnation (Romans 8). Surely this God deserves our praise!

NOTES:

1. Edmund Burke, *On the Sublime and Beautiful*, in *The Writings and Speeches of the Right Honourable Edmund Burke*, Beaconsfield Edition, 12 volumes (Boston: Little, Brown and Company, 1901), volume 1, pages 142-143.
2. David apparently composed Psalm 18 in his old age. It first appears as a song in 2 Samuel 22. The title tells us that David wrote particularly in view of God's deliverances from Saul. Verses 4-24 seem to refer to the period when Saul repeatedly tried to kill him. But in verses 29-45 he seems to turn to later battles.
3. Augustine, *Expositions on the Book of Psalms*, ed. A. Cleveland Coxe, in *A Select Library of the Nicene and Post-Nicene Fathers of the Christian Church*, 28 volumes, ed. Philip Schaff (Grand Rapids: Eerdmans, 1979 rpt.), Series I, volume VIII, page 51.
4. C.S. Lewis, *Reflections on the Psalms* (London: Fontana Books, 1962), page 80.
5. For help in conceiving of this world view, see C.S. Lewis's *The Discarded Image: An Introduction to Medieval and Renaissance Literature* (Cambridge, England: Cambridge University Press, 1976).

Man of
the Covenant
PSALM 15

Early in his reign, King David decided to bring the Ark of the Covenant, which had lain for years ignored at Kiriath Jearim, to Jerusalem. The Ark was a testimony to the Covenant between God and Israel and a symbol of the presence of Jehovah. As such it belonged at the focus of the nation. So he gathered 30,000 people to join in the entourage and began the journey.

But along the way, the oxen pulling the Ark stumbled. Lest the Ark fall to the ground, Uzzah, one of the attendants, reached out and took hold of it. God's reaction shocked and frightened everyone: "The LORD's anger burned against Uzzah because of his irreverent act; therefore God struck him down and he died there beside the ark of God" (2 Sam. 6:7).

When David saw what happened, he responded first with anger, then with fear. "How can the ark of the LORD ever come to me?" he asked (verse 9). The display of God's holy wrath breaking out against one who had trespassed against His Law by touching the Ark without ceremonial authority and with carnal motives— thinking that he, a mere man, could prevent embarrassment to the earthly throne of Almighty God—made David wonder whether he himself could survive the presence of the Ark in Jerusalem. So

he left it at the home of Obed-Edom. But Obed-Edom's household experienced God's blessing because of the Ark, so finally David brought it to Jerusalem.

Who May Dwell in God's Sanctuary?

Seeing Uzzah slain by God for an offense that seemed so slight must have had a lasting impact on David. Perhaps it led to his writing Psalm 15, in which the question, "How can the ark of the LORD ever come to me?" is inverted to, "LORD, who may dwell in your sanctuary? Who may live on your holy hill?" (Ps. 15:1). David wants to know the sort of man who might live safely and worthily in the presence of One so holy and awful as Jehovah.

This simple psalm has three sections: the question (verse 1), the answer, in both summary and exemplary detail (verses 2-5), and a promise to the righteous (verse 5).

David's Question

Today we are tempted to treat the question lightly, few of us being convicted of God's holiness and of the seriousness of relating to Him. But David sees things differently. He addresses God as Jehovah, Covenant God, whose nature determines the answer to the question. The words *sanctuary* (or tabernacle) and *holy hill* make it more explicit. Each idea is rooted in the delivery of Israel out of Egypt.

The incident in which God revealed His covenant name to Moses began with Moses seeing a burning bush and turning to examine it. As he came near, God said, "Do not come any closer. . . . Take off your sandals, for the place where you are standing is holy ground" (Ex. 3:5). The idea of God's holiness—purity unapproachable by the impure without the greatest danger—was impressed on Moses and, through him, on all Israel.

Later, when God prepared to give Moses the Law, He called Moses apart to a mountain. Picture the scene as Moses describes it:

> On the morning of the third day there was thunder and
> lightning, with a thick cloud over the mountain, and a very
> loud trumpet blast. Everyone in the camp trembled. Then
> Moses led the people out of the camp to meet with God,
> and they stood at the foot of the mountain. Mount Sinai
> was covered with smoke, because the LORD descended on
> it in fire. The smoke billowed up from it like smoke from a
> furnace, the whole mountain trembled violently, and the
> sound of the trumpet grew louder and louder. Then Moses
> spoke and the voice of God answered him.
>
> The LORD descended to the top of Mount Sinai and
> called Moses to the top of the mountain. So Moses went up
> and the LORD said to him, "Go down and warn the people
> so they do not force their way through to see the LORD and
> many of them perish. Even the priests, who approach the
> LORD, must consecrate themselves, or the LORD will break
> out against them." (Ex. 19:16-22)

This must have had a powerful influence on any faithful Jew's
understanding of his relationship with God. God was not to be
approached lightly; the Law He gave from the midst of the smoke
and fire was not to be transgressed without the most dire conse-
quences. Consecration—holiness, purity, separation from all that
was sinful and unclean—was the condition of fellowship with
God.

The same awful holiness marked the Tabernacle and its
contents. When Moses gave instructions for their transportation,
he insisted that those involved must be Levites specially conse-
crated to that service, and even they ". . . must not touch the holy
things or they will die" (Num. 4:15).

For the pious, God-fearing Israelite, then, dwelling with
Jehovah in His Tabernacle on the holy hill of Zion was a grave
matter. No one must presume his own worthiness; everyone must
take special care to see whether he was suited to that privilege—

lest entering unworthily he should offend the God of the covenant and die.

The Apostle Paul warns Christians to honor the holiness of Communion just as diligently when he writes:

> . . . whenever you eat this bread and drink this cup, you proclaim the Lord's death until he comes.
>
> Therefore, whoever eats the bread or drinks the cup of the Lord in an unworthy manner will be guilty of sinning against the body and blood of the Lord. A man ought to examine himself before he eats of the bread and drinks of the cup. For anyone who eats and drinks without recognizing the body of the Lord eats and drinks judgment on himself. That is why many among you are weak and sick, and a number of you have fallen asleep. But if we judged ourselves, we would not come under judgment. (1 Cor. 11:26-31)

The Tabernacle, its contents, and the rituals enacted within it were designed to illustrate the saving acts of God for Israel, and anyone who profaned the symbols through disrespect insulted what they symbolized. Much more, the elements of the Lord's Supper illustrate the saving act of Christ on the cross, and whoever profanes them through disrespect insults God and His works. In each instance, the offender invites on himself God's judgment.

Jehovah, the Holy God of the covenant, cannot have fellowship with the unholy (Hab. 1:13, 2 Cor. 6:14-18). No wonder David seeks so earnestly an answer to his question! "LORD, who may dwell in your sanctuary? Who may live on your holy hill?"

God's Answer

To David's urgent question, he himself, having learned from God, gives a clear, unmistakable reply. First comes a summary; later he will give details. "He whose walk is blameless and who does what

is righteous, who speaks the truth from his heart" (Ps. 15:2).

The man who dwells in the sanctuary with Jehovah must be like Jehovah and the sanctuary. Whoever lives on the holy hill must be holy.

A Summary of Holiness

Here in verse 2, David writes of three broad characteristics of the holy man: an upright walk, righteous deeds, and total truthfulness. His overall lifestyle, his individual deeds, and his thoughts and speech must all be holy, acceptable to God (see also Ro. 12:1-2). The verbs David uses are all participial in form, indicating habitual practices. He writes of the man "walking uprightly," "doing what is righteous," and "speaking truth in his heart."

Blameless in the NIV translates a Hebrew word whose fundamental meaning is "complete," meaning not that the man is absolutely free from sin but that he possesses everything that constitutes a good character.[1] It is the idea of *integrity*, wholeness, consistency. Every aspect of his walk is congruous with everything else. He is not careful about some things and careless about others, but strives, as Paul would put it, to take every thought captive to make it obedient to Christ (2 Cor. 10:5).

The holy man's deeds are "righteous," conformed to the right standard of God's Law. And notice that David writes here of deeds, not only of talk, for it is the doers of the Law and not the hearers only who are justified (Jas. 1:22,25).

The Hebrew that the NIV translates as "speaks the truth *from* his heart" probably literally means, "speaks the truth *in* his heart." David's idea is not merely of one who does not lie to others, but of one who does not lie to himself. Even in his own heart, where no other man can examine him to see whether he is honest, the holy man is truthful. How many times do we stray from this standard? When we imagine great things of ourselves, or inwardly justify ourselves while outwardly we apologize to someone, or fool ourselves into thinking we've done better than we have, we are not

speaking the truth in our hearts, regardless what show of truthfulness we make outwardly.

Examples of Holiness

Now David turns from his summary to some specific examples of the holiness that befits a man for fellowship with God. He is one who:

> . . . has no slander on his tongue,
> who does his neighbor no wrong
> and casts no slur on his fellow man,
> who despises a vile man
> but honors those who fear the LORD,
> who keeps his oath
> even when it hurts,
> who lends his money without usury
> and does not accept a bribe against the innocent.
> (Ps. 15:3-5)

Here again the verbs indicate habitual action, not because they are participial but because they are all in the perfect tense: He never slandered with his tongue, never did his neighbor wrong, never cast a slur on his fellow man; he always despised vile men, always honored God-fearers; he never reneged on his oath, never loaned money on usury, never accepted a bribe against the innocent. This is a man of integrity! His walk is consistent.

The first three traits all seem to have to do with the tongue (verse 3). He is no slanderer, or "backbiter," the Hebrew describing someone who sneaks around trying to discover others' faults so that he can broadcast them (verse 3; see also Lev. 19:16). The implication is that he never harms his neighbor by his speech (verse 3). And, being one who will not harm by slander, he also will not put up with others when they do it: the third clause of verse 3 is better translated, "nor takes up a reproach against his

friend" (NASB; i.e., he will not even listen or give credit to verbal attacks against the innocent).

The early Church Father Tertullian drove home the importance of the Christian's guarding what he observes as well as what he says when he wrote, "What a man should not say he should not hear. All licentious speech; every idle word is condemned by God. The things which defile a man in going out of his mouth, defile him also when they go in at his eyes and ears. The true wrestlings of the Christian are to overcome unchastity by chastity, perfidy by faithfulness, cruelty by compassion and charity."[2] Augustine is said to have had inscribed over his table, "He that doth love with bitter speech the absent to defame, must surely know that at this board no place is for the same."[3]

Next David writes of how the holy man looks on others. It is with the strictest honesty, judging all impartially. A vile man, whether of high or low station, he despises (not because he thinks himself better, but because God's standard is not to be abandoned), while a God-fearing man, even if he is poor and outcast by society, he honors. He is not like those of whom God spoke through Isaiah saying, "Woe to those who call evil good and good evil, who put darkness for light and light for darkness, who put bitter for sweet and sweet for bitter" (Is. 5:20). The man of God believes and speaks only the truth about everyone.

Next David illustrates in three ways the extent of the honesty required of one who would dwell with Jehovah: (1) If he makes a promise and it turns out that keeping it will bring him harm, he doesn't go back on his word (Ps. 15:4). (2) If he lends money to help someone in need, he neither asks nor accepts interest on the loan (verse 5). (3) If he is entrusted with the task of judging between the guilty and the innocent, no bribe can corrupt his judgment (verse 5). In short, his integrity is not for sale. He is living proof that the proverb, "Every man has his price," is a lie.

The Law of Moses forbade an Israelite's vowing to present one sacrifice to God and then substituting something else (Lev.

5:4, 27:10). The Hebrew David uses in Ps. 15:4 refers to that rule, showing that it should be understood as requiring faithfulness to all commitments. John Calvin expressed the implications well:

> . . . the faithful will rather submit to suffer loss than break their word. When a man keeps his promises, in as far as he sees it to be for his own advantage, there is in this no argument to prove his uprightness and faithfulness. . . . Every one considers with himself what is for his own advantage, and if it puts him to inconvenience or trouble to stand to his promises, he is ingenious enough to imagine that he will incur a far greater loss than there is any reason to apprehend. . . . David, therefore, condemning this inconstancy, requires the children of God to exhibit the greatest steadfastness in the fulfilment of their promises.[4]

Not personal gain, but personal integrity marks the life of the man of God.

The clause, "who lends his money without usury" (verse 5), is one of several references in the Old Testament to interest on loans that have led to great controversies in the history of Jewish and Christian ethics.[5] The most common explanation—one that I believe is correct—is that the prohibition of interest applied only to emergency loans to the poor. The root passages, Ex. 22:25 and Lev. 25:35-37, expressly refer to loans to the poor, or needy, as does Nehemiah 5, and the parallelism in Prov. 28:8 implies the same, while in Ezekiel 18 it is implied that the condemnation is based on the harm that the interest does to the borrower. It seems reasonable to understand the passages that do not mention that restriction as governed by it.

Also helpful is the meaning of the word for *usury* or *interest.* The same Hebrew word is translated both ways—there is not one word for the concept of "excessive interest" and another for "reasonable interest," but a single word for any interest whatever.

From its root the word conveys the idea of "biting," thus hurting, the borrower. Interest-bearing loans to the poor "bite" because they are meant to meet immediate needs, not to finance productive enterprises the profit from which the borrower can share with the lender without suffering himself.

Reasonable interest on commercial loans, then, is not the subject here. What is forbidden is "biting" borrowers—whether by charging any interest at all on loans to meet the emergency needs of the poor, or by charging such high rates of interest on any loans as to eat up all proceeds the borrower might earn and leave him worse off after the loan than before it. Emergency loans to the poor ought to be acts of sacrificial love, not of profit seeking. We get a good sense of David's idea, then, if we read Ps. 15:5, ". . . who lends his money without 'biting.'"

The final example of moral rectitude that David offers is that the holy man is proof against bribery. God made this requirement clear when He instituted the system of judges in Israel:

> Appoint judges and officials for each of your tribes in every town the LORD your God is giving you, and they shall judge the people fairly. Do not pervert justice or show partiality. Do not accept a bribe, for a bribe blinds the eyes of the wise and twists the words of the righteous. Follow justice and justice alone, so that you may live and possess the land the LORD your God is giving you. (Dt. 16:18-20)

Refusing bribes is akin to the idea set forth in Ps. 15:4 of despising a vile man and honoring a God-fearing man. We are to render impartially to each his due without considering outside factors (Ro. 13:7).

The Promise

Having described the man who is worthy to dwell with Jehovah, David now tells of God's promise to him: "He who does these

things will never be shaken" (Ps. 15:5). He will never be shaken because he is a man of the covenant, true to the covenant. Each of the prohibitions and requirements in verses 3-5 reflect some aspect of the Law, the conditions of God's covenant. Adherence to the Covenant makes men loyal to God, loyal to their neighbors, and loyal to their own integrity. They are unshakable in this life and the next.

Jesus, after He gave His commentary on the Law (Mt. 5:17-7:23), gave a promise to those who lived by His instruction, and a threat to those who rejected it:

> "Therefore everyone who hears these words of mine and puts them into practice is like a wise man who built his house on the rock. The rain came down, the streams rose, and the winds blew and beat against that house; yet it did not fall, because it had its foundation on the rock. But everyone who hears these words of mine and does not put them into practice is like a foolish man who built his house on sand. The rain came down, the streams rose, and the winds blew and beat against that house, and it fell with a great crash." (Mt. 7:24-27)

Holiness, purity, righteousness, conformity to the Law of God—whatever we use to sum up the character of the man who is fit to dwell with God—only that gives anyone lasting stability. Whether we face temptation, or suffer illness or poverty or persecution, or hover at the gate of death, we can stand firm if we are loyal to the Covenant, if our lives are conformed to the Law of God.

How Can We Measure Up?

David's description of the man who can dwell in the presence of God sets before us a high standard. It is nothing less than complete

inward and outward conformity to God's Law. Yet in another psalm, David tells us, "The LORD looks down from heaven on the sons of men to see if there are any who understand, any who seek God. All have turned aside, they have together become corrupt; there is no one who does good, not even one" (Ps. 14:2-3). How then can anyone ever hope to measure up to God's requirements?

No one can, on his own. Paul, after citing Ps. 14:2-3, concludes that ". . . no one will be declared righteous in [God's] sight by observing the law; rather, through the law we become conscious of sin" (Ro. 3:20). Then he explains that righteousness is a gift of God received by faith (verses 21-22). But does this release us from the requirements of the Law? No, it upholds the Law by showing that even the slightest deviation from it deserves punishment, so that we must seek justification by some way other than law-keeping (Ro. 3:31). But gaining justification by faith does not mean we need not walk in conformity to the Law thereafter. Rather than releasing us from the requirements of the Law, faith releases us from slavery to sin and binds us into slavery to righteousness—righteousness as defined by the Law (Ro. 6:15-22).

Thus what God expects to see in the lives of the faithful is ever-increasing conformity to His Law, and this He makes possible by sending Jesus Christ to break the power of sin in our lives. As Paul expresses it, ". . . through Christ Jesus the law of the Spirit of life set me free from the law of sin and death. For what the law was powerless to do in that it was weakened by the sinful nature, God did by sending his own Son in the likeness of sinful man to be a sin offering. And so he condemned sin in sinful man, in order that the righteous requirements of the law might be fully met in us, who do not live according to the sinful nature but according to the Spirit" (Ro. 8:2-4).

The first and absolutely essential step to becoming worthy to dwell with God, then, is dying to sin and being made alive in Christ—the new birth. We cannot conform to the Law on our own. But through the power of the Holy Spirit indwelling all who

believe in Christ, we may begin to live outwardly the righteousness that God places within us.

Three Steps to Growth in Righteousness

What now? Do we sit back and wait for God to change our lives? No. Like another psalmist, we kneel down and plead with Him to do it!

> Teach me, O LORD, to follow your decrees;
> > then I will keep them to the end.
> Give me understanding, and I will keep your law
> > and obey it with all my heart.
> Direct me in the path of your commands,
> > for there I find delight.
> Turn my heart toward your statutes
> > and not toward selfish gain.
> Turn my eyes away from worthless things;
> > renew my life according to your word. (Ps. 119:33-37)

Would not God be delighted if we were to pray regularly through Psalm 15 to Him? "O Lord, make me fit to dwell in Your sanctuary, to live on Your holy hill! Teach me, O Lord, to walk blamelessly, to do only what is righteous, to speak the truth in my heart. Teach me, Father, never to slander anyone, never to do wrong to my neighbor, never to entertain unkind words about another. Teach me, O God, to despise the wicked and honor those who fear You. Teach me, Lord Jesus—You who kept Your promise though it meant the Cross—never to break a promise, never to take advantage of another's distress, never to sell justice for a bribe! Help me, Lord, to be like the wise man who built his house on the rock of Your words and who therefore was never shaken!"

Even after praying, we must not rest. For the prayer itself would be mere empty words if we were not to add to it our own

diligent study of God's Word, especially His Law, which instructs us in righteousness. The same psalmist who prayed for God to teach him His decrees (Ps. 119:33-37) also wrote,

> Oh, how I love your law!
>> I meditate on it all day long.
> Your commands make me wiser than my enemies,
>> for they are ever with me.
> I have more insight than all my teachers,
>> for I meditate on your statutes.
> I have more understanding than the elders,
>> for I obey your precepts. (Ps. 119:97-100)

There simply is no substitute for studying God's Law if we are to become conformed to it.

Finally, we will only be diligent in prayer and study if we begin to grasp the awfulness of God's holiness and to consider what a weighty matter it is to live in His presence. The author of the Epistle to the Hebrews agreed with David's high estimation of our need for holiness when he wrote, "Make every effort to live in peace with all men and to be holy; without holiness no one will see the Lord" (Heb. 12:14). If anything, the Christian's need for holiness is even greater than the Old Testament believer's. Notice the contrast between the holy mountain to which Moses went and that to which the Christian comes:

> You have not come to a mountain that can be touched and that is burning with fire; to darkness, gloom and storm; to a trumpet blast or to such a voice speaking words, so that those who heard it begged that no further word be spoken to them, because they could not bear what was commanded: "If even an animal touches the mountain, it must be stoned." The sight was so terrifying that Moses said, "I am trembling with fear."

But you have come to Mount Zion, to the heavenly Jerusalem, the city of the living God. You have come to thousands upon thousands of angels in joyful assembly, to the church of the firstborn, whose names are written in heaven. You have come to God, the judge of all men, to the spirits of righteous men made perfect, to Jesus the mediator of a new covenant, and to the sprinkled blood that speaks a better word than the blood of Abel.

See to it that you do not refuse him who speaks. If they did not escape when they refused him who warned them on earth, how much less will we, if we turn away from him who warns us from heaven? At that time his voice shook the earth, but now he has promised, "Once more I will shake not only the earth but also the heavens." The words "once more" indicate the removing of what can be shaken—that is, created things—so that what cannot be shaken may remain.

Therefore, since we are receiving a kingdom that cannot be shaken, let us be thankful, and so worship God acceptably with reverence and awe, for our God is a consuming fire. (Heb. 12:18-29)

Properly understood, everything about the Christian life ought to inspire awe and reverence. Not just anyone is fit to dwell in the Tabernacle of the Most High. Neither is just anyone fit to abide in the Church, the Body of Christ. There will come a time when the wheat will be separated from the tares and the grain from the chaff. Knowing these things ought to inspire us to strive with all our hearts to be like the man David describes in Psalm 15—to be fit to dwell with the Most High.

NOTES:
1. Albert Barnes, *Psalms*, 3 volumes, ed. Robert Frew (Grand Rapids: Baker Book House, 1975 rpt.), volume 1, page 120.

2. Cited in Philip Schaff, *History of the Christian Church*, 8 volumes (U.S.A.: Associated Publishers and Authors, n.d. rpt.), volume 2, page 155.

3. Cited by Richard Turnbull, in Charles Spurgeon, *The Treasury of David*, 3 volumes (McLean, Va.: MacDonald, n.d. rpt.), volume 1, page 186.

4. John Calvin, *Commentary on the Book of Psalms*, 3 volumes, trans. James Anderson (Grand Rapids: Baker Book House [1846] 1984), volume 1, pages 210-211.

5. See also Ex. 22:25, Lev. 25:35-37, Dt. 23:19, Neh. 5:1-13, Prov. 28:8, Ezk. 18:8-13. A good historical survey of the controversy is Benjamin N. Nelson's *The Idea of Usury* (Princeton, N.J.: Princeton University Press, 1949). A good discussion of relevant biblical texts is Gary North's "Stewardship, Investment, and Usury: Financing the Kingdom of God," in Rousas John Rushdoony's *Institutes of Biblical Law* (Nutley, N.J.: Craig Press, 1973), pages 799ff.

No Other Reward
PSALM 73

n his classic autobiographical novel, *Two Years Before the Mast*, Richard Henry Dana tells of a time when his ship's captain, a wretchedly cruel man, unjustly flogged two innocent crewmen. Just before his flogging began, the second man asked why he was being flogged. The captain said it was merely for having asked a question that implied disapproval of the first flogging. Then, the flogging under way, the captain's ". . . passion increased, and he danced about the deck, calling out as he swung the rope,—'If you want to know what I flog you for, I'll tell you. It's because I like to do it!—because I like to do it!—It suits me! That's what I do it for!'

"The man writhed under the pain, until he could endure it no longer, when he called out, with an exclamation more common among foreigners than with us—'Oh, Jesus Christ! Oh, Jesus Christ!'

"'Don't call on Jesus Christ,' shouted the captain; *'he can't help you. Call on Captain T——, he's the man! He can help you! Jesus Christ can't help you now!'"

Dana, who planned to become a lawyer, tells us that he later thought soberly "of the prospect of obtaining justice and satisfac-

tion for these poor men; and vowed that if God should ever give me the means, I would do something to redress the grievances and relieve the sufferings of that poor class of beings [sailors], of whom I then was one."[1]

Why Do the Wicked Prosper?

Why, so often, do the wicked prosper while the innocent suffer? Wrestling with that question almost drove the psalmist Asaph to apostasy (Psalm 73). Joining him in his struggles can steel us to face the problem ourselves, as we must do repeatedly throughout our lives.

"Surely God is good to Israel," Asaph began, "to those who are pure in heart" (Ps. 73:1). We can take comfort in the fact that Asaph *began* his psalm this way; all that follows, despite contrary appearances, will confirm it.

Asaph fortified himself with the goodness of God. It was his stronghold from which to war against doubt. As in the face of a bent world Job clung to God's omniscience (Job. 24:1), and Jeremiah to God's justice (Jer. 12:1), and Habakkuk to God's holiness (Hab. 1:13), so Asaph set forth God's goodness. He was committed to it in faith—he could not be torn from it easily.

The Prosperity of the Wicked

But that stronghold was not impenetrable. Into it the darts of temptation and doubt could fly, and one of them sank deeply into Asaph's heart. He succumbed to envy when he "saw the prosperity of the wicked" (Ps. 73:3).

Asaph saw the wicked healthy, free from common burdens, and full of pride and violence (verses 4-6). Although their very hearts overflowed with iniquity, and they scoffed at God and all that is pure, still they claimed a right to Heaven and earth (verses 7-9). And they drew along with them all the masses of people who

drank in their intoxicating words, saying, "How can God know? Does the Most High have knowledge?" (verse 11).

With their prosperity he compared his own misery, and thought that he had kept his heart pure in vain. After all, though he strove to remain innocent, still he was "plagued . . . punished every morning" (verse 14). How could a good God permit this? Was God truly "good . . . to those who are pure in heart"? The doubts gripped him, and he "almost slipped."

Second Thoughts

What held him back? What rescued him from wallowing in envy and self-pity? We naturally guess that it was his prior commitment to faith in the goodness of God. But we guess wrong—or at best partly right. That commitment checked his headlong rush into apostasy enough that he could think of something else—God's people: "If I had said, 'I will speak thus,' I would have betrayed this generation of your children"[2] (verse 15). To harbor such doubts in his own heart was dangerous enough, but to voice them, leading others astray? That he could not do.

Suppressing his doubts didn't relieve him (verse 16). But it did enable him to calm down long enough to get God's perspective. Standing quietly in God's presence, Asaph's second thoughts corrected the first. Finding his own reasoning inadequate to resolve his difficulty, he turned and asked God directly. There the mystery was solved.

The Perspective of Destiny

How was the mystery solved? When he brought his complaint about the wicked's prosperity into "the sanctuary of God," Asaph "understood their final destiny" (verse 17): "Surely you place them on slippery ground; you cast them down to ruin. How suddenly are they destroyed, completely swept away by terrors!"

(verses 18-19). All their apparent prosperity in this life was but a dream, a fantasy that would vanish in an instant before the judgment of God. Eternal loss awaited them. No glory on earth could outweigh it.

Seeing suddenly the destiny of the wicked, Asaph was ashamed of his envy and unbelief: "When my heart was grieved and my spirit embittered, I was senseless and ignorant; I was a brute beast before you" (verses 21-22). Senseless and ignorant because his eyes were fixed on this fleeting world instead of on eternity! Brutish because he sought more to satisfy the flesh than the spirit, held prosperity more precious than God Himself!

What was all worldly wealth compared with having God always with him, upholding him, guiding him (verse 23)? What was the promise of health or power or fame compared with the promise of standing in the presence of the divine glory (verse 24)? These things awaited the righteous. And no worldly suffering could outweigh them.

Eternal loss for the wicked, eternal gain for the righteous. In these Asaph saw at last the answer: "We must judge of persons and things as they appear by the light of Divine revelation, and then we shall judge righteous judgment; particularly we must judge by the end. All is well that ends well, everlastingly well; but nothing well that ends ill, everlastingly ill. The righteous man's afflictions end in peace, and therefore he is happy; the wicked man's enjoyments end in destruction, and therefore he is miserable."[3]

These things at last understood, Asaph committed himself to God and to spreading this good news: "I have made the Sovereign LORD my refuge; I will tell of all your works" (verse 28).

Making Faith Firm

There are at least six abiding principles to be learned from studying Psalm 73. Understanding each can help us to respond right-

eously to the temptation to envy the wicked in their prosperity, or to pity ourselves in our sufferings.

First, our faith must be founded on an understanding of the nature of God. Asaph's original trust in the unchanging goodness of God prevented his confusing illusion with reality. When we have settled in our hearts that God *is* good, that He *is* just, that He *is* all powerful, and that He *will* do right both now and for eternity, we will have the spiritual strength needed to defeat the temptation to envy others and pity ourselves.

Second, it was not God who was on trial, but Asaph. The real faults portrayed in the psalm lie not in God but in the psalmist: envy, bitterness, ingratitude, selfishness, and unbelief. Asaph began and ended by affirming God's goodness and sufficiency to His people. But immediately after writing, "Surely *God* is good . . . ," he confessed, "But as for *me*, *my* feet had almost slipped; *I* had nearly lost my foothold. For *I* envied the arrogant when I saw the prosperity of the wicked" (verses 1-3).

In preaching on this passage, Augustine said, "When were the feet moved, except when the heart was not right?"[4] When we wallow in doubts about God's goodness rather than answering them with the testimony of Scripture and the demonstration of His grace and goodness on the cross and in Christ's resurrection, we tread on dangerous ground. Tempted to doubt God's goodness, we must seek the problem in ourselves. In his temptation, Asaph learned to think humbly of himself, and to abase and accuse himself instead of God.[5] His is a good example for us to follow.

Third, when confronted with great difficulties that cause us to doubt God, we should go to the Lord in prayer for His solution rather than leaning on man and infecting others with our doubts. It was when Asaph "entered the sanctuary of God" that he gained understanding. How often we resort to the latest book, or a popular teacher, or the counsel of a friend, rather than hiding ourselves away with the Word in prayer, wrestling with God and saying, "I will not let You go until You bless me!"

Fourth, Asaph is concerned not with the traditional "problem of evil" but with the problem of *justice*. The "problem of evil" is typically stated this way: "An all-good, all-powerful, and all-knowing God would not permit creatures to suffer. But creatures do suffer. Therefore no all-good, all-powerful, and all-knowing God exists." This is a legitimate difficulty that Christians must face.[6] Nevertheless, to read Psalm 73 as if it answered that problem is to miss its point.

Asaph is not concerned—at least here—with why *anybody* suffers. Instead, he is concerned with why it so often seems that those who *deserve* to suffer don't, and those who *don't deserve* to suffer do. This indicates a radically different focus from that of the traditional "problem of evil." The latter focuses on man's suffering; Asaph's question focuses on God's goodness and justice.

The "problem of evil" tacitly assumes man's happiness as the highest end in creation; the problem of justice assumes that the display of God's moral perfection—including justice in reward and punishment—is the highest end in creation (Ps. 19:1, Eph. 3:10, Ro. 9:22-23). The one is man-centered, the other God-centered. And neither our thoughts nor our lives will ever be right until they are God-centered.

When we make our own happiness, or even the happiness of those we love, the measure of God's justice, we will always conclude that He is less than p fectly just. For our lives are less than perfectly happy *in this world*. But when we make the display of God's justice the ultimate measure of the goodness of creation—when we see that God made all things for *His* pleasure, not theirs, that justice is revealed in judgment as well as in reward, that the justice of God's final judgment on the wicked is made the more clear by their ingratitude in prosperity, and that the justice of His final reward to the righteous is made more clear by their contentment and praise in distress—then we can stand firm in our faith that God is both just and good, and we can endure our trials patiently as we anticipate the rewards to come.[7]

Fifth, and closely related to this, the psalmist's answer to the problem of justice is *eschatological*: He refers to the end, the eternal destiny of the wicked and the righteous. He does not contend that everyone receives his due now. Instead, he looks forward to the day when God will set all things right.

When God's people in Malachi's day spoke harshly against Him, saying, "It is futile to serve God. What did we gain by carrying out his requirements and going about like mourners before the LORD Almighty? But now we call the arrogant blessed. Certainly the evildoers prosper, and even those who challenge God escape" (Mal. 3:14-15), God responded:

> ". . . you will again see the distinction between the righteous and the wicked, between those who serve God and those who do not.
>
> "Surely the day is coming; it will burn like a furnace. All the arrogant and every evildoer will be stubble, and that day that is coming will set them on fire Not a root or a branch will be left to them. But for you who revere my name, the sun of righteousness will rise with healing in its wings. . . ." (Mal. 3:18-4:2; see also 2 Cor. 4:16-18, 2 Thess. 1:6-10)

In his book *Learning to Live with Evil*, Theodore Plantinga wrote, "I have no theodicy to offer, no justification of God's decisions in the face of the evil in the world. Instead I believe we must look ahead to the coming triumph over evil, to the establishment of the Kingdom of God which is already among us but is not yet fully manifest and recognized."[8]

We rightly want to improve this world, but we must not fall prey to the temptation to think that we can, in our own power, create Heaven on earth. The consummation of all things lies in the hands of God. To Him we must look for final justice.

This brings us to our sixth and final abiding principle, a major

theme in many of Augustine's writings: Just as one who marries for money is contemptible, so also is one who serves God for money, or comfort, or safety, or health, or power. Whoever serves God only to gain a reward from Him actually holds the reward more precious than God. The sole reward we should seek in serving God is God Himself. And whoever seeks and serves God only for Himself, and not for any other reward, will always be content in Him, for God has promised to reveal Himself to those who seek Him with their whole hearts (Jer. 29:13).[9]

Martin Luther expressed this lesson beautifully in a hymn:

> The whole wide world delights me not,
> For heaven and earth, Lord, care I not,
> If I may but have Thee;
> Yea, though my heart be like to break,
> Thou art my trust that nought can shake.[10]

God Himself must be our ultimate satisfaction. "Whom have I in heaven but you?" asked Asaph. "And being with you, I desire nothing on earth. My flesh and my heart may fail, but God is the strength of my heart and my portion forever" (Ps. 73:25-26).

Heaven itself would be hell without God; but whoever possesses God possesses Heaven, even on earth.

NOTES:

1. R.H. Dana, Jr., *Two Years Before the Mast*, ed. Charles W. Eliot (New York: P.F. Collier & Son Corp., Harvard Classics Edition), page 102.

2. NIV, 1978 version.

3. Matthew Henry, *A Commentary on the Old and New Testaments*, 3 volumes (New York: Robert Carter and Sons, n.d.), volume 2, pages 219-220.

4. Augustine, *Expositions on the Book of Psalms*, in Philip Schaff, ed., *A Select Library of the Nicene and Post-Nicene Fathers of the Christian Church*, First Series, volume VIII, trans. A. Cleveland Coxe (Grand Rapids: Eerdmans, 1979), page 335.

5. See Henry, *A Commentary on the Old and New Testaments*, volume 2, page 220.

6. See E. Calvin Beisner, "Why Does God Permit Evil?" in *Discipleship Journal*, July 1,

1985, pages 12-16; C.S. Lewis, *The Problem of Pain* (New York: Macmillan, 1976); Norman Geisler, *The Roots of Evil* (Grand Rapids: Zondervan, 1978); Alvin Plantinga, *God, Freedom & Evil* (Grand Rapids: Eerdmans, 1982); John Wenham, *The Goodness of God* (Downers Grove, Ill.: InterVarsity Press, 1979); and Theodore Plantinga, *Learning to Live with Evil* (Grand Rapids: Eerdmans, 1982).

7. For excellent discussions of this contrast in focus, see Charles Hodge, *Systematic Theology*, 3 volumes (Grand Rapids: Eerdmans, 1973 rpt.), volume 1, pages 435-436; Stephen Charnock, *The Existence and Attributes of God*, 2 volumes (Grand Rapids: Baker Book House, 1980 rpt.), volume 2, page 229; and Theodore Plantinga, *Learning to Live with Evil*, page 71.

8. Plantinga, *Learning to Live with Evil*, page 115.

9. See Augustine, *Expositions on the Book of Psalms*, page 341.

10. Cited in Franz Delitzsch, *Commentary on the Old Testament*, 10 volumes (Grand Rapids: Eerdmans, 1976), volume 5, part 2, pages 321-322.

Curses on
Covenant-Breakers
PSALM 109

I n the late seventh century BC, Judah fell into great apostasy. The people worshiped pagan gods and participated in pagan rituals. For national security they relied on pagan alliances. In the midst of this God raised up the prophet Jeremiah to denounce their treason against the Covenant and to call them back to loyalty.

For this task God gave Jeremiah overwhelming love for them, so much that he has been called "the weeping prophet." Repeatedly the people scorned Jeremiah's messages. Once they announced clearly their intention to ignore him (Jer. 18:18). To this the weeping prophet responded in prayer:

> Listen to me, O LORD; hear what my accusers are saying! Should good be repaid with evil? Yet they have dug a pit for me. Remember that I stood before you and spoke in their behalf to turn your wrath away from them. So give their children over to famine; hand them over to the power of the sword. Let their wives be made childless and widows; let their men be put to death, their young men slain by the sword in battle. Let a cry be heard from their houses when

161

you suddenly bring invaders against them, for they have
dug a pit to capture me and have hidden snares for my feet.
But you know, O LORD, all their plots to kill me. Do not
forgive their crimes or blot out their sins from your sight.
Let them be overthrown before you; deal with them in the
time of your anger. (Jer. 18:19-23)

What a frightful response! Can Jeremiah be called a man of
love, who prays that God will forgive and restore these people?
And how will God answer such a prayer as his? How He might
answer in every case, we don't know; but how He answers in this,
we do:

"This is what the LORD Almighty, the God of Israel, says:
Listen! I am going to bring a disaster on this place that will
make the ears of everyone who hears of it tingle. . . .
 "In this place I will ruin the plans of Judah and Jerusa-
lem. I will make them fall by the sword before their ene-
mies, at the hands of those who seek their lives, and I will
give their carcasses as food to the birds of the air and the
beasts of the earth. I will devastate this city and make it an
object of scorn; all who pass by will be appalled and will
scoff because of all its wounds. I will make them eat the
flesh of their sons and daughters, and they will eat one
another's flesh during the stress of the siege imposed on
them by the enemies who seek their lives." (Jer. 19:3-9)

The hideous prophecy proved true just twenty years later in
the siege of Jerusalem in 587 BC (Lam. 2:20, 4:10). The highest
curse of the Covenant, foretold by Moses, fell on a nation of
covenant-breakers: "Because of the suffering that your enemy will
inflict on you during the siege, you will eat the fruit of the womb,
the flesh of the sons and daughters the LORD your God has given
you" (Dt. 28:53; see also Lev. 26:29).

A Psalm of Cursing

Such wrath is hard for Christians to understand. Harder still is it for us to fathom, even to conceive, of the idea of praying—seriously, that is, not in a fit of uncontrolled anger—for God to curse anyone. But Jeremiah was not the only Old Testament character to pray that way. King David, the man after God's own heart, whose gentle soul was "like a weaned child with its mother" (Ps. 131:2), prayed similarly more than once.[1] A prime example of such a prayer is Psalm 109. In that imprecatory prayer David describes his plight (verses 1-5), spends the bulk of his time calling on God to curse his chief enemy (verses 6-20), asks God to save him from treachery (verses 21-28), and finally rejoices in knowing that his enemies' destiny will be shame and disgrace while his will be to enjoy the presence of the Lord (verses 29-31). After examining David's prayer of cursing, we'll be better prepared to understand imprecatory prayer and its role in the life of the people of the Covenant.

David's Plight

David's prayer grows out of a situation much like Jeremiah's. He is surrounded by "wicked and deceitful men" who speak slanderous lies against him (verse 2), whose unprovoked attack stands in stark contrast with his loving friendship (verses 3-4). Despite his prayer on their behalf (verse 4), they repay him evil for good and hatred for friendship (verse 5). Indeed, his chief attacker seems to have been among his closest advisers and to have given bad counsel purposely to undermine his rule.[2]

What is David's response? Does he call on his troops to wreak vengeance on his enemies? Does he devise schemes to catch them and execute them for treason? Does he drag them into the royal court for trial? No, he prays: "O God, whom I praise, do not remain silent" (verse 1). It is as if he said, "O God, whom I praise in the midst of unfaithful people, look at me. I'm surrounded by

mockers, slanderers who seek my life. But I won't fight in my own defense. Instead I turn to my God. Speak now in my defense! Judge those who persecute me without cause!"

The Prayer of Cursing

What a prayer David prays! We would almost rather he *had* dragged his enemies into court, tried them, and executed them. That would have seemed familiar, perhaps even mild, compared with the curses he breathes forth. At least then he would have opposed only his own human power to theirs. Instead he calls on God to lash out against them, and we're tempted to think he just isn't playing fair.

His curses focus on one particular opponent, probably the ringleader of the treasonous affair. He starts by praying just against him (verses 6-8), but soon turns against his wife and descendants (verses 9-13), and even his parents (verses 14-15). And then, to demonstrate the justice of his curses, he pleads with God to make the man suffer precisely the treatment he gave to others (verses 16-20).

Curses on the Enemy

His first curse envisions the man brought before the bar of justice, and thus far we're prepared to go along. "Okay, let him pray for justice. We can understand that." But look what he prays: He asks God to appoint for his enemy an *evil man* as judge (verse 6)[3] and an accuser (literally, a "satan") as defender (verse 6), someone who will serve him as badly as he has served David.

How can this be justice? That a man should stand before an honest judge, with a competent attorney, and be found guilty of a crime he actually committed—that would be justice. But for a man to be tried by a wicked, unjust judge, and with a duplicitous defender who would rather sell him down the river than present a credible defense? The deck is stacked against him! Can this possibly be justice?

But think again. This man has purposely misled his king. He leads a conspiracy to undermine the king's authority. "Wicked and deceitful," he speaks slanderous lies. Without cause—that is, unjustly—he attacks David. What could be more just, in the great scheme of things, than for an unjust man to suffer injustice? Not that we should take it upon ourselves to judge someone unjustly merely because we think he is unjust, but God *knows* who is unjust. He need not put him on trial first to discover his heart. So God can render just punishment on the unjust by raising up for him an unjust judge and a traitorous defender. That is what David prays for: that this manifestly unjust man will suffer injustice of precisely the kind he has meted out.

For one who has returned hatred for love, David prays that he will be found guilty and that his begging for mercy will irritate the judge all the more so that he will hand down a harsher punishment (verse 7), cutting off his life so that someone else can take his office in the royal court (verse 8).

Curses on the Enemy's Family

So far, then, we see the justice of David's prayer. But David is not satisfied with cursing his enemy. Now he turns on his enemy's wife and children: "May his children be fatherless and his wife a widow," he prays (verse 9). He asks God to make the traitor's children homeless beggars (verse 10), bereft of all inheritance (verse 11) and even of others' kindness (verse 12). He begs God to cause them to be "cut off" (verse 13)—a judicial term for the death penalty, rooted in the Pentateuch. Even the man's parents don't escape David's curses, which reach now beyond this life into eternity: "May the iniquity of his fathers be remembered before the LORD; may the sin of his mother never be blotted out. May their sins always remain before the LORD, that he may cut off the memory of them from the earth" (verses 14-15).

Was It Just to Curse the Family? How are we to understand this? Is it just for one to pray that a man's children and

parents should suffer for his sins? After all, God has laid down an eternal standard of justice: "The soul who sins is the one who will die. The son will not share the guilt of the father, nor will the father share the guilt of the son. The righteousness of the righteous man will be credited to him, and the wickedness of the wicked will be charged against him" (Ezk. 18:20).

Recognizing Natural Consequences? There are three plausible explanations. First, it may be that David simply recognizes the natural consequences of his enemy's condemnation and execution on his descendants.[4] Naturally, if the man is to be executed for treason, his children must be orphaned and his wife widowed. And, human society being what it is, the survivors of a traitor are themselves treated like traitors. Whether this is fair is not the point; it may well occur. Perhaps David is saying something like this: "Even if it means his children must become homeless, begging orphans, and his wife a widow; even if no one will ever again show his children kindness; even if the family name will forever be a cause of reproach—still the traitor deserves his fate."

But there are weaknesses in this understanding. First, David's language indicates that he *intends* that the family should suffer these things. It communicates not resignation to a sad fate for the family, but an eager longing. Second, in at least one known instance, David showed exceptional kindness to an innocent descendant of an enemy,[5] creating a presumption against this explanation. Third, while public scorn might naturally fall on the man's widow and orphans, it seems less likely that it would strike his parents, who established their reputations before him. But the strongest objection is this: While David might be resigned that the *public* would hold family members guilty when they were innocent, he cannot think so of God. Yet he expressly prays that God will keep their sins ever before Him (Ps. 109:14-15).[6] It seems clear, then, that David intends his enemy's family to suffer.

Recording David's Sinful Anger? A second explanation is that David goes beyond the bounds of justice.[7] According to this

view, the unjust curse is recorded simply because David really thought it—just as was his sin in committing adultery with Bath-sheba. We learn from it how easily even a spiritual giant like David may succumb to the temptation of injustice.

But this view, too, is weak, mainly because of David's character. On the one hand, David was not vengeful; on the other, he claims that his chief motive is that God's name should be honored (verse 21), and we are hardly in a position to judge his honesty. John W. Wenham effectively demolishes the idea that this or any other curses David prayed evidenced sin rather than righteousness:

> David was not a vindictive person. Though, like all his con-temporaries, he was ruthless enough to his country's ene-mies, yet he showed extraordinary generosity to personal enemies who sought his death. Saul, without any justifica-tion, repeatedly tried to kill him, but David twice refrained from touching him when he had him at his mercy. He was culpably weak when his own son Absalom was plotting his overthrow and when he finally raised armed insurrection. On the death of Saul he composed an elegy which con-tained not a word of reproach; on the death of Absalom he was almost heartbroken. When Abigail intervened to pre-vent the death of her churlish husband at his hands, David was deeply grateful: 'Blessed be you, who have kept me this day from bloodguilt and from avenging myself with my own hand!' When David's fortunes were at their lowest ebb, and Shimei rained curses on him, he refused the request of Abishai to 'go over and take off his head'. . . . To his personal enemies David was not vindictive; he was generous to a fault.[8]

Like Father, Like Son. So we come to the third explana-tion: David really, and rightly, wanted his enemy's parents, wife, and

children punished with him. He rightly breathed out curses on them in prayer that he honestly expected God to honor. But why?

To understand this, we need to remind ourselves again that David was a man of the Covenant. The Law of God lay always foremost in his mind, including the warnings of punishment on covenant-breakers (see Leviticus 26, Deuteronomy 28). The curses David prays all reflect the curses God promised on covenant-breakers in Deuteronomy 28. And this particular curse—that the man's family should share in his guilt and condemnation—rests on a warning attached to the Second Commandment: ". . . I, the LORD your God, am a jealous God, punishing the children for the sin of the fathers to the third and fourth generation of *those who hate me . . .*" (Ex. 20:5, emphasis added).

Children normally follow in their parents' footsteps. In his prayer, David assumes—we may be confident that observation confirmed assumption—that the man's family shares his character. What this great enemy has done is just what his parents and children would do, given the opportunity. Indeed, they may have shared in his intrigues. What he deserves, they deserve, for they are as wicked and deceitful, as hateful and spiteful as he, and David prays for no more than this.[9]

The Justice of the Curses

Turning from the enemy's family back to the traitor himself, David demonstrates how just it is that this man should suffer. The enemy "never thought of doing a kindness, but hounded to death the poor and the needy and the brokenhearted" (Ps. 109:16), so it is fitting that he should find no mercy in his judge but be condemned to death (verses 7-8). "He loved to pronounce a curse— may it come on him; he found no pleasure in blessing—may it be far from him" (verse 17); let him, in other words, reap what he sowed. Reaching a climax, David describes how totally given over to sin the man was: "He wore cursing as his garment; it entered

into his body like water, into his bones like oil" (verse 18)—it was the warp and woof of the man's soul.

What does such a man deserve? The Apostle Paul tells us that people who devote themselves to sin eventually are hardened in it, God giving them over to the sinful desires of their hearts (Ro. 1:24,26,28). The sin they love entwines them so tightly in its web that they cannot get free. Just so did David pray: "May it be like a cloak with which he covers himself, like a belt with which he constantly girds himself" (Ps. 109:19, NASB).[10] The stress in David's prayer is that the man brings all these things on himself as just retribution from God: "May this be the LORD's payment to my accusers, to those who speak evil of me" (verse 20).

David's Prayer for Himself

Now David stops his cursing and prays for himself. But notice how he prays. He is not presumptuous. He does not tell God what He must do for him, he makes no demands. He simply places himself in God's hands and asks God to do with him whatever will glorify His name. This simplicity comes across well in the KJV: "But do thou for me, O GOD the Lord. . . ."[11]

In this verse, too, we find the motive behind the whole psalm: "Deal . . . with me _for your name's sake._" It is the honor and glory of God's name that concerns David more than anything. That— not personal vengeance—is the motive for David's cursing prayer against his enemies. That men should deal treacherously with anyone is a gross injustice that dishonors God; but that they should deal so with God's anointed king, whom God personally set over His chosen people, is a greater affront. So both in praying for his enemies' punishment and in praying for his own deliverance (which he roots not in anything good in himself but solely in the goodness of God's love—verse 21), David prays for God to be honored.

Through all his enemies' attacks, how does David himself feel? Poor, needy, wounded at heart, as if his life were wasting

away (verses 22-23). Here is another sign that the imprecations are not rooted in personal vengeance. "This lowliness does not comport with the supposed vengeful spirit of the preceding verses: there must therefore be some interpretation of them which would make them suitable in the lips of a lowly-minded man of God."[12] His grief is so severe that he cannot eat—or will not, for the sake of focusing all his energies on prayer—and so his body is so "thin and gaunt" that his accusers scorn him as if he, not they, had transgressed the Covenant (verses 24-25; see also Dt. 28:37). He has no strength in himself; he cannot rise in his own defense. So he calls out to God for help: ". . . save me in accordance with your love" (Ps. 109:26).

More than this: Even if David *could* save himself, he would not, for he wants his enemies to know that they stand not merely against him, but against God. To know this, they must see that their destruction comes not from him but from God. "Let them know that it is your hand, that you, O LORD, have done it" (verse 27). Despite the initial appearance that David is most concerned about himself—for he prays curses against people who have hurt him—his ultimate concern is for God's glory.

To their curses he opposes God's blessing, confident that God will put them to shame when they rise against him. Therefore, he expects to rejoice in God's saving acts (verse 28).

A Contrast of Destinies

Finally, assured that God has heard and will answer his prayer, David confidently looks ahead at two starkly contrasted destinies. His enemies will clothe themselves with disgrace and shame when they appear before the Judge (verse 29), but he will "extol the LORD," praising Him amid a throng of God's people (verse 30). What a contrast with the destiny of his enemy! David finds the Lord at his right hand pleading on his behalf, while his enemy finds an accusor, or "satan," there conniving his destruction (see also 1 Jn. 2:1).

Ought Christians to Use Imprecatory Prayers?

Are Christians even permitted—let alone required—to pray this way? Who has the right to pray curses on someone else? Who is a proper object of cursing? And what are proper occasions for imprecatory prayer?

It is tempting to write off the whole idea of imprecatory prayer as something God permitted only in Old Testament times, when He hadn't yet revealed the extent of the love and grace He wanted people to exercise toward each other. But this idea fails for two reasons. First, the Old Testament has the same high standard of love and forgiveness that the New Testament has: "Do not seek revenge or bear a grudge against one of your people, but love your neighbor as yourself" (Lev. 19:18); "If you come across your enemy's ox or donkey wandering off, be sure to take it back to him. If you see the donkey of someone who hates you fallen down under its load, do not leave it there; be sure you help him with it" (Ex. 23:4-5; see also Prov. 25:21-22).

Second, the New Testament itself countenances imprecation. We can see this partly by observing the New Testament's use of the Psalms. The New Testament quotes or alludes to the Psalms about 125 times, slightly less than once each. But it cites the seven most strongly imprecatory psalms (58, 68, 69, 79, 109, 137, 139) thirteen times—almost twice each.[13] More to the point, though, Jesus both used and taught "cursing prayers," and so did Paul.

Jesus and Cursing Prayer

In Luke's report of Jesus' Sermon on the Plain, Jesus' beatitudes ("Blessed are you who are poor . . ." [Lk. 6:20-22]) lead immediately to His curses ("But woe to you [literally, "Cursed are you"] who are rich . . ." [verses 24-26]), and this pronouncement of curses closely reflects the solemn ceremony of cursing on covenant-breakers that was part of the re-ratification of the Covenant just before Israel crossed the Jordan (Dt. 27:12-26). In

Lk. 11:39-52, Jesus pronounced six woes, or curses, on the Phari-
sees and lawyers of His day. And He warned that in the final
judgment He would say to the unjust and unmerciful, "Depart
from me, you who are *cursed*, into the eternal fire prepared for the
devil and his angels" (Mt. 25:41)—expressing His *intention* to
judge and condemn those who ultimately refuse Him. More
pointed, though, are three other instances in Jesus' teaching: the
Lord's Prayer, His commission to His missionaries, and the inci-
dent at the fig tree.

The Lord's Prayer. Jesus taught His disciples to pray, "Our
Father in heaven, hallowed be your name, *your kingdom come,
your will be done on earth as it is in heaven*" (Mt. 6:9-10, emphasis
added). Only failure to consider the implications of this prevents
our seeing that it implies an imprecation on all who persist in
rebellion against God.

> When we pray "Thy kingdom come," we pray for the over-
> throw of evil. We know that the answer to that prayer will
> be partly by grace and partly by judgment. It is not for us to
> choose which it shall be. We shall rejoice with the angels
> over the sinner that repents. And when God himself makes
> plain that they will not yield to his love and that the day for
> anguished intercession is over, we shall rejoice with all the
> servants of God at the destruction of those who sought to
> destroy God's fair earth.[14]

Martin Luther even goes so far as to say that we cannot rightly
pray this prayer without cursing all who profane God's name and
oppose God's will and Kingdom.[15]

Christ's Commission to the Missionaries

When Jesus Christ sent seventy-two disciples on a preaching
mission, He told them to proclaim the coming of God's Kingdom
(Lk. 10:9)—that is, to announce that people must submit to God's

rule in their lives. Jesus instructed them to pray for peace on any house they approached, assuring them that those who welcomed the message would have peace, but that if anyone rejected it, the peace would return on the disciples (verse 5). But we must consider what He said they should do if their message were rejected—that is, if the hearers persisted in rebellion against God's rule—"But when you enter a town and are not welcomed, go into its streets and say, 'Even the dust of your town that sticks to our feet we wipe off against you. Yet be sure of this: The kingdom of God is near'" (verses 10-11).

What would be the result of that denunciation? "I tell you, it will be more bearable on that day for Sodom [on which God sent fire from Heaven in judgment for its wickedness] than for that town" (verse 12). Immediately Jesus added curses on Korazin, Bethsaida, and Capernaum for their rejection of His message (verses 13-15). He then explained to the disciples the great authority He had given them: "He who listens to you listens to me; he who rejects you rejects me; but he who rejects me rejects him who sent me" (verse 16). This is the fundamental basis for calling down God's curses on anyone: his persistent rebellion against God's authority expressed in His Law and the ministry of His servants.

The Incident at the Fig Tree

In his narrative of events leading up to the Crucifixion, Matthew focuses on God's rejection of the Jewish nation because of its rejection of King Jesus. Immediately after describing Jesus' triumphal entry into Jerusalem (Mt. 21:1-9), he tells of Jesus' exertion of authority over the Temple (verses 12-17). Next comes a passage that puzzles many readers: Jesus comes across a barren fig tree and curses it, saying, "May you never bear fruit again!" (verse 19), after which the tree immediately withers. The fig tree was a common symbol for the nation of Israel, and in a parable (Lk. 13:6-9) Jesus had taught that God would one day destroy Israel because of its spiritual barrenness. His cursing of the fig tree,

then, is a vivid picture of Israel's future.

But then, in answer to His disciples' question, "How did the fig tree wither so quickly?" (Mt. 21:20), He says, "I tell you the truth, if you have faith and do not doubt, not only can you do what was done to the fig tree, but also you can say to this mountain, 'Go, throw yourself into the sea,' and it will be done. If you believe, you will receive whatever you ask for in prayer" (Mt. 21:21-22). To understand this, we must remember that Jesus and the disciples are on the road to Jerusalem from Bethany. The whole mountainous complex of Jerusalem, including the Temple, stands in plain sight. It represents the earthly throne of the Kingdom of God. To say to *this* mountain (not just any mountain), "Go, throw yourself into the sea," is paramount to pronouncing a curse on Israel, praying for God to remove it from its place of honor.[16] And that happened when, some forty years later, Jerusalem was conquered and destroyed by the Romans, and the Jews were sent into a dispersion from which they have never been fully regathered.

Matthew continues this focus on Israel's rejection by telling of a challenge to Jesus' authority (21:23-27), then relating Jesus' parables of the two sons (Mt. 21:28-32) and the tenants (Mt. 21:33-44), climaxing in this withering denunciation: "Have you never read in the Scriptures: 'The stone the builders rejected has become the capstone; the Lord has done this, and it is marvelous in our eyes'? Therefore I tell you that the kingdom of God will be taken away from you and given to a people who will produce its fruit" (verses 42-43). Then follows the parable of the wedding banquet (Mt. 22:1-14), which sustains the same theme.

Jesus, then, taught His disciples that imprecatory prayers— calling on God to curse His enemies—would be effective when used properly in faith.

Paul and Cursing Prayer

The Apostle Paul, too, uses imprecations on enemies of the Lord. In Gal. 1:8-9, heretics are his targets: "But even if we or an angel

from heaven should preach a gospel other than the one we preached to you, let him be eternally condemned! As we have already said, so now I say again: If anybody is preaching to you a gospel other than what you accepted, let him be eternally condemned!" In 1 Cor. 16:22 he writes, "If anyone does not love the Lord—a curse be on him. Come, O Lord!" Even the phrase "Come, O Lord!" may be part of the curse, if by it Paul means, "Come in judgment." Paul's view of the manner of Christ's return supports this understanding: Jesus will come in judgment, bringing with Him "destruction" on those who cry, "Peace and safety" (1 Thess. 5:4).

Indeed, whenever we pray for the Lord's return, we imply (consciously or not) imprecations on those who resist Him:

> Probably we do not couch our prayer in the following terms: In flaming fire take vengeance on those who know not God and who obey not the gospel; give them their due punishment, even eternal destruction from Thy face. But, according to 2 Thessalonians 1:8 [7-9], these things are inseparable from the coming, and therefore by implication, if not explicitly, we are asking for them.[17]

The Martyrs' Imprecatory Prayer

There are other examples of imprecation in both testaments, some explicit and others implicit.[18] But one of the most stunning occurs in the book of Revelation. There we read of the martyred saints—people undoubtedly transformed into moral perfection in the presence of God—praying under the altar in Heaven, calling out in a loud voice, "How long, Sovereign Lord, holy and true, until you judge the inhabitants of the earth and avenge our blood?" (Rev. 6:10; see also 8:4-5). John's vision then presents much of the wrathful judgment of God on the earth as an answer to their prayer. It climaxes in a great shout of triumph at the destruction of "Babylon": "Hallelujah! Salvation and glory and power belong to

our God, for true and just are his judgments. He has condemned the great prostitute who corrupted the earth by her adulteries. *He has avenged on her the blood of his servants*" (Rev. 19:1-2, emphasis added; see also 18:20,24).

Principles for the Use of Imprecatory Prayer

Imprecatory prayer, then—calling on God to curse His enemies (who consequently are the enemies of His people)—is approved by both testaments. Christians may pray this way. But how ought we to do it? Three questions, and their answers, will help to clarify the matter.

Who May Rightly Pray Curses?

A survey of the various imprecatory passages in Scripture indicates that the use of curses in prayer is reserved especially for God's faithful people—those who are keepers of the Covenant. (And why shouldn't it be? What right would His enemies have to call on Him to curse their enemies?) But certain special classes of people are particularly suited to offer imprecatory prayers: those whom God has placed in authority, whether ecclesiastical or civil, when people rebel against their God-ordained authority (like David, King of Israel); God-anointed preachers whose message is spurned (like the prophet Jeremiah and the missionaries sent out by Jesus); those who suffer persecution (like the martyrs in Heaven); and leaders of the Church who confront unrepentant heresy and apostasy (like the Apostle Paul, see Gal. 1:8-9) or unrepentant sin among church members (Mt. 18:15-18, 1 Cor. 5:1-5).[19]

　　　In every instance, *one calling for God to vindicate Himself (or avenge the offended person who is praying) must be innocent in the matter at hand,* as David was when he prayed against his enemies (Ps. 7:8; 109:4-5,22-25,30-31), or he cannot expect God to honor his prayer. In short, covenant-keepers, especially those

raised to authority by God, may offer imprecatory prayers against covenant-breakers for opposing the rule of God through His Law and His ministers, whether civil (Ro. 13:1-7) or religious.

Whom May We Curse in Prayer?

Those against whom prayers of cursing are appropriate may be defined in reference to those who may rightly pray curses: God-ordained authorities may pray against those who rebel against the proper exercise of their authority (Psalm 140); prophets and preachers of God's Word may pray against those who reject that Word and seek to hinder its spread (2 Tim. 4:14); the persecuted may pray against their oppressors (Psalm 137); and Christ's Church and its leaders may pray against those who corrupt or attack it and resist the dominion of God's Word through it by fostering sin on the earth (Psalm 74).

Yet we should pray curses only when forced to the conclusion—after long struggles in prayer and admonition—that the enemy is hardened beyond repentance. (There are such people, though we do not always properly recognize them; see Ro. 1:24,26,28.) Before praying curses, we should make every possible effort to persuade someone to repent and be reconciled to God and those he injured. David prayed *for* his enemies before he prayed against them (Ps. 109:4). And even when he finally resorted to praying curses against them, he acknowledged the possibility of their repentance (Ps. 7:12) and conditioned the curse on their unrepentance. John Calvin warns against too rash a use of imprecation:

> Only let believers be on their guard, lest they should betray too much haste in their prayers, and let them rather leave room for the grace of God to manifest itself in their behalf; because it may turn out that the man, who to-day bears towards us a deadly enmity, may by to-morrow through that grace become our friend.[20]

Limits on Imprecatory Prayer

Besides the fact that only those who are truly innocent in the case at hand may properly pray curses, and only against those who are hardened beyond redemption, there are three other limits on the use of imprecatory prayer.[21]

First, the curses must be firmly rooted in God's standard of righteousness and judgment, not in our own petty opinions or hurt pride. The fact that someone offends me doesn't necessarily mean that he has offended God. I might be at fault. I might need to repent, not he. Careful study of the curses offered in the Covenantal ratification ceremony on Mount Ebal (Dt. 27:9-26), comparing them with the Ten Commandments, shows that each curse is conditioned on a violation of a fundamental aspect of God's Law. Personal jealousy, envy, covetousness, and personal revenge are wrong motives for imprecatory prayer. We should seek not *our* vindication, but God's (Ps. 109:21). "The ready way to fetch a curse upon thyself," wrote William Gurnall, citing Ps. 109:17-18, "is to imprecate one sinfully upon another."[22]

This leads naturally to a second limit on imprecatory prayer: It must be offered only for God's glory, not our own. A civil ruler or pastor who prays for God to curse someone simply so that he can gloat over his fallen enemy misuses the prayer and will find his request rejected by God. It is God's holy name and Law that are most offended by sin and that deserve vindication by the punishment of unrepentant sinners.

Third, cursing prayer must be offered only in the utmost personal humility and after merciless self-examination, for it amounts to pronouncing God's judgment. We must be sure first that the offense is really in another, not in ourselves (Mt. 7:1-5). Calvin urges all the faithful to "conduct themselves meekly, that their humility and contrition of spirit may come up before God with acceptance. And as we cannot distinguish between the elect and the reprobate, it is our duty to pray for all who trouble us; to desire the salvation of all men; and even to be careful for the

welfare of every individual. At the same time, if our hearts are pure and peaceful, this will not prevent us from freely appealing to God's judgment, that he may cut off the finally impenitent. . . . For as often as we draw near to the tribunal of God, we must take care that the equity of our cause may be so sure and evident as to secure for it and us a favourable reception from him."[23]

Benefits of Imprecatory Prayer

All this said, however, still we are left with this question: *Why* should we pray for God to curse anyone? Why not pray solely for people's repentance and conversion? Aside from the simple fact that it is a biblically sanctioned practice and therefore worthy of our imitation, what are some benefits of imprecatory prayer, when properly used?

First, it can be a way to control our anger so that we are not so likely to try to wreak our own vengeance. There may be times when we are so offended that we do not—whether we should is another question—immediately turn to God in prayer for grace to forgive. But if we do at least turn to God in prayer, we offer Him an opportunity to correct our hearts, if we are wrong, and we avoid the inevitable consequences of lashing out in vengeance ourselves. Perhaps when we come into God's presence in prayer, His Spirit will soothe our hearts and turn our wrath away from those who have hurt us so that we pray for them instead of against them.

The second benefit is closely related to the first: Because we can be sure that God will not answer a prayer of cursing based on wrong motives, we can be sure that imprecatory prayer—unlike personal vengeful action—will not accidentally hurt the innocent. We may well be wrong in our judgment of another, even when we think we have examined the case thoroughly. If we strike out in our own power, we may do irrevocable harm. But if we go to God in prayer, even cursing prayer, He may simply deny our request, and we hurt only ourselves.

Third, imprecatory prayer demonstrates faith in God. When

we attack the wicked directly (whether verbally or physically), we declare our faith in our own ability to establish justice. But when we ask God to punish the guilty instead, we prove to ourselves, to fellow believers, and even to the unbelieving world, that we trust not in might or power but in the Spirit of the Lord. With David we should pray that when the wicked are punished they will "know that it is your hand, that you, O LORD, have done it" (Ps. 109:27).

This is especially important in our prayers for justice for the oppressed and punishment for oppressors. Resorting solely to our own, worldly power to oppose injustice is the way of secular humanism—of atheism—not of Christian faith. If we defeat them by our own might, the wicked might say, "Boy, those Christians are tough customers!" What we want is for them to say, "Surely the righteous still are rewarded; surely there is a God who judges the earth" (Ps. 58:11, the culmination of an imprecatory prayer; see also Ps. 88:17-18).[24] Prayer is, in fact, spiritual warfare. One weapon is prayer for conversion of spiritual enemies; another is prayer for judgment on those who finally refuse to be converted. We handicap the army of God when we refuse to use both of these great weapons that He has given us.

Finally, we should use imprecatory prayer—under the right conditions—because *it works.* God answers believing, rightly motivated prayer when it is according to His will (Mt. 17:20, Jas. 4:3, 1 Jn. 5:14-15). And a cursing prayer was among those that He specifically promised to grant (Mt. 21:21-22; see also God's answers to Jeremiah's imprecatory prayer, Jer. 18:19-19:9, and to the martyrs' prayer, Rev. 6:10, 19:2). In the battle between the saints of God and the servants of darkness, imprecatory prayer is an indispensable weapon.

NOTES:

1. Of the seven psalms most commonly called "imprecatory," or cursing (58, 68, 69, 79, 109, 137, 139), five (all but 79 and 137) are by David. Of thirty-nine psalms held by R.M. Benson to include imprecations, twenty-seven are by David. The thirty-nine are:

5, 7, 9, 10, 16, 17, 28, 35, 36, 40, 41, 44, 49, 52, 54, 55, 57, 58, 59, 62, 63, 64, 68, 69, 70, 71, 74, 75, 79, 83, 87, 92, 94, 108, 109, 137, 139, 140, 143. See R.M. Benson, _War Songs of the Prince of Peace_ (London: 1901), cited in John W. Wenham, _The Goodness of God_ (Downers Grove, Ill.: InterVarsity Press, 1974), page 149.

2. See Ps. 109:6,8, David prays that the same fate will befall his enemy.

3. The Hebrew translated "an evil man to oppose him" in the NIV is literally "an evil man _over_ him," and the idea is of a judge. See NASB and Franz Delitzsch, _Psalms_, 3 volumes in 1, trans. Francis Bolton, in C.F. Keil and Franz Delitzsch, _Commentary on the Old Testament_, 10 volumes (Grand Rapids: Eerdmans, 1976 rpt.), volume 5, part 3, page 178.

4. See Charles Spurgeon, _The Treasury of David_, 3 volumes (McLean, Va.: MacDonald, n.d. rpt.), volume 2, pages 439-440, and Albert Barnes, _Psalms_, 3 volumes, ed. Robert Frew (Grand Rapids: Baker Book House, 1975 rpt.), volume 3, page 131.

5. See 2 Samuel 9, the story of David's provision for Saul's grandson Mephibosheth.

6. It seems likely that while verse 14 of Psalm 109 speaks specifically of the enemy's parents' sins, verse 15 views the enemy's parents, wife, and children all together.

7. See Barnes, _Psalms_, volume 3, page 131, and C.S. Lewis, _Reflections on the Psalms_ (London: Fontana Books, 1962), chapter 3, "The Cursings."

8. Wenham, _The Goodness of God_, pages 158-161.

9. See John Calvin, _Commentary on the Book of Psalms_, 3 volumes, trans. James Anderson (Grand Rapids: Baker Book House [1846] 1984), volume 2, page 281.

10. The NASB here brings forth the reflexive sense of the Hebrew better than does the NIV. The subject of the verb acts on himself.

11. Spurgeon, _The Treasury of David_, volume 2, page 443.

12. Spurgeon, _The Treasury of David_, volume 2, page 443.

13. Wenham, _The Goodness of God_, page 158.

14. Wenham, _The Goodness of God_, page 165.

15. Cited in Spurgeon, _The Treasury of David_, volume 1, page 455.

16. That "mountain" is frequently an image of the Kingdom of God in Scripture, see David Chilton, _Paradise Restored_ (Tyler, Tex.: Reconstruction Press, 1985), pages 29-36. See also Is. 2:2-4, 11:9, 25:6-9, 56:3-8, 65:25; Mic. 4:1-4; Dan. 2:34-35,44-45; Heb. 12:22; 2 Pet. 1:16-18. See also Colin Brown and W.L. Liefeld, "_oros_," in C. Brown, ed., _New International Dictionary of New Testament Theology_, 3 volumes (Grand Rapids: Zondervan, 1978), volume 3, pages 1009-1013.

17. J.A. Motyer, cited in Wenham, _The Goodness of God_, pages 168-169.

18. Some others outside the Psalms are: Dt. 27:11-26,28; Is. 13:9,16 (also Ps. 137:9); Jer. 11:18-23, 20:6, 28:16, 29:30-32, 36:30; Am. 7:16; Na. 1:2-8, 3:1-10; Mt. 10:14-15, 18:15-18; Mk. 6:11; Lk. 6:20-49, 17:1-2, 22:22; 1 Cor. 5:3-5; 2 Cor. 2:5-11; 2 Tim. 4:14; Tit. 3:10; 2 Jn. 10; Rev. 16:5-7, 18:20, 19:1-16. See Wenham, _The Goodness of God_, pages 151-157.

19. That God has appointed all believers priests and kings indicates that all God's people, not only those who hold official positions of authority, may share in the work of imprecatory prayer. See 1 Pet. 2:9; Rev. 1:6, 3:21, 5:10.

20. Calvin, _Commentary on the Book of Psalms_, volume 2, page 276.

21. For a slightly different list of limits on imprecatory prayer, see William Gurnall, *The Christian in Compete Armour; A Treatise of the Saints' War against the Devil* (Carlisle, Pa.: Banner of Truth Trust, 1979 rpt.), volume 2, pages 444-446. Gurnall's limits are: "Take heed thou dost not make thy private particular enemies the object of thy imprecation." "When thou prayest against the enemies of God and his church, direct thy prayers rather against their plots than person." "When praying against the persons of those that are open enemies to God and his church, it is safest to pray indefinitely and in general . . . because we know not who of them are implacable, and who not, and therefore cannot pray absolutely and peremptorily against particular persons." "In praying against the implacable enemies of God and his church, the glory of God should be principally aimed at, and vengeance on them in order to that." Gurnall's is an excellent essay on the use of imprecatory prayer.

22. Gurnall, *The Christian in Compete Armour*, volume 2, page 445. See also Calvin, *Commentary on the Book of Psalms*, volume 2, page 285, on Ps. 109:18, and pages 275-276, on verses 6-11.

23. Calvin, *Commentary on the Book of Psalms*, volume 2, pages 283-284.

24. See Chilton, *Paradise Restored*, page 216.

Prayer for Forgiveness and Blessing
PSALM 85

When Moses prepared to send the Israelites into the Promised Land with Joshua, he sternly warned them that treason against the Covenant would be their downfall (Dt. 29:24-28). But with the warning came God's promise that those who repented under chastisement would again experience His blessing (Deuteronomy 30). Specifically, Moses told the people, ". . . when you and your children return to the LORD your God and obey him with all your heart and with all your soul according to everything I command you today, then the LORD your God will *restore your fortunes* and have compassion on you and gather you again from all the nations where he scattered you" (Dt. 30:2-3).

For roughly seven centuries, Israel learned that lesson over and over. It rebelled against God, suffered calamities, repented, and experienced revival and prosperity. The cycles recurred until, after the nation had divided against itself, first the northern half and then the southern were taken into captivity. Seventy years ensued in which the Jews were strangers in a strange land. There seemed no hope. Yet again some of the Jews turned to God, and He responded by causing Cyrus to permit them to return to

Jerusalem (Ezra 1). It was a time of great rejoicing when the Jews got back to their land. Yet then only a few actually returned, and they found a land shattered by war and grown wild by neglect. Their joys were mixed with sorrows.

Prayer for Completion of God's Work

It may have been then that an unknown writer penned Psalm 85,[1] which begins with a joyous recitation of God's mercies to Israel (verses 1-3), shifts suddenly to a heartfelt petition for renewal of those mercies and enlargement of the benefits resulting from them (verses 4-7), and concludes with confident expectation of God's gracious work among His people (verses 8-13).

Recitation of God's Mercies

The psalmist, considering the great turn of fortune God had brought to the Jews by releasing them from their captivity in Babylon and restoring them to their land, first voices his wonder and gratitude at God's work:

> You showed favor to your land, O LORD;
>> you *restored the fortunes* of Jacob.
> You forgave the iniquity of your people
>> and covered all their sins. *Selah*
> You set aside all your wrath
>> and turned from your fierce anger. (Ps. 85:1-3)

He evidently sees the restoration of Judah as a fulfillment of God's promises, made when the Covenant was reaffirmed before entering the Promised Land. The very word translated "restored the fortunes" (verse 1) is the same that we saw in God's promise of restoration to repentant people (Dt. 30:3). When he writes of God's having turned from His "fierce anger," he uses the same word God predicted foreign nations would use when asking,

incredulously, why Israel was so devastated: "Why has the LORD done this to this land? Why this fierce, burning anger?"[2] God's favor (Ps. 85:1), forgiveness (verse 2), and withdrawal of wrath (verse 3) all demonstrate the compassion God promised to show to His people when they repented (see Dt. 30:3).

The six verbs in these three verses—"showed," "restored," "forgave," "covered," "set aside," "turned"—all are in the perfect tense. They show that the psalmist views God's actions as finished and irrevocable. The favor God has shown He will not suddenly take away; the fortunes restored will not be withdrawn. His anger will not suddenly burn again over sins once forgiven.

The psalmist gives all the credit to God. Every action in the three verses is His. Israel can take no credit for its restoration, for its forgiveness, for the cessation of God's wrath toward it. All comes from Him. Indeed, even the repentance that preceded God's forgiveness and blessing was wrought by God, not by men (Ps. 85:4,6). Only the renewal of His anger could be their doing, should they renew their sin (verse 8). But in praising God's grace, the psalmist does not ignore human sin. Israel's tribulation in Babylon was punishment for sin (verse 2) that was forgiven only when the people repented.

God's grace, then, exhibited in His compassionate acts on behalf of His people, is the basis of the psalmist's prayer. He gains encouragement for the present and the future by looking at the past, which for him records God's gracious deeds.

Petition for Enlarged Mercies

The psalmist needs all the encouragement he can get from the past. For the present, despite the recent turn of events, looks hopeless. "A part of the nation had returned indeed, but to a ruined city, a fallen Temple, and a mourning land, where they were surrounded by jealous and powerful enemies. Discouragement had laid hold on the feeble company; enthusiasm had ebbed away; the harsh realities of their enterprise had stripped off its imaginative charm;

and the mass of the returned settlers had lost heart as well as devout faith."[3]

The psalmist is candid enough to admit that if God has brought about the nation's partial restoration, God must be responsible too for its continued troubles. So he prays:

> Restore us again, O God our Savior,
> > and put away your displeasure toward us.
> Will you be angry with us forever?
> > Will you prolong your anger through all generations?
> Will you not revive us again,
> > that your people may rejoice in you?
> Show us your unfailing love, O LORD,
> > and grant us your salvation. (Ps. 85:4-7)

It is as if he said, "Yes, Lord, I see all that You have given us. But why do some remain in Babylon? Why do we have rubble where we need a temple, and charred ruins where we need villages? Why are our fields overrun by briars? It must be because You remain indignant with some of Your people. So restore us again, O God!"

The psalmist seems to see things in terms of the cycles of rebellion, punishment, repentance, and restoration described in Deuteronomy. But this cycle, this turning, isn't yet complete. Though some of God's people have reached the last stage, others are still in the second, and the psalmist longs for them to be reunited with their brothers. Perhaps this is why he is so enamored by the word *turn,* which he uses five times in these thirteen verses: God "turned the captivity" of Jacob (verse 1, Hebrew); He "turned from" His fierce anger (verse 3). So will He not "turn us again" (verse 4, Hebrew), turn Himself (verse 6, Hebrew) and revive His people again? Yes, He will, but they must not "turn again to folly" (verse 8).

This continued suffering is no light matter. The psalmist

describes it in powerful terms. It evidences God's indignation, or "burning anger"—that same special word again, used only for God's anger[4] (verse 4)—that seems likely to go on and on forever (verse 5).

As the trouble is God's doing, so only God's gracious turning can end it. The only hope is that God will turn yet again from His anger (verse 6, compared with verses 4-5) and breathe new life into His people. Only His unfailing love (verse 7) can withstand the heat of His anger. So for that the psalmist prays.

The past provides the basis for hope that the prayer is not in vain. The restoration he prays for in verse 4 would be nothing but the extension of the restoration he looked back on in verse 1. So also, when he prays for God to bring an end to His anger (verses 4-5), he asks the Lord to complete what He has begun (verse 3). And what is the plea for salvation (verse 7) if not a reflection of the confidence that God has already forgiven those He has already restored (verse 2)? His prayer for God to show the people His "unfailing love" (verse 7) is rooted, too, in God's self-revelation at Mount Sinai, where He proclaimed Himself, "The LORD, the LORD, the compassionate and gracious God, slow to anger, abounding in love and faithfulness, maintaining love to thousands, and forgiving wickedness, rebellion and sin" (Ex. 34:6-7).

The Promise of Extended Grace

As suddenly as he turned from joyful reminiscing on God's past mercies to woeful complaints about the present, the psalmist now changes his focus again. He looks toward the future, and instead of talking to God, he listens to Him and then declares, in beautiful language, this hopeful message of God:

> I will listen to what God the LORD will say;
> > he promises peace to his people, his saints—
> > but let them not return to folly.
> Surely his salvation is near those who fear him,

> that his glory may dwell in our land.
> Love and faithfulness meet together;
> righteousness and peace kiss each other.
> Faithfulness springs forth from the earth,
> and righteousness looks down from heaven.
> The LORD will indeed give what is good,
> and our land will yield its harvest.
> Righteousness goes before him
> and prepares the way for his steps. (Ps. 85:8-13)

To the psalmist's plea that God would end His anger, he gets the firm assurance that God will speak peace to His people (see Is. 40:1ff)—peace chiefly with Him who had once burned against them, but also among themselves because of their peace with God. Even this promise, though, is accompanied by that ever-present warning: "but let them not return to folly." The cycle can begin again if the people rebel again.

If it seems as if God will prolong His anger "through all generations" (Ps. 85:5), still it is true that His salvation is "*near* those who fear him" (verse 9). As a parent is ready and eager to end a spanking and embrace his child the moment the child shows true repentance, so is God toward His people. Only let them reverence Him, and show that reverence by genuine sorrow for sin and willingness to obey Him in the future, and He is ready to embrace them.

Then begins a lovely allegory in which the psalmist represents various virtues as persons joyfully reunited in the coming fullness of the restoration. Loving-kindness and Truth—or Troth, as MacLaren translates it, using a word that conjures up images of marital fidelity—meet together; Righteousness and Peace, seeing each other perhaps for the first time in years, kiss each other. Troth springs up from earth, and Righteousness smiles down from Heaven.

There are several plausible ways of understanding verses

10-11.[5] One way is to view verses 10-11 as a unit with verse 9, explaining the warning at the end of verse 8. There we were warned that while God speaks peace to His people, still they must not turn again to their folly—that is, to sin. Why not? Because God's salvation is near to those who fear Him (verse 9), not to those who persist in rebellion. God's love and faithfulness, His righteousness and peace, are inseparable (verse 10). Therefore, only when man is faithful is God's righteousness pleased (verse 11). So if we want peace with God, we must pursue righteousness, love, and faithfulness. For without these three, we cannot have peace. In Augustine's words, "Do righteousness, and thou shalt have peace. . . . For if thou love not righteousness, thou shalt not have peace. . . ."[6]

But it seems more reasonable to me to see verses 10-11 as expressing the agreement of God's attributes in the work of gracious salvation for those who repent of sin. God's love and peace, the first and fourth attributes mentioned in verse 10, long for man's pardon and salvation. But His truth and righteousness, or justice, the middle two of the four, demand punishment for sin. How are these demands to be reconciled in the case of sinful man? By the sinner's forsaking sin (verses 4,6,8) and God's carrying away the sin and covering its stain (verses 2,4).

The Jews had a picture of this wonderful atonement in their sacrificial system. The sinner's guilt was placed symbolically on the animal sacrifice, which suffered God's wrath for the sinner, so that God could look on the person as cleansed from sin. But the reality that picture portrayed was the atoning work of Christ on the cross. There our sins were placed on Him and He suffered for us, so that His righteousness might be imputed to us and we might enjoy the rewards of righteousness (see Ro. 5:12-19). There love and truth met together, righteousness and peace kissed each other. And the glorious result is that believers have not only Christ's righteousness imputed to them but also a new practical righteousness worked out in their lives by the power of the Holy

Spirit, so that truth can spring forth in their lives and God's righteousness can smile on them from Heaven (Ps. 85:11; see also Ro. 8:1-4).

However we understand these verses, the promise of God to those who forsake their sin and cry out to Him for mercy and revival is peace, *shalom* (Ps. 85:8). In this context, this word carries special significance. The psalmist writes as a representative of a divided people who need healing. He lives in a war torn and dilapidated land that needs restoration. Some of his people still suffer God's displeasure and need reconciliation with Him. The wonderful promise of *shalom* addresses all these needs. Unlike the common New Testament word for peace, *eirene*, which means primarily quiet, security, safety, and prosperity, *shalom* emphasizes reconciliation of a once broken relationship, healing of a wounded people, restoration of a shattered land. The idea it conveys is of "a bringing of some difficulty to a conclusion, a finishing off of some work, a clearing away, by payment or labour or suffering, of some charge."[7]

To the psalmist's prayer, then, that God will not stop after restoring half the nation to the Promised Land, after covering over the sins of only a portion of His chosen people, after withdrawing His anger from only a select few, comes this marvelous answer: God promises *shalom* to His people (verse 8)—their complete restoration, reconciliation, and forgiveness. Even their land itself will share in the benefits: it—like the people on whom God's grace rains and who therefore bear the fruit of righteousness—will, when the Lord rains "what is good" upon it, render its harvest (verse 12).

All of this will reach its zenith with the coming of Jehovah among His people. "Righteousness goes before him and prepares [literally, "attends to"] the way for his steps" (verse 13). When the people of God turn from sin to righteousness, He will walk among them again in peace, as He once did in the Garden of Eden. And then they will walk with Him, imitating His righteousness.

A Pattern for Prayer

Psalm 85 makes a wonderful pattern for Christian prayer. In it we find things to imitate when we approach the throne of grace.

Praying for Perfection

The most striking thing about the psalm is the psalmist's refusal to be satisfied with a partial restoration of Israel. Just so, the Christian must not be satisfied with a partial work of God's grace in his life. Not justification only, but sanctification also must be the goal of the Christian life.

That is, no Christian should be satisfied merely to be delivered from the penalty of sin; we must press on in prayer until God has delivered us also from sin's power. Our aim should be constantly increasing conformity to Christ (Ro. 8:29, Phil. 3:7-16). Not imperfection, but perfection—wholeness, completeness—of holiness is our proper goal. "I am the LORD your God; consecrate yourselves and be holy, because I am holy" (Lev. 11:44). "Be perfect, therefore, as your heavenly Father is perfect" (Mt. 5:48).

What if we know that we can never, in this life, achieve such perfection (1 Jn. 1:8)? Shall we not pray for it? No, we should pray the harder, knowing the difficulty. If we think perfection in holiness is easily reached (and we can only think so if our knowledge of God's standard, and of our moral corruption, is horribly deficient), we will invest only slight effort toward it. But if we know it is the most difficult thing in the world to reach—no, impossible—yet are persuaded that it is also the most desirable, then we will strive toward it with all the energy God gives us. Let us not rest where we are, but press toward the prize of the high calling of God for us in Christ Jesus.

Praying for the Body of Christ

We don't follow the psalmist's example completely if we pray only for ourselves. Though he was already in the Promised Land

and could have rested in assurance that whatever fate his brothers and sisters in Babylon faced, he was delivered, he prayed that God would restore them, too.

Christians, in the same way, need to pray for the spiritual welfare of the whole Church. When we see other Christians succumbing to sin, we should lift them to the Lord in prayer that He might strengthen them to resist it. When some suffer persecution, we should pray for God to give them strength to endure faithfully, to make them stand firm in the faith, and—if it is God's will—to deliver them from persecution. When we see ministries struggling to grow, we should plead with God to make them fruitful. And the continuing divisions among God's people are a constant occasion for us to pray that God will heal the Body.

Praying for Repentance

The psalmist, when he viewed Israel suffering under God's chastisement, didn't simply ask God to relent. He first asked God to turn Israel, to revive it.

So also, when I suffer God's discipline, I need to pray first that God will change my life, turn me from sin to righteousness. Am I sincere in praying for God's forgiveness if I do not first pray that He will give me a truly repentant heart? I must be willing to turn from sin, as He empowers me to by His grace, before I can honestly ask Him to turn from His anger (see Ps. 85:4).

Praying for Perseverance

Finally, just after the psalmist declares the Lord's marvelous promise of peace to His people, he adds this pointed warning: "but let them not return to folly" (verse 8). He doesn't lull the people into thinking that a momentary, half-hearted repentance will win for them God's permanent favor. Rather, those who want to be counted among God's people, to whom God gives peace, must continue in repentance.

How can I expect to continue to enjoy God's blessing if I do

not intend to continue to walk in His ways? Said Jesus to a man whom He had healed of a crippling disease from which he had suffered thirty-eight years, "See, you are well again. Stop sinning or something worse may happen to you" (Jn. 5:14). At worst, persistence in sin by one who professes faith may mean that he really has no part in Christ (2 Pet. 2:20-22). At best, it means that he will continue to experience the Lord's chastisement, which in any case will never be pleasant (Heb. 12:5-13). With our prayer for God's favor, then, should always go our prayer that He will enable us to resist sin, for "without holiness no one will see the Lord" (Heb. 12:14).

When we, like the psalmist, pray for the completion of God's work in us, when we pray for God to fill our hearts with repentance and to keep us from falling back into sin, we too can be confident that He will speak *shalom* to us, that we will be filled with His love and faithfulness, righteousness and peace (Ps. 85:10). We will gain confidence that He who has begun a good work in us—and in the whole Body of Christ—"will carry it on to completion until the day of Christ Jesus" so that we "may be pure and blameless until the day of Christ, filled with the fruit of righteousness that comes through Jesus Christ—to the glory and praise of God" (Phil. 1:6,10-11).

NOTES:

1. The psalm may not have been post-exilic. But Alexander MacLaren's reasons for assigning it to that time seem more persuasive than any alternatives. No other time would so well explain the sudden shifts in feeling, from joy (Ps. 85:1-3) to grief (verses 4-7) to confident expectation (verses 8-13). See Alexander MacLaren, *The Psalms*, 3 volumes, in W. Robertson Nicoll, ed. *The Expositor's Bible* (New York: Hodder & Stoughton, n.d.), volume 2, page 452.

2. The Hebrew term here translated "fierce," *charon*, is a special one, probably used only of God's anger, never of man's. See Francis Brown, S.R. Driver, and Charles Briggs, edd., *A Hebrew and English Lexicon of the Old Testament* (Oxford: Clarendon Press, [1907] 1978), page 354.

3. MacLaren, *The Psalms*, volume 2, page 452.

4. "Indignation" is surely a better word for this vehement emotion than the NIV's

"displeasure."

5. See, e.g., MacLaren, *The Psalms*, volume 2, page 458, in which he argues that love and righteousness typically are seen as God's attributes, and righteousness and peace as man's, in which case, "The point of the assurance in ver. 10 is that heaven and earth are blended in permanent amity." Or see John Calvin, *Commentary on the Book of Psalms*, 3 volumes, trans. James Anderson (Grand Rapids: Baker Book House [1846] 1984), volume 2, pages 375-376, where he applies the passage to the atoning work of Christ.

6. Augustine, *Expositions on the Book of Psalms*, in Philip Schaff, ed., *A Select Library of the Nicene and Post-Nicene Fathers of the Christian Church*, First Series, volume VIII, trans. A. Cleveland Coxe (Grand Rapids: Eerdmans, 1979), page 408.

7. Robert Baker Girdlestone, *Synonyms of the Old Testament* (Grand Rapids: Eerdmans, [1897] 1976), page 96. Its verb form has been rendered in the KJV "to be ended," "to be finished," "to prosper," "to make amends," "to pay," "to perform," "to recompense," "to repay," "to make restitution," "to restore," "to reward." Its root "may have originally signified *oneness* or *wholeness*, and so *completeness*. Not only does it represent the ideas of peace and perfection, but also of compensation or recompense," page 95.

A Psalm of Praise for God's Mercies

PSALM 103

Shortly after God delivered Israel from Egypt, He gave Moses His Law. While Moses was with the Lord on Mount Sinai, the people worshiped an idol. For their sin God saw to the execution of 3,000 of them (Ex. 32:28), demonstrating His intense wrath against rebellion.

Perhaps because he was puzzled about this seeming paradox in God—that He should deliver His people, only to kill so many of them—Moses later prayed, "You have said, 'I know you by name and you have found favor with me.' If I have found favor in your eyes, teach me *your* ways so *I may know you* and continue to find favor with you" (Ex. 33:12-13, emphasis added). In answer, God arranged to appear before him on Mount Sinai: "Then the LORD came down in the cloud and stood there with him and proclaimed his name, the LORD. And he passed in front of Moses, proclaiming, 'The LORD, the LORD, the compassionate and gracious God, slow to anger, abounding in love and faithfulness, maintaining love to thousands, and forgiving wickedness, rebellion and sin. Yet he does not leave the guilty unpunished; he punishes the children and their children for the sin of the fathers to the third and fourth generation'" (Ex. 34:5-7).

This, then, was how God wanted to be known: as Jehovah, full of compassion and grace, patient and forgiving and loving, yet also just and sure to punish the unrepentant. These two sides of God's nature Paul summed up when he urged Christians to consider "the kindness and sternness of God: sternness to those who fell, but kindness to you, provided that you continue in his kindness" (Ro. 11:22).

King David, in Psalm 103, extols God's kindness, hinging his praises on God's declaration to Moses (Ps. 103:8; see also Ex. 34:5-7). For God's compassion and grace he calls himself and, ultimately, all things to praise the Lord. In the psalm, David's focus progresses, as if in ever-larger circles, from himself (verses 1-5), to Israel and all nations, especially seen as oppressed and delivered by God (verses 6-19), to the angels of Heaven (verses 20-21), and then to the whole creation (verse 22). His vision of the praise that should be rendered to God starts with himself, but rapidly swells until it encompasses all things. And suddenly, at just that moment, his thoughts collapse back in on himself (verse 22), as if either exhausted by the strain of such great imagination or afraid that in his longing for others to praise God he might forget to do it himself. The psalm works like a great symphony—starting quietly, swelling to a dramatic climax, and resolving into quiet again.

Because of its clear declaration of man's sinfulness and God's forgiving grace, Charles Spurgeon called Psalm 103 "one of those all-comprehending Scriptures which is a Bible in itself," adding that "it might alone almost suffice for the hymn-book of the church."[1] "Praise the LORD, O my soul," David begins; "all my inmost being, praise his holy name" (verse 1). As reason for his praise he considers first the benefits he himself has received from God, especially pardon for sin (verses 2-5), then God's benefits to all mankind, focusing on Israel (and again forgiveness is central; verses 6-19), calling attention in the midst of that section to the great differences between God and man and how those highlight

God's grace (verses 8-16). Then he calls on the angels and all creation to join him in praise (verses 20-22), and finally he reins in his thoughts and focuses again on himself: "Praise the LORD, O *my* soul" (verse 22, emphasis added).

Forget Not All His Benefits

Praise the LORD, O my soul;
 all my inmost being, praise his holy name.
Praise the LORD, O my soul,
 and forget not all his benefits.
He forgives all my sins
 and heals all my diseases;
he redeems my life from the pit
 and crowns me with love and compassion.
He satisfies my desires with good things,
 so that my youth is renewed like the eagle's.
(verses 1-5)

As David first calls on himself to praise God, so he first thinks of God's benefits specifically on himself. And it is no accident that the first of these is forgiveness of sin (verse 3). So long as sin remains unforgiven, God and man are enemies (Ro. 5:9-11). The barrier of sin must be removed before the great blessings of God can come upon us—or rather, since some of God's blessings come on the just and the unjust alike (Mt. 5:45)—before we can recognize them and praise Him for them. But once sins are forgiven, the way is clear for God to rain on us many more blessings, including healing (Ps. 103:3), preservation of life (verse 4), and making us loving and compassionate (verse 4)—in short, all godly desires (verse 5; see also Mt. 6:33).

The clause, "[He] heals all my diseases" (Ps. 103:3) is puzzling. Does it mean that God is obliged to heal all the diseases of the faithful? Can we, as some say, "claim our healing"? I don't

think so. Rather than implying that every disease the believer ever has God heals, here and now, there is a different sense here. First, every healing we experience comes from God—God is our ultimate Physician, and no healing, regardless what means He uses to do it, comes apart from His blessing. Second, there *will* come a time when every disease will be healed, even though it will not be in this life. Just as one day our souls will be perfected, our sanctification will be complete, but not in this life, so also one day our bodies will be perfected, but again, not in this life.

Praise God for His Benefits

In response to these benefits David calls on himself to bless, or praise, the Lord. Here David gives us a practical example to follow, a pattern to imitate. First, he talks to himself. Rather than depending on habit or chance to occasion his praising God, he reminds himself consciously of his duty. Second, he is careful to praise the Giver, not the gifts: "Praise the LORD, O my soul," he writes, not "praise forgiveness" or "praise healing." Third, he demands sincerity in his praise. Otherwise it is empty and worthless. Praise must come from his *soul*, his "inmost being," not as a mere outward show like the condemned worship of the formalists (Ps. 50:7-13). Fourth, his praise must be wholehearted: "*all* my inmost being, praise his holy name." He permits no division in his heart, no reservations. Everything must be praise. There is no room for complaint. As God forgives *all* his sins, will ultimately heal *all* his diseases, redeems his *whole* life, and satisfies *all* his desires, so *all* his inmost being must praise Him.

What is it to praise God? Quite simply, it is to speak well of Him, to laud Him, to boast of Him before others. Or, as one person put it, it is ". . . to declare to all about us, as loudly as we can, the goodness and grace of his conduct towards men, and our infinite obligations for all our enjoyments to him"[2] And that is precisely what David does throughout this whole psalm, all of which is dedicated to reciting God's praiseworthy nature and

works. All the benefits God grants to David, to Israel, and to anyone—but especially God's very nature as "compassionate and gracious, slow to anger, abounding in love" (Ps. 103:8)—are grounds for praise.

The Lord Is Compassionate and Gracious

Having thought first of what God has done for him, David now thinks of God's benefits to others:

> The LORD works righteousness
>> and justice for all the oppressed.
> He made known his ways to Moses,
>> his deeds to the people of Israel:
> The LORD is compassionate and gracious,
>> slow to anger, abounding in love.
> He will not always accuse,
>> nor will he harbor his anger forever;
> he does not treat us as our sins deserve
>> or repay us according to our iniquities.
> For as high as the heavens are above the earth,
>> so great is his love for those who fear him;
> as far as the east is from the west,
>> so far has he removed our transgressions from us.
> As a father has compassion on his children,
>> so the LORD has compassion on those who fear him;
> for he knows how we are formed,
>> he remembers that we are dust.
> As for man, his days are like grass,
>> he flourishes like a flower of the field;
> the wind blows over it and it is gone,
>> and its place remembers it no more.
> But from everlasting to everlasting
>> the LORD's love is with those who fear him,

and his righteousness with their children's children—
with those who keep his covenant
 and remember to obey his precepts.
The LORD has established his throne in heaven,
 and his kingdom rules over all.
(Ps. 103:6-19)

Verses 6 and 19 frame the section. They declare, first, that God "works righteousness and justice for all the oppressed" (verse 6), and second, that there is no place where He has no jurisdiction, for from His throne in Heaven He "rules over all" (verse 19). As an example of this "justice for all the oppressed," David immediately thinks of God's delivering Israel from oppression in Egypt (verse 7). But rather than tracing the miraculous works God did during the Exodus (as is done, for instance, in Psalm 106, which, like this psalm, begins and ends with "Praise the LORD"), David drives to the heart of the matter when he traces those works to their Source. For it is not, as we noted before, the deeds that David praises, but the God who does them. Hence after the briefest reference to God's miraculous works he tells what those works spoke about God Himself, which is, summarized, that God is "compassionate and gracious" (Ps. 103:8).

The Greatness of God's Compassion

God shows His compassion in that He feels for people who suffer, knowing their frailty (verses 14-16). Thus He is "slow to anger" (verse 8), and when He does become angry He doesn't nurse His anger forever (verse 9), but sets it aside when sinners learn to fear Him and so to keep His Covenant (verses 11,13,17-18). And He shows His grace in that He does not "always accuse" (verse 9) or "treat us as our sins deserve or repay us according to our iniquities" (verse 10). Rather, in His great love He removes our transgressions from us (verse 12).

David chooses three images to depict the greatness of God's

love, compassion, and grace toward us. His love is as great as the heavens are high above the earth (verse 11)—that is, infinitely great. He removes our sins from us "as far as the east is from the west" (verse 12)—that is, infinitely far. And His compassion on us is like a father's for his children (verse 13)—tender and kind, patient and gentle.

The Greatness of Man's Need

The benefits of God's grace and compassion stem not only from God's nature, but also from man's. But not from anything meritorious in man. Not at all. Rather, it is because God knows man's frame—"we are dust" (verse 14)—that He is compassionate toward us. What brings God's grace to us is nothing noble in us, but solely and purely our need. God's holiness (verse 1) meets man's sinfulness with forgiveness (verse 10). God's eternity (verse 17) meets man's mortality (verses 15-16) with life-giving redemption (verse 4). God's heavenly throne (verse 19) answers man's earthy composition (verse 14) with the promise of youthful strength (verse 5).

God's Love Is for Those Who Fear Him

But—this is essential if we are not to misunderstand totally what this psalm is about—while man can never deserve God's grace, he can reject it. For God's grace and compassion triumph over judgment only in "those who fear him . . . who keep his covenant and remember to obey his precepts" (verses 11,13,17-18). Grace leads to repentance, and where there is no repentance judgment must ensue. "Those who are presuming upon the infinite extent of divine mercy, should here be led to consider that although it is wide as the horizon and high as the stars, yet it is only meant for them that fear the Lord, and as for obstinate rebels, they shall have justice without mercy measured out to them."[3] We cannot lay claim to God's forgiveness if we insist on living in rebellion against Him.

What Is the Fear of God?

Just what is it to "fear God"? Some Christians, aiming to preserve pure the doctrine of God's grace, think of the fear of God solely as reverence or awe—something akin to what we feel on seeing a majestic mountain or a towering redwood tree. And there is that in it. But there is more.

Awe and Fear. Keeping in mind that God consistently reveals His grace and His justice together, or as the Apostle Paul put it, God's "kindness and sternness" (Ro. 11:22), it seems appropriate to think of the fear of God as composed of both reverence and actual fear, or trembling at the prospect of danger. John Calvin, in his *Institutes of the Christian Religion*, captured well the combination of these two attitudes when he explained the fear of God:

> . . . God has in his own right the reverence of a father and of a lord. Therefore, he who would duly worship him will try to show himself both an obedient son to him and a dutiful servant. The Lord, through the prophet, calls 'honor' that obedience which is rendered to him as Father. He calls 'fear' the service that is done to him as Lord. 'A son,' he says, 'honors his father; a servant, his lord. If, then, I am a father, where is my honor? If I am a lord, where is my fear?' [Mal. 1:6]. However he may distinguish them, you see how he fuses together the two terms. Therefore, let the fear of the Lord be for us a reverence compounded of honor and fear. No wonder if the same mind embraces both dispositions! For he who ponders within himself what God the Father is like toward us has cause enough, even if there be no hell, to dread offending him more gravely than any death. But also—such is the wanton desire of our flesh to sin without restraint—in order to check it by every means we must at once seize upon this thought: that the Lord, under whose power we live, abhors all iniquity. And they who, by living

wickedly, provoke his wrath against themselves will not escape his vengeance.[4]

It was believers, not unbelievers, whom Paul urged to set their "minds on things above" and to mortify "whatever belongs to your earthly nature," adding, "Because of these, the wrath of God is coming" (Col. 3:2-6). Shortly he made the fear of God a motive for sincere service (verse 22), adding, "Whatever you do, work at it with all your heart, as working for the Lord, not for men, since you know that you will receive an inheritance from the Lord as a reward. It is the Lord Christ you are serving. Anyone who does wrong will be repaid for his wrong, and there is no favoritism" (verses 23-25).

Fear of Displeasing God. This leads to another element in fearing God. There are times when one says of his best friend, "I'm afraid I really hurt him! I didn't mean to, and I could kick myself for it. But I think what I said really cut deep." There is in this fear no expectation of angry retaliation, no apprehension of punishment. Instead there is the deep, wounding sorrow of recognizing that we have disappointed someone we love. In this fear we almost rather punish ourselves than are punished by another.

One who deeply loves God and knows how great God's love is for him fears God in this way. He not only stands in awe of Him as great and fears punishment for sin, but also sincerely fears offending His holiness. He longs so intensely to please Him that he is loathe to displease Him. Augustine called this ". . . that chaste fear wherewith the Church, the more ardently she loves her Spouse, the more carefully does she take heed of offending Him. . . ."[5]

Fear and Love. But doesn't John write that "perfect love drives out fear, because fear has to do with punishment" (1 Jn. 4:18)? Yes. But note the particular punishment of which John writes. It is that of the "day of judgment" (verse 17), for which believers are perfectly prepared in Christ. That fear of ultimate

rejection by God is driven out by the entrance of God's love into the heart of the believer. But these other fears—reverence of God's greatness, fear of temporal punishment for violation of God's Law, and loving fear of displeasing the Beloved—these are not driven out but intensified by our growing love for God. "For by loving you fear, lest you grievously offend One who is loved and loves. . . . If you love not, fear lest you perish; if you love, fear lest you displease. That fear charity casteth out, with this it runneth within."[6]

The Fear of God and Covenant-Keeping

Thus it is that David, after referring three times to "those who fear him" as those who alone enjoy the benefits of God's grace and compassion (Ps. 103:11,13,17), finally explains the sort of life God-fearers display. They are "those who keep his covenant and remember to obey his precepts" (verse 18). Reverence for His majesty, fear of chastisement, and loathing of displeasing Him— all of these should motivate the faithful to honor the Covenant by complying wholeheartedly—even if never perfectly—with its conditions. Loving God and fearing God are inextricably intertwined, so that in the same context Moses could tell the children of Israel:

> These are the commands, decrees and laws the LORD your God directed me to teach you to observe. . . . Hear, O Israel, and be careful to obey so that it may go well with you. . . .
>
> Hear, O Israel: The LORD our God, the LORD is one. Love the LORD your God with all your heart and with all your soul and with all your strength. These commandments that I give you today are to be upon your hearts. . . .
>
> When the LORD your God brings you into the land . . . be careful that you do not forget the LORD, who brought you out of Egypt, out of the land of slavery.

Fear the LORD your God, serve him only. . . . for the LORD your God, who is among you, is a jealous God and his anger will burn against you, and he will destroy you from the face of the land. (Dt. 6:1-15)

To those who fear God, who keep His Covenant and obey His precepts (Ps. 103:17-18), the Lord's love is "from everlasting to everlasting," and so is His righteousness—here apparently denoting His faithfulness to His own side of the Covenant, His promise to bless those who love, fear, and obey Him (verse 17). What wonderful assurance this is! If we but fear God sincerely, striving to live by the Covenant, He promises that there will be no end to His love and faithfulness toward us! How beautifully did the hymnist Thomas Chisholm express this idea when he wrote these words:

"Great is thy faithfulness," O God my Father,
There is no shadow of turning with Thee;
Thou changest not, Thy compassions they fail not;
As Thou hast been Thou for ever wilt be.

There is a firmness, a sureness, a permanency in believers' relationship with God that can be had in nothing else. Families and friends, nation and government, health and even life may fail us, but God never will. On us His love and righteousness are "from everlasting to everlasting" (Ps. 103:17). The God who established His throne in Heaven and rules over all (verse 19) is the God who forgives our sins, heals our diseases, redeems us from the pit, crowns us with love and compassion, renews our youth like the eagle's, and works righteousness and justice for us when oppressed (verses 3-6). The Lord Jehovah, God of the Covenant, "is compassionate and gracious, slow to anger, abounding in love" (verse 8) toward all who fear Him. How truly, then, does this love cast out fear of final condemnation (1 Jn. 4:17-18) in those who have

received not the spirit of bondage to fear but the "Spirit of sonship" that entitles us to cry, "Abba, Father" (Ro. 8:15)!

A Crescendo of Praise

No wonder, then, that David, having recited God's benefits to himself and to all who fear Him, now finds himself driven on to invite everything to praise Him:

> Praise the LORD, you his angels,
> you mighty ones who do his bidding,
> who obey his word.
> Praise the LORD, all his heavenly hosts,
> you his servants who do his will.
> Praise the LORD, all his works
> everywhere in his dominion. (Ps. 103:20-22)

I cannot but think, with Matthew Henry,[7] that here David senses deeply and even painfully his own inadequacy for the task of rendering to God the praise due to Him. He knows himself to be like all other men—dust, grass, a flower of the field that withers and disappears when struck by a blazing wind. How can such a creature praise God as He ought to be praised? And so David calls on angels, who are so far from being dust and grass and flowers that they are themselves winds and flaming fires (Ps. 104:4). Far greater than the faltering praise of the lips of sinful men is the praise of these majestic creatures—"mighty ones" because they "do his bidding [and] obey his word" (Ps. 103:20), who are better fitted by far to render the uninterrupted praise God deserves.

But even that is not enough. Not enough that men should praise God; not enough that angels should join in that praise! No, the One who rules over all deserves praise from all, and so David reaches the climax of this symphony of praise when he cries out,

"Praise the LORD, *all* his works everywhere in his dominion" (verse 22)!

Then, remembering again his own duty, he almost whispers to himself: "Praise the LORD, O *my* soul" (verse 22).

NOTES:

1. Charles Spurgeon, *The Treasury of David*, 3 volumes (McLean, Va.: MacDonald, n.d. rpt.), volume 2, part 2, page 275.

2. William Dunlop, cited in Spurgeon, *The Treasury of David*, volume 2, part 2, page 285.

3. Spurgeon, *The Treasury of David*, volume 2, part 2, page 280.

4. John Calvin, *Institutes of the Christian Religion*, trans. Ford Lewis Battles, ed. John T. McNeill (Philadelphia: Westminster, 1977), III. ii. 26, pages 572-573.

5. Augustine, *Expositions on the Book of Psalms*, in Philip Schaff, ed., *A Select Library of the Nicene and Post-Nicene Fathers of the Christian Church*, First Series, volume VIII, trans. A. Cleveland Coxe (Grand Rapids: Eerdmans, 1979), page 55, on Ps. 19:9.

6. Augustine, *Of Holy Virginity*, section 39, Philip Schaff, ed., *A Select Library of the Nicene and Post-Nicene Fathers of the Christian Church*, First Series, volume III, page 431.

7. Matthew Henry, *Commentary on the Old and New Testaments*, 3 volumes (New York: Robert Carter and Brothers, n.d.), volume 2, page 268.

Rejoice! God Rules Over History

PSALM 105

The Ark of the Covenant was a key symbol of the presence of God with the people of Israel. Its loss to the Philistines was seen as a great tragedy in which God's glory departed from the nation (1 Sam. 4:21-22). Israel's failure, upon regaining possession of the Ark, to restore it to a central place of worship may have stemmed from the nation's spiritual lethargy during a period of some twenty years (1 Sam. 7:1-2). During a revival under King David, the nation recognized the importance of restoring the Ark to the Tabernacle and, after one abortive attempt in which God's anger lashed out at the people because they had ignored His instructions for carrying the Ark (1 Chronicles 13; 15:13), they finally brought it to Jerusalem, where they held a joyous celebration (1 Chronicles 15; 16:1-6).

Celebration of God's Covenantal Faithfulness

For the celebration David wrote a song urging the people to thank and praise God for upholding the Covenant by giving them Canaan as an inheritance (1 Chron. 16:8-36). Generations later, apparently, while the people of God were held captive in Babylon

209

and in danger of abandoning their faith, another psalmist incorporated the first half of David's song into a new psalm designed to remind Israel of God's faithfulness to His Covenant and to reinvigorate their faith (Ps. 105:1-15). In the face of what seemed the beginning of the end of Israel, the psalmist boldly proclaims God's sovereign rule over all history as an absolute assurance that the Covenant will be upheld and the people will one day be restored to their land.

Verses 1-6 of Psalm 105 exhort the people again and again to thank God, to praise Him, to glory and rejoice in Him as they "remember the wonders he has done, his miracles, and the judgments he pronounced" (verse 5). Verses 7-44 recite prominent examples of God's wonders, miracles, and judgments on behalf of His chosen people—demonstrating that no difficulty has ever foiled His plans. The last verse tells the great purpose God had in His whole redemptive work and then insists again that the people praise Him.

Give Thanks to the Lord
The psalmist first urges the people of Israel to thank and praise God, to seek Him, and to remember His deeds on their behalf:

> Give thanks to the LORD, call on his name;
>> make known among the nations what he has done.
> Sing to him, sing praise to him;
>> tell of all his wonderful acts.
> Glory in his holy name;
>> let the hearts of those who seek the LORD rejoice.
> Look to the LORD and his strength;
>> seek his face always.
> Remember the wonders he has done,
>> his miracles, and the judgments he pronounced,
> O descendants of Abraham his servant,
>> O sons of Jacob, his chosen ones. (verses 1-6)

The exiled Jews in Babylon must have been tempted as strongly as the Jews during the Exodus to bemoan their condition. They were slaves, strangers without their own homes. In such a situation, giving thanks to God might have been the farthest thing from their minds. But that is precisely what the psalmist calls them to do. And he intends, by reminding them of the long history of God's redeeming acts for Israel, to show them why that makes sense.

Tell of All His Wonderful Acts

The psalmist doesn't ignore their plight. He urges them to call on God's name while they give thanks, implying that thanksgiving may be combined with earnest petition for new benefits (see also Phil. 4:6). Yet they are not to dwell on their requests, but to proclaim to others that God has been answering His people's prayers for centuries. Thus they should testify to unbelievers around them of God's wonderful acts, so that more people can know Him and join in their song of praise.

Glorifying God by telling what He has done can be a great cure for the depression that comes from thinking ourselves abandoned by Him. Though sickness or financial distress or grief may make us feel cast aside, we as believers can look back on our lives and say, "Yes, God was here, and God was there. God was everywhere. He led me to repentance and saving faith. He lifted me out of the grasp of sin. He has provided for me a thousand times before. Surely He is here with me now. Surely He will provide again!" Many times I have gone to church depressed and worried, only to be renewed in joy because someone said something that reminded me of a blessing of God, and after I told others about it the Lord reminded me of more and more of His blessings.

Remember the Wonders He Has Done

To the weakness the exiled Jews felt, the psalmist responds by urging them to seek Jehovah and His strength, to make that

seeking a continual, unending activity (Ps. 105:4). And how might they be strengthened? By remembering "the wonders he has done, his miracles, and the judgments he pronounced" (verse 5). We gain strength by remembering that the Lord is strong, and we see His strength demonstrated in the history of redemption.

I well remember when someone taught me a special way to express thanks to God for salvation. He suggested that I begin clear back at the Fall and recite what God had done from then until my conversion, seeing all of it as tied into God's great gift to me. What a mother lode of golden ore that revealed for which I could thank God! God promised Eve that her Seed would one day crush the serpent's head. He raised up righteous Noah to preserve the human race and promised him that He would never again destroy the world with a flood. He called Abraham and established His Covenant with him and with Isaac and Jacob, confirming it to their descendants on Mount Sinai and Mounts Ebal and Gerizim. He preserved Israel through the famine by sending Joseph to Egypt, and then multiplied His people there. And when Egypt turned against them, He delivered them from bondage, purifying them during their wanderings in the desert and bringing them safely into the Promised Land. God gave barren Hannah a son named Samuel and used him to call Israel to faithfulness under the Covenant. He raised up King David and, through his line, sent the Messiah. To Him God called the disciples, who spread the good news. He knocked Saul from his horse, forcing him to his knees in repentance and then using him to spread the gospel farther than ever before. He gave early Christians strength to remain faithful in the face of the most hideous forms of death, and preserved the Church through the persecutions of Nero and Diocletian and Aurelius and through the doctrinal schisms of the third and fourth centuries. God gave Athanasius, Augustine, Gregory, and Jerome spiritual wisdom to defend the gospel against innumerable attacks. He tormented the conscience of a lonely monk in a cell until at last he realized that his sole hope was in God's grace, and then gave

that monk the courage to post ninety-five theses on the door of the chapel. He added to lonely Luther a whole chorus of reformers—Calvin, Bucer, Melanchthon, Zwingli, Knox, and later Wesley. He moved Charlotte Elliott, in 1836, to write the song, "Just as I Am," and anointed Billy Graham to preach the gospel. God moved my father to insist, when I was in seventh grade, that our family attend a Billy Graham Crusade, and there He spoke to me through Graham's preaching and through "Just as I Am" so that at last I saw my sinfulness and God's grace and turned my life over to Him. And all this is just the beginning of God's dealings with me! (This can be a wonderful reason for Christians to study Church history. The more we learn about it the more we know for which we can thank God.)

To this kind of reminiscing the psalmist calls Israel. (In Ps. 105:9-44 he demonstrates it.) When God's chosen people take time to remember what He has done for us, we are strengthened and can rejoice in Him.

Why should we take heart from what God did for earlier generations? The people of Israel could do it because they were members of the same Covenant, descendants of Abraham, sons of Jacob, "his chosen ones" (verse 6). And Christians today can do it because we, too, are children of Abraham—who is the father of all those who believe—and therefore we are members of that Covenant also (Ro. 4:16-17). What God has done before He will do again.

God's Wonderful Acts of Redemption

Now the psalmist demonstrates, by a brief history of the founding of Israel (Ps. 105:7-44), what he means when he calls believers to remember God's wonderful acts. First he asserts in general terms God's sovereignty—His absolute rule over all things—and His faithfulness to the Covenant (verses 7-11). Then he demonstrates both God's sovereignty and God's faithfulness to the Covenant by tracing His acts in Israel's history (verses 12-44). At last he

reminds us of God's purpose in redemption and man's proper response of praise (verse 45).

God's Sovereignty and Faithfulness

He is the LORD our God;
 his judgments are in all the earth.
He remembers his covenant forever,
 the word he commanded, for a thousand generations,
the covenant he made with Abraham,
 the oath he swore to Isaac.
He confirmed it to Jacob as a decree,
 to Israel as an everlasting covenant:
"To you I will give the land of Canaan
 as the portion you will inherit." (verses 7-11)

The psalmist presents side-by-side two striking themes: God's universal sovereignty and His special choice of Israel. He rules over "all the earth" (verse 7)—everyone must face His judgment—but He is "the LORD *our* God" (verse 7) and made His Covenant with Abraham, Isaac, and Jacob as representatives of all Israel (verses 8-10), promising them a special land as their inheritance (verse 11). That Covenant He will remember "for a thousand generations" (verse 8). God's promises, as John Calvin says, "do not become obsolete by length of time. . . ."[1]

This immediate juxtaposition of God's universal sovereignty and His particular election of Israel brings to light the basis of the Covenant in God's grace. There was nothing meritorious in Abraham, Isaac, Jacob, or any of the people of Israel that made them especially attractive to God. He chose them freely by His grace. In the same way, He calls men to faith in Christ freely by His grace, not on the basis of their having fulfilled any special conditions beforehand (Eph. 1:3-12, 1 Pet. 1:1-2).

The psalmist's emphasis on God's faithfulness to the Cove-

nant (Ps. 105:8) also reveals the basis of Israel's hope for restoration and, likewise, the Christian's hope for ultimate perseverance in faith. Why did God preserve the descendants of Abraham through all the trials they encountered? Not because they were good, but because He "had entered into covenant with them in their father Abraham, and to this covenant he remained faithful."[2] So also the Christian's confidence in the ultimate outcome of his faith rests not on himself but on God's faithfulness to His promise. We are "confident of this, that he who began a good work in [us] will carry it on to completion until the day of Christ Jesus" (Phil. 1:6).

Here, too, the psalmist provides additional motivation for believers to remember "the wonders he has done" (Ps. 105:5). "If the Lord has his promise in memory, surely we ought not to forget the wonderful manner in which he keeps it. To us it should be matter for deepest joy that never in any instance has the Lord been unmindful of his covenant engagements, nor will he be so, world without end. O that we were as mindful of them as he is."[3]

The psalmist intends, by insisting so strongly on God's faithfulness to His Covenant, to incite his people to praise and thanksgiving (verses 1-3). How much more ought Christians to be motivated to praise and thank God when we think of how He provided for us in Christ Jesus and sealed us by the Holy Spirit! "For no matter how many promises God has made, they are 'Yes' in Christ. And so through him the 'Amen' is spoken by us to the glory of God. Now it is God who makes both us and you stand firm in Christ. He anointed us, set his seal of ownership on us, and put his Spirit in our hearts as a deposit, guaranteeing what is to come" (2 Cor. 1:20-22). To the fulfilled promises of God in Christ believers should shout "Amen!" in heartfelt praise.

God's Faithful Sovereignty Revealed in History

The psalmist provides particular examples of God's sovereign, redemptive acts for Israel to show the greatness of His grace, wisdom, and power. He reviews the Lord's protection of the

Patriarchs (Ps. 105:12-15), His raising up Joseph to care for Israel during famine (verses 16-22), His causing Israel to prosper in Egypt and turning Egypt to hate Israel (verses 23-25), His judgment of Egypt (verses 26-36), and His delivering Israel from Egypt and bringing it into the Promised Land (verses 37-44). In all of these, he gives Israel a picture of what God can do for the nation that suffers in exile.

God's Protection of the Patriarchs. First the psalmist reminds Israel of how God protected their forefathers, Abraham, Isaac, and Jacob, during their wanderings. They, like Israel in Babylon, were strangers in a strange land, at the mercy of their hosts. And look what God did for them:

> When they were but few in number,
> few indeed, and strangers in it,
> they wandered from nation to nation,
> from one kingdom to another.
> He allowed no one to oppress them;
> for their sake he rebuked kings:
> "Do not touch my anointed ones;
> do my prophets no harm." (verses 12-15)

In caring for the Patriarchs, God demonstrated, long before He brought Israel into the Promised Land, that His promise was sacred, that He would fulfill it. "If this was true then," the psalmist seems to say to the discouraged people of his day, "is it not true for us?" So also for Christians today.

For instance, those who have lost husband or wife or child need not "grieve like the rest of men, who have no hope. We believe that Jesus died and rose again and so we believe that God will bring with Jesus those who have fallen asleep in him. . . . For the Lord himself will come down from heaven, with a loud command, with the voice of the archangel and with the trumpet call of God, and the dead in Christ will rise first. After that, we

who are still alive and are left will be caught up with them in the clouds to meet the Lord in the air. And so we will be with the Lord forever. Therefore encourage each other with these words" (1 Thess. 4:13-18). If God kept His promise to the Patriarchs, will He not keep this promise to us?

More to the point, God protected the Patriarchs from harm. And He promises to protect Christians: "I tell you, my friends, do not be afraid of those who kill the body and after that can do no more. But I will show you whom you should fear: Fear him who, after the killing of the body, has power to throw you into hell. Yes, I tell you, fear him. Are not five sparrows sold for two pennies? Yet not one of them is forgotten by God. Indeed, the very hairs of your head are all numbered. Don't be afraid; you are worth more than many sparrows" (Lk. 12:4-7). Is this not reason to give thanks to God, to praise and glorify Him, as the psalmist instructs us to do?

God's Protection of Joseph. But God's promise of protection does not mean that we will never suffer. For while God never forgets any of His sparrows, still some of them—according to His plan—"fall to the ground" (Mt. 10:29). Suffering is part of God's plan for exalting His people. The psalmist demonstrates this through the life of Joseph, who was sold into slavery by his envious brothers, cast into prison on a false charge, and languished there for years until at last the word of the Lord released him. Then he was exalted:

> He called down famine on the land
> and destroyed all their supplies of food;
> and he sent a man before them—
> Joseph, sold as a slave.
> They bruised his feet with shackles,
> his neck was put in irons,
> till what he foretold came to pass,
> till the word of the LORD proved him true.

> The king sent and released him,
> the ruler of peoples set him free.
> He made him master of his household,
> ruler over all he possessed,
> to discipline his princes as he pleased
> and teach his elders wisdom.
> Then Israel entered Egypt;
> Jacob lived as an alien in the land of Ham.
> The LORD made his people very fruitful;
> he made them too numerous for their foes,
> whose hearts he turned to hate his people,
> to conspire against his servants. (Ps. 105:16-25)

In God's service, the way up is down. Servanthood comes before authority, slavery before freedom, death before life. So it was with Joseph. "His way to a position in which he could feed his family lay through the pit, the slaver's caravan, the slave market and the prison, and who shall deny but what it was the right way, the surest way, the wisest way, and perhaps the shortest way. Yet assuredly it seemed not so. . . . God's way is *the* way. Our Lord's path to his mediatorial throne ran by the cross of Calvary; our road to glory runs by the rivers of grief."[4]

Joseph's troubles were sent to him by God to purify and strengthen him. Mustn't Babylon, then, be a mere tool in God's hand to purify and strengthen Israel? And mustn't Christians' troubles today be designed to strengthen us? In everything God works out His own will for our good (Ro. 8:28-30, Eph. 1:11).

This is true not only of Joseph's suffering but also of the famine that then struck his family—the roots of the nation of Israel. God *sent* the famine (Ps. 105:16). It was His means of driving Israel into Egypt, where it would prosper and be made strong before being given possession of the Promised Land.

The sufferings of the faithful contribute not only to their own growth but also to the building of the Kingdom of God—as

Joseph's did. This is why the early Church grew so rapidly: it suffered, and suffered bravely. So powerful was the testimony of Christians' suffering that a prominent Roman lawyer named Tertullian was converted when he saw believers face death with praises on their lips. "The blood of Christians is seed," he later wrote.[5]

So it is that God sovereignly controls even the wicked to build His Kingdom. When Egypt became envious and hateful of Israel, it was not by chance, but because God had turned their hearts "to hate his people, to conspire against his servants" (Ps. 105:25). Not that God put the sin there; they were sinful and envious in and of themselves. But He used their envy for good by turning it against His people so that they would not become too content with life outside the Promised Land, but would eventually march triumphantly out of bondage and into freedom.

What a great God this is, and how worthy of His people's praise! He minds over the whole world, even to determining its harvests, but also over individual people like Joseph. Here again the psalmist demonstrates God's universal sovereignty and His faithfulness to His Covenant and the particular people who live under it.

God's Judgment of Egypt. Now the psalmist gives a specific example to demonstrate the general principle he pronounced when he wrote that God's "judgments are in all the earth" (verse 7):

> He sent Moses his servant,
>> and Aaron, whom he had chosen.
> They performed his miraculous signs among them,
>> his wonders in the land of Ham.
> He sent darkness and made the land dark—
>> for had they not rebelled against his words?
> He turned their waters into blood,
>> causing their fish to die.

Their land teemed with frogs,
> which went up into the bedrooms of their rulers.
He spoke, and there came swarms of flies,
> and gnats throughout their country.
He turned their rain into hail,
> with lightning throughout their land;
he struck down their vines and fig trees
> and shattered the trees of their country.
He spoke, and the locusts came,
> grasshoppers without number;
they ate up every green thing in their land,
> ate up the produce of their soil.
Then he struck down all the firstborn in their land,
> the firstfruits of all their manhood. (verses 26-36)

Even proud Egypt could not escape God's judgment. And how fittingly did it come! To a proud people that held shepherds in contempt God sent Moses the shepherd to bring them to their knees. To a people that believed they would profane their temples by entering them with insects on their bodies, He sent flies and gnats and lice so thick they couldn't be avoided. To demonstrate His omnipotence to a people that worshiped a river as a mighty god, Almighty God turned the Nile to stinking blood. Frogs covered the land and not even Pharaoh's bedroom was exempt from their humbling presence! What humiliation God wrought on Egypt!

The people of the psalmist's day could not have failed to understand the message: "If God could humble Egypt then, can He not humble Babylon now?" He could, and He would. One day He would raise up Cyrus of Persia and by him bring Babylon down to humiliating defeat (Is. 44:21-45:7). All this He would do to demonstrate the truth of His promise to Israel: "I have made you, you are my servant; O Israel, I will not forget you" (Is. 44:21).

Christians have the same expectation. We long for the day when what God revealed to the Apostle John will be complete: "The kingdom of the world has become the kingdom of our Lord and of his Christ, and he will reign for ever and ever" (Rev. 11:15).

God's Deliverance of Israel. Now, to inflame the exiles' hope that God would one day restore them to their homes, the psalmist reminds them what He did for their ancestors:

> He brought out Israel, laden with silver and gold,
> > and from among their tribes no one faltered.
> Egypt was glad when they left,
> > because dread of Israel had fallen on them.
> He spread out a cloud as a covering,
> > and a fire to give light at night.
> They asked, and he brought them quail
> > and satisfied them with the bread of heaven.
> He opened the rock, and water gushed out;
> > like a river it flowed in the desert.
> For he remembered his holy promise
> > given to his servant Abraham.
> He brought out his people with rejoicing,
> > his chosen ones with shouts of joy;
> he gave them the lands of the nations,
> > and they fell heir to what others had toiled for. . . .
> (Ps. 105:37-44)

The people who had suffered in slavery departed with cart loads of gold and silver and jewels given to them by a people eager to see them go, regardless of the cost. They left behind a nation still stinging from the plagues of lice and famine and storms in which every family grieved over the death of its firstborn. But among the people of God none was ill, no one even so much as limped (verse 37). Throughout their journey to the Promised Land the faithful enjoyed God's protection, guidance, and provision.

Would God respond to His people in Babylon by delivering them, too? Would Jehovah, who "remembers his covenant forever," do for them what He had done for their ancestors? Yes. The psalmist, trusting in God's fidelity to His Covenant, believed that one day he could write as truly of God's delivering the exiles from Babylon as he could write then of His delivering their ancestors from Egypt: "For he remembered his holy promise given to his servant Abraham. He brought out his people with rejoicing, his chosen ones with shouts of joy; he gave them the lands of the nations, and they fell heir to what others had toiled for" (verses 42-44).

And so it happened. At the end of seventy-years' captivity, the same God who had turned the hearts of the Egyptians to hate Israel—a first step toward delivering the nation—also "moved the heart of Cyrus king of Persia to make a proclamation throughout his realm and to put it in writing:"

> This is what Cyrus king of Persia says:
> "The LORD, the God of heaven, has given me all the kingdoms of the earth and he has appointed me to build a temple for him at Jerusalem in Judah. Anyone of his people among you—may his God be with him, and let him go up to Jerusalem in Judah and build the temple of the LORD, the God of Israel, the God who is in Jerusalem. *And the people of any place where survivors may now be living are to provide him with silver and gold, with goods and livestock, and with freewill offerings for the temple of God in Jerusalem.*" (Ezra 1:2-4, emphasis added)

What a demonstration of God's sovereignty and faithfulness to the Covenant! He brought the nation of Israel out of Egypt laden with silver and gold, and He brought it out of Babylon over 700 years later—laden with silver and gold! And all because He remembered His Covenant. When the psalmist wrote, he didn't

know just how God would deliver His people again; but because he knew God kept His promises, he knew He *would* deliver them. And we can have that same faith today, bolstered by even more evidences than the psalmist had at his disposal!

The Goal of Redemption

Now the psalmist drives home his point. He has already called God's people to thank Him, to praise Him, to "glory in his holy name" (Ps. 105:3), and now he returns to it, having given them ample reason for obeying. He explains the purpose of God in redeeming a people for Himself: ". . . that they might keep his precepts and observe his laws. Praise the LORD" (verse 45).

Those who have been so gloriously delivered owe their Deliverer the glory of obedience. This is the psalmist's argument: "God has been faithful to you, now you be faithful to Him. He has remembered His part of the Covenant, now you remember yours." The Apostle Paul uses this argument to impress on Christians their obligation to lead holy lives of righteousness rather than continuing in sin:

> You have been set free from sin and have become slaves to righteousness. . . . Just as you used to offer the parts of your body in slavery to impurity and to ever-increasing wickedness, so now offer them in slavery to righteousness leading to holiness. When you were slaves to sin, you were free from the control of righteousness. What benefit did you reap at that time from the things you are now ashamed of? Those things result in death! But now that you have been set free from sin and have becomes slaves to God, the benefit you reap leads to holiness, and the result is eternal life. (Ro. 6:18-22)

The goal of the Covenant of redemption, whether of Israel in the Old Testament or of Christians in the New, is that believers—

empowered by the Holy Spirit to do what the unregenerate cannot (Ro. 8:1-4)—should abide by God's Law and give Him glory. No wonder Paul so closely connected God's sovereignty, His work of redemption, believers' holiness, and the glory of God:

> Praise be to the God and Father of our Lord Jesus Christ, who has blessed us in the heavenly realms with every spiritual blessing in Christ. For he chose us in him before the creation of the world to be holy and blameless in his sight. In love he predestined us to be adopted as his sons through Jesus Christ, in accordance with his pleasure and will—to the praise of his glorious grace, which he has freely given us in the One he loves. In him we have redemption through his blood, the forgiveness of sins, in accordance with the riches of God's grace that he lavished on us with all wisdom and understanding. And he made known to us the mystery of his will according to his good pleasure, which he purposed in Christ, to be put into effect when the times will have reached their fulfillment—to bring all things in heaven and on earth together under one head, even Christ.
>
> In him we were also chosen, having been predestined according to the plan of him who works out everything in conformity with the purpose of his will, in order that we, who were the first to hope in Christ, might be for the praise of his glory. And you also were included in Christ when you heard the word of truth, the gospel of your salvation. Having believed, you were marked in him with a seal, the promised Holy Spirit, who is a deposit guaranteeing our inheritance until the redemption of those who are God's possession—to the praise of his glory! (Eph. 1:3-14, exclamation point added)

In the words of Matthew Henry, "We are . . . made, maintained, and redeemed, that we may live in obedience to the will of

God; and the hallelujah with which the psalm concludes, may be taken both as a thankful acknowledgment of God's favours and as a cheerful concurrence with this great intention of them. Has God done so much for us, and yet doth he expect so little from us? 'Praise ye the Lord.'"[6]

Will the message of Psalm 105 enter into our hearts? Will we, trusting confidently in His sovereign faithfulness to His Covenant, give thanks to the Lord and praise Him for His wonderful acts? Will we remember the wonders He has done? And will we respond by living holy lives that bring Him glory?

NOTES:

1. John Calvin, *Commentary on the Book of Psalms*, 3 volumes, trans. James Anderson (Grand Rapids: Baker Book House [1846] 1984), volume 3, part 1, page 177.
2. Charles Spurgeon, *The Treasury of David*, 3 volumes (McLean, Va.: MacDonald, n.d. rpt.), volume 2, part 2, page 338.
3. Spurgeon, *The Treasury of David*, volume 2, part 2, page 338.
4. Spurgeon, *The Treasury of David*, volume 2, part 2, page 341.
5. Tertullian, *Apology*, chapter 50, in Alexander Roberts and James Donaldson, edd., *The Ante-Nicene Fathers*, 12 volumes (Grand Rapids: Eerdmans, 1976), volume 3, page 55. From Tertullian's idea comes the famous statement of Laurens Beyerlinck in his *Magnum Theatrum Vitae Humanorum* (1665), "The blood of martyrs is the seed of Christians."
6. Matthew Henry, *Commentary on the Old and New Testaments*, 3 volumes (New York: Robert Carter & Brothers, n.d.), volume 2, page 274.

A King Under the Covenant
PSALM 101

When Sir George Villiers (1592-1628), First Duke of Buckingham, became prime minister under King James I of England, Lord Francis Bacon advised him about the people he should choose as his courtiers: "In those the choice had need be of honest and faithful servants, as well as of comely outsides who can bow the knee and kiss the hand. King David (Psalm ci. 6, 7) propounded a rule to himself for the choice of his courtiers. He was a wise and a good king; and a wise and a good king shall do well to follow such a good example; and if he find any to be faulty, which perhaps cannot suddenly be discovered, let him take on him this resolution as King David did, '*there shall no deceitful person dwell in my house.*'"[1] Sadly, Villiers ignored Bacon's advice. He not only had untrustworthy servants, but became one himself—so much so that his advice to James I and, later, Charles I "contributed to the unpopularity of their governments and was therefore among the long-term reasons for the English Civil War." Haughty and tactless, imperious and profligate, he betrayed his more respectable friends in the British nobility—Bacon among them. His death by assassination brought to a close a life that was, according to one historian, "a magnificent

failure."[2]

In recommending Psalm 101 to Sir George as a model for administration, Bacon followed a long tradition. Martin Luther called this psalm "David's mirror of a monarch," and Christian princes and kings through the ages have looked to it for instruction. Ernest the Pious (1601-1675), Duke of Saxe-Gotha, is said to have sent an unfaithful civil servant a copy of this psalm as a rebuke. From that arose a saying that whenever someone in his administration did anything wrong he would "certainly soon receive the prince's Psalm to read."[3]

What does David set forth in Psalm 101 as the great principles of godly government? He summarizes them in his introduction:

> I will sing of your love and justice;
> > to you, O LORD, I will sing praise.
> I will be careful to lead a blameless life—
> > when will you come to me? (verses 1-2)

The three great principles that David declares will regulate his conduct as king are these: lovingkindness or mercy (Hebrew: *hesed*), justice or judgment (Hebrew: *mishpat*), and blamelessness, integrity, or innocence (Hebrew: *tamiym*). From his commitment to these principles, David declares, will flow all of his actions as king.

David discusses these principles in reverse order from how he introduces them. In verses 2-4, he tells what he means by blamelessness and how he will achieve it; in verses 5-8, he turns to justice and mercy, focusing in verse 5 on the practical effects of justice and in verses 6-8 on the effects of mercy (though, as we shall see, justice and mercy are so closely intertwined that the two ideas overlap in this psalm). At the close of verse 8, he hints at the grand design of it all by mentioning "the city of the LORD"—it appears that his goal is to make that city shine with righteousness, the wicked being cut off from it and the faithful exalted in it.

A Blameless Life

I will be careful to lead a blameless life—
> when will you come to me?
I will walk in my house
> with blameless heart.
I will set before my eyes
> no vile thing.
The deeds of faithless men I hate;
> they will not cling to me.
Men of perverse heart shall be far from me;
> I will have nothing to do with evil. (verses 2-4)

A godly king must attend to his own character before he can properly attend to his subjects' needs. And, more important, he can only expect a successful reign if God grants him His presence, His approval on his efforts (see verse 2, "when will you come to me?"), and God's presence and approval come only on those who are innocent. Perhaps this is why David first insists on his determination to "be careful to lead a blameless life" (verse 2). Two things stand out here: first, that David will "be careful," second, that he will "lead a blameless life."

What Is Prudence?

David believes that living innocently requires care. Thus he says that he will "be careful," or "behave prudently" (NASB margin). The Hebrew verb is *sacal*, meaning to look at, to give attention to something, to consider or ponder, or to have insight and comprehension.[4] It is as if David said, "I'm not walking into this with my eyes closed. I'll be on my guard against all that could corrupt my rule or reputation."

This was an unusual attitude. Ancient kings were accustomed to living as if accountable to no one. They treated their subjects as playthings and recognized no duties toward them.

Whatever they desired they got—or at least tried to get—regardless of the cost. John Calvin calls David's prudence "a rare virtue for the man who may do as he pleases"[5]

What, precisely, is prudence? It is not identical to wisdom, which is a much broader concept and emphasizes not so much technical skill as moral understanding. Wisdom includes all the virtues, while prudence is their skillful application. It is what moral philosophers once called "expedience," by which they meant not opportunism (which was its degradation) but "wise application of general knowledge [principles] to particular circumstances." And how does one gain prudence? According to the Christian moral philosopher and practical statesman Edmund Burke (1729-1797), "One arrives at principle [the first step toward prudence] through comprehension of nature and history, looked upon as manifestations of divine purpose; one acquires prudence by patient observation and cautious investigation, and it becomes 'the director, the regulator, the standard' of all the virtues. Expedience implements principle, but never supplants principle. For principle is our expression of cognizance of providential purpose."[6]

Prudence, then, is the insightful application of principles to action. It is an understanding honed by careful observation of the world around us, seeing it not as some chance combination of events and persons and things, but as a manifestation of God's purpose. The prudent man understands how best to apply the principles, or virtues, revealed by God, to the situations into which God places him.

Prudence is the opposite of foolishness. It is gained by meditating on God's Law (Ps. 119:99), while the foolish ignore that Law and so act as if there were no God: "They are corrupt, their deeds are vile; there is no one who does good. . . . [They all] have turned aside, they have together become corrupt; there is no one who does good, not even one" (Ps. 14:1,3).

David realizes that real blamelessness, or innocence, depends

on a right understanding not only of the moral principles God reveals in His Law but also of the concrete situations in which those principles must be applied. And so when he writes, "I will be *careful* to lead a blameless life," he acknowledges the difficulty of maintaining innocence and commits himself to the endeavor.

What Is Blamelessness?

The object of David's exquisite care is that he might "lead a blameless life." The Hebrew *tamiym*, here translated "blameless," describes a man who is sound, wholesome, morally unimpaired, or innocent in the eyes of God's Law—a man of integrity.[7] *Tamiym* is more narrowly defined than its root, *tom*, which describes a man's completeness or wholeness,[8] his lack of inner contradictions. A man might conceivably be *tom*—complete or whole—and yet not be *tamiym*, blameless. He might be wholly wicked rather than wholly innocent. David is determined to be *tamiym*.

The KJV translates this passage, "I will behave myself wisely in a *perfect way*," and in some respects this captures the sense of *tamiym* better than the alternatives "blameless" and "innocent." Perfection combines in itself both completeness and innocence. Yet even this stops short of the whole idea, for in addition to completeness and innocence, *tamiym* conveys the idea of sincerity. There would be nothing fake about David as king. He was determined to comply carefully with the whole of God's Law, not only in outward display but also in inward thought. This heightens the contrast between his own intentions and those of the people he shortly says he will have nothing to do with: "faithless men" (Ps. 101:3), men of "perverse heart" (verse 4), anyone who "practices deceit" or "speaks falsely" (verse 7).

The element of sincerity comes forward in David's saying, "I will walk *within my house* in the integrity of my heart" (verse 2, NASB).[9] Holiness begins at home, in the private life, out of public scrutiny. "We must have a perfect heart at home, or we cannot

keep a perfect way abroad."[10] Far from a man's private life being irrelevant to his public service, it is the most relevant thing of all. In private he is himself. There he reveals his real character, and it is that character that will count under the pressures of public service. (Paul similarly insists that only those who govern their own households well are fit for the ministry, 1 Tim. 3:4.)

Hate What Is Evil

How would David go about maintaining such a high standard of moral purity? He tells us that he will do it by avoiding everything evil, everything that would lead him astray. He will focus his attention on nothing vile, worthless, or base (Ps. 101:3); he will hate the "deeds of faithless men" and keep such deeds from clinging to him (verse 3); he will not permit perverse, crooked, distorted, twisted men to remain near him (verse 4); in short, he will "have nothing to do with evil" (verse 4). David knows that the things with which we surround ourselves, or allow ourselves to be surrounded, will infiltrate and shape our hearts, and he is committed to maintaining an environment conducive to his own holiness.

The Apostle Paul instructs Christians to do the same: "Test everything. Hold on to the good. Avoid every kind of evil" (1 Thess. 5:21-22); "Love must be sincere. Hate what is evil; cling to what is good" (Ro. 12:9). We cannot live blamelessly if we constantly entertain stimuli to wickedness. That is why Paul tells us to focus our minds on whatever is true, noble, right, pure, lovely, and admirable—whatever is excellent or praiseworthy (Phil. 4:8). And if we do this, he says, ". . . the God of peace will be with you" (verse 9). David saw the same connection between pure living and enjoying the *shalom* of God's presence (Ps. 101:2).

Blameless living requires constant choice—choice to turn from evil and toward good. "A bird may light upon a man's house, but he may choose whether she shall nestle or breed there, or no: and the devil or his instruments may represent a wicked object to a

man's sight; but he may choose whether he will entertain or embrace it or no. For a man to set wicked things before his eyes is nothing else but to sin of set purpose"[11]

A Just Rule

David first brought up the subject of wickedness and wicked men in connection with the idea of his own intended blamelessness. If he were to be blameless, he must avoid such men. But while merely avoiding them might fulfill his duty as a private person, it would not fulfill his duty as king. In that office he must exercise judgment, the second of the great principles of godly administration to which he commits himself in Ps. 101:1. And what would be just judgment toward such men?

> Whoever slanders his neighbor in secret,
> > him will I put to silence;
> whoever has haughty eyes and a proud heart,
> > him will I not endure. (verse 5)

Upon such men justice demands punishment—sure, swift, and conclusive. The Hebrew translated here "put to silence" is the word _tsamath_ and means literally to exterminate, to consume or destroy, to cut off.[12]

Why such severity? Because evil could be so injurious to the king's subjects. Consider the sorts of wickedness David recounts in verses 3-5: apostasy, perversion, slander, pride, and deception.

Judgment on Apostasy

"The deeds of _faithless_ men" (verse 3) are literally deeds of apostasy, turning away, swerving from righteousness.[13] The Hebrew _suwt_ referred especially to deeds of rebellion or idolatry. Such deeds struck at the root of the Covenant, the constitution of Israel that was the sole guarantee of the nation's welfare. David

has in mind here not slight divergences from perfection but revolution against God and the order He has established in the Covenant. This infidelity is in marked contrast to the fundamental sense of "love" or "mercy" (Hebrew: *hesed*) to which David himself is committed (verse 1). For *hesed* is, at bottom, loyalty—whether of God to men, men to men, or men to God. *Suwt*, then, is its precise opposite.

Judgment on Perversion

"Men of *perverse* heart" (verse 4) are crooked, distorted, false, twisted, or contorted[14] from the straight standard of God's Law and from the straightness, the uprightness, of God Himself. Long before David, Moses had drawn the tragic contrast between God and His rebellious people, relying on precisely these images:

> I will proclaim the name of the LORD. Oh, praise the greatness of our God! He is the Rock, his works are perfect, and all his ways are just. A faithful God who does no wrong, upright and just is he.
>
> They have acted corruptly toward him; to their shame they are no longer his children, but a warped and crooked generation. Is this the way you repay the LORD, O foolish and unwise people? Is he not your Father, your Creator, who made you and formed you? (Dt. 32:3-6)

The Covenant required the people of God to be straight, not bent. Those who insisted on being bent undermined the Covenant and so endangered the whole nation.

Judgment on Slander

What of the one who "slanders his neighbor in secret" (Ps. 101:5)? In our day, when gossip earns millions on newsstands and passes for "sharing" in many church congregations, we find it hard to take the offense so seriously. Why would David think it so wicked

that slanderers should be "exterminated"? As we have seen already in relation to apostasy and perversion, so it is here: David took the Covenant seriously, and slander threatened the peace and unity of the covenant people. It could even endanger their lives by submitting them to judgment for crimes of which they were innocent (Lev. 19:16). For this reason God's Law required stern punishment of slanderers: They must suffer the very punishment their victims—had they been found guilty—would have suffered. "Show no pity: life for life, eye for eye, tooth for tooth, hand for hand, foot for foot" (Dt. 19:21; see also verses 16-20).

Judgment on Pride

Whoever "has *haughty eyes* and a *proud heart*" David also will not endure (Ps. 101:5). Haughtiness and pride are different but related things. The "haughty" (Hebrew: *gabahh*) man lifts himself up high, exalts himself[15] above his God-given station. He steals honors not properly his. Thus he dishonors God and those God has set in authority. The "proud" (Hebrew: *rachab*) heart is wide, broad, spacious[16]—expansive or greedy. Men of proud hearts, says Calvin, "are never satisfied unless they swallow up the whole world."[17] Both the haughty and the proud, then, rebel against the divinely ordained structure of the covenant people.

In verses 7-8, though they are part of his discussion of mercy,[18] David describes two other sorts of men who deserve judgment under a godly king:

No one who practices deceit
 will dwell in my house;
no one who speaks falsely
 will stand in my presence.
Every morning I will put to silence
 all the wicked in the land;
I will cut off every evildoer
 from the city of the LORD. (verses 7-8)

Judgment on Deception

David describes deceptive people in two ways. They "practice deceit" (Hebrew: *remiyah*) and "speak falsehood" (Hebrew: *sheqer*). The latter term denotes simply false information knowingly conveyed. But David has a particularly heinous kind of false dealing in mind. For *remiyah* denotes not simple deception but treachery, treason against one to whom the perpetrator has a debt of loyalty.[19] This scurrilous activity is the exact opposite of the fidelity that was supposed to bind together all of God's people.

Judgment on Wickedness

At last David sums up all sorts of evil, and declares his intention to punish it, when he writes of "the wicked" and "every evildoer" (verse 8). The "wicked" (Hebrew: *rasha*) is one guilty of crime or hostility toward God or His people—one guilty of sin. The "evildoer" (Hebrew: *aven*) is a man of trouble or vanity—what we today would call a "troublemaker"[20] who constantly disrupts society.

Each of the sorts of people on whom David vows judgment eats at the heart of the civil social order. Where they prevail the community must be in constant turmoil (see Prov. 6:12-19). And that turmoil is itself contrary to a broader sense of "judgment" than that to which David commits himself in Ps. 101:1. That judgment is *shaphat* (a root to which *mishpat* is related). It is ". . . the totality of God's government in which he executes judgment. . . . God's judgment is a making right in such a way that the aggressor is punished and the victim is compensated. It is God's activity of restoring the fallen created order by punishment on the one hand, and deliverance on the other."[21]

The duty of civil government is to maintain *shalom*, the peaceful order in which people can prosper in freedom and mutual respect. That cannot happen unless those who disturb that order by injuring their neighbors are punished, and the injured neighbors restored. When David, then, commits himself to

"judgment" (verse 1), he commits himself to maintaining this order among God's people.

A Merciful Rule

Having explained the practical effects of blamelessness (verse 2) and judgment (verse 1), David now explains, in verses 6-8, the effects of "love" or "mercy" (Hebrew: *hesed*, verse 1). He approaches it from two angles, commending those who do right and punishing those who do wrong. But before we consider those, let us see what *hesed* means.

Hesed is one of the richest words of the Old Testament. It means goodness or kindness. When used of men it refers especially to helping others, and it takes on the sense of mercy when that help is offered to the lowly, the needy, or the miserable. Used of God, it refers to His lovingkindness, His "condescending to the needs of His creatures." It is demonstrated in God's redemption of His people from enemies and trouble, in His preserving their lives, in His giving them spiritual life and redeeming them from sin, and in His keeping the Covenant and all His promises under it.[22] Because all of God's creatures are miserable and lowly compared with Him, *hesed* always bears at least some sense of mercy when used of God. The translators of the Septuagint usually rendered *hesed* by the Greek *eleos*, a word signifying mercy, compassion, pity, or clemency.[23] It is this quality that the good Samaritan exhibited to the victim of muggers (Lk. 10:37), and this—especially as contrasted with judgment—is the sense here in Psalm 101.

Yet *hesed* has an even more fundamental sense. It conveys the idea of strength[24]—strength exercised for the benefit of someone else. Thus David writes in Ps. 144:1-2: "Blessed be the LORD, my rock, who trains my hands for war, and my fingers for battle; my lovingkindness (*hesed*) and my fortress, my stronghold and my deliverer; my shield and He in whom I take refuge; who subdues my people under me" (NASB). Though *hesed* does stand

for mercy, it does not stand for weak-kneed capitulation to the incorrigibly wicked. This, as we shall see, is a most important distinction, for it means that *hesed* requires very different actions toward very different people.

Mercy in Commending the Righteous

The first practical effect of mercy is to commend and defend the righteous, to help them when they are in need, to promote them to places of honor:

> My eyes will be on the faithful in the land,
> that they may dwell with me;
> he whose walk is blameless
> will minister to me. (Ps. 101:6)

The word *blameless* in this verse is the same one David has already used in verse 2 of himself; he will measure his servants by the same standard he uses for himself. It is a strict standard, but a fair one and impartially applied. The word *faithful* is the Hebrew *aman*, from which we get our word *amen*. It describes someone who is trustworthy or truthful.

Because he longs to exercise *hesed*, David is intent on exalting faithful, blameless people to positions of honor and authority in Israel. He watches over them to protect them. He knows that such people will, if given responsibility in his government, contribute to the nation's justice, order, peace, and prosperity, rather than tearing it down. And he knows how essential it is to have such people as his servants, for the nation would profit little from his own faithfulness and integrity if his servants did not share his character.

Finding such servants would be no easy matter—it would require the prudence of which David wrote in verse 2. Indeed, many of the troubles that arose during David's reign were rooted in treacherous, unreliable advisers,[25] and in at least one instance he

and his people suffered terribly because he refused to exercise judgment on his own son.[26] But how much worse might things have been had David not at least begun his reign intending to have good rather than evil servants!

Mercy in Punishing the Wicked

Real mercy—*hesed*—sometimes requires punishing the wicked to protect the righteous. This is how *hesed* differs so radically from the coddling that goes by the name of mercy in some circles today. It recognizes that good people can be safe only so long as bad people are restrained and punished. Thus mercy and justice, rather than working at cross purposes, actually complement each other. This is why David portrays punishment of the wicked as the practical outcome not only of judgment (*mishpat*, verses 3-5) but also of mercy (verses 7-8).

We find a chilling example of this element of mercy in Dt. 33:8-11—Moses' blessing on the Levites. He describes the Levites as "merciful"—that is, *hasid*, the adjectival form of *hesed*. And why were they *hasid*? In part because they had carried out God's command to execute rebellious Israelites who had worshiped the golden calf—even though that meant, for some of them, slaying their own fathers and mothers, brothers and sisters, sons and daughters (see Ex. 32:25-29).

Merciful because they slew even their own family members for idolatry? Yes! Merciful because their faithfulness to the God of the Covenant, which demanded the execution of idolaters, resulted in the purification of the people of Israel and the protection of the faithful from harm.[27]

Is it mercy when a convicted murderer is paroled and immediately kills someone else? Is it mercy when a rapist is sentenced to probation and rapes someone else? Surely not. It may be pity, it may be coddling, but it is not *hesed* (see Prov. 17:15). For "To favour sin is to discourage virtue; undue leniency to the bad is unkindness to the good."[28]

David understood the need for both of these two great principles in the administration of his government. In himself he must be blameless. Toward his people, who depended on him as God's agent for the maintenance of *shalom*, he must act always in both judgment and mercy. He must hate evil and love good. He would have agreed with Edmund Burke's wise observation, "They will not love where they ought to love, who do not hate where they ought to hate."

Augustine aptly described what happens when governing authorities misunderstand judgment and mercy: ". . . when men judge, sometimes overcome by mercy, they act against justice; and mercy, but not justice, seemeth to be in them: while sometimes, when they wish to enforce a rigid judgment, they lose mercy. But God neither loseth the severity of judgment in the bounty of mercy, nor in judging with severity loseth the bounty of mercy."[29] God's perfect combination of judgment and mercy, then, is the model for every man and every government. "Judgment," wrote Hugh Stowell, "first awakes to terror and to fear; mercy meets the poor, trembling, returning prodigal, and falls on his neck, and kisses, and forgives. Then, through all his chequered course, God hems up his way with judgment, that he may not wander, and yet brightens his path with mercy, that he may not faint."[30] We can and should, then, thank God as much for His judgment as for His mercy to us, for both are integral to our salvation and our spiritual growth.

Thy Kingdom Come!

No wonder David begins, "I will *sing* of lovingkindness and justice" (NASB)! Each is laudable. Each is cause for praise. God uses each in bringing sinners to repentance and regeneration, and He uses each in molding the free, peaceful, ordered society He desires for His people. Both shine when the righteous are rewarded and when the wicked are punished (see Ro. 13:1-4). Both are key

principles of godly government and a godly ruler.

But the sad fact is that David's own government fell miserably short of living up to his intentions. He himself was not blameless. He had treacherous, deceitful advisers. Sometimes he exalted the wicked and condemned the righteous. Sometimes he failed to punish evil men and to protect good men.

What are we to make of Psalm 101, then? Is it all empty dreaming? No. It points beyond David to the Son of David and the Kingdom He would set up. It is God's Kingdom, God's rule (Psalm 99) that truly answers all the aspirations of Psalm 101. For the fullness of that Kingdom on earth Jesus taught all believers to pray (Mt. 6:10). "And if it seems to us that he tarries too long, we should think of that morning which will suddenly dawn, that all filthiness being purged away, true purity may shine forth."[31]

NOTES:

1. Cited by William Binnie in Charles Spurgeon, *The Treasury of David*, 3 volumes (McLean, Va.: MacDonald, n.d. rpt.), volume 2, part 2, page 242.

2. Maurice Percy Ashley, "Buckingham, George Villiers, 1st Duke," in *Encyclopaedia Britannica* (Chicago, London: Encyclopaedia Britannica, Inc., 1969), volume 4, pages 346-347.

3. Franz Delitzsch, *Psalms*, 3 volumes in 1, trans. Francis Bolton, in C.F. Keil and Franz Delitzsch, *Commentary on the Old Testament*, 10 volumes (Grand Rapids: Eerdmans, 1976 rpt.), volume 5, part 3, page 107, n.

4. Francis Brown, S.R. Driver, and Charles Briggs, edd., *A Hebrew and English Lexicon of the Old Testament* (Oxford: Clarendon Press, 1978), page 968.

5. John Calvin, *Commentary on the Book of Psalms*, 3 volumes, trans. James Anderson (Grand Rapids: Baker Book House [1846] 1984), volume 3, part 1, page 88.

6. Russell Kirk, *The Conservative Mind from Burke to Eliot*, 6th edition (South Bend, Ind.: Gateway Editions, Ltd., 1978), pages 35-36. Kirk is describing Burke's ideas.

7. Brown, Driver, and Briggs, *Lexicon*, page 1071.

8. Brown, Driver, and Briggs, *Lexicon*, page 1070.

9. The word for "integrity" here, or "blameless" in the NIV, is the Hebrew *tom*, relating to completeness or wholeness. It is not the same as the word translated "blameless" in Ps. 101:2, though it is the root of that word.

10. Spurgeon, *The Treasury of David*, volume 2, part 2, page 240.

11. George Hakewill, cited in Spurgeon, *The Treasury of David*, volume 2, part 2, page 246.

12. Brown, Driver, and Briggs, *Lexicon*, page 856.

13. Brown, Driver, and Briggs, *Lexicon*, page 962.

14. Brown, Driver, and Briggs, *Lexicon*, page 786.

15. Brown, Driver, and Briggs, *Lexicon*, page 147.

16. Brown, Driver, and Briggs, *Lexicon*, page 932.

17. Calvin, *Commentary on the Book of Psalms*, volume 3, part 1, page 91.

18. We will see later that *hesed*, "mercy," includes the idea of punishment on those who hurt others.

19. Brown, Driver, and Briggs, *Lexicon*, pages 941, 1055.

20. Brown, Driver, and Briggs, *Lexicon*, page 20.

21. William Dyrness, *Themes in Old Testament Theology* (Downers Grove, Ill.: Inter-Varsity Press, 1979), page 235.

22. Brown, Driver, and Briggs, *Lexicon*, pages 338-339.

23. Walter Bauer, *A Greek-English Lexicon of the New Testament and Other Early Christian Literature*, transs. William F. Arndt and F. Wilbur Gingrich, Rev. F. Wilbur Gingrich and Frederick W. Danker, 2nd. ed. (Chicago: University of Chicago Press, 1979), page 250.

24. Dyrness, *Themes in Old Testament Theology*, page 58.

25. See for example Joab's murder of Abner, 2 Samuel 3; Jonadab's corruption of Amnon, 2 Samuel 13; Hushai's defection to Absalom, 2 Sam. 16:15ff.

26. See the story of Absalom's insurrection, 2 Samuel 15-18.

27. See Robert B. Girdlestone, *Synonyms of the Old Testament—Their Bearing on Christian Doctrine* (Grand Rapids: Eerdmans, [1897] 1976), page 114.

28. Spurgeon, *The Treasury of David*, volume 2, part 2, page 241.

29. Augustine, *Expositions on the Book of Psalms*, in Philip Schaff, ed., *A Select Library of the Nicene and Post-Nicene Fathers of the Christian Church*, First Series, volume VIII, trans. A. Cleveland Coxe (Grand Rapids: Eerdmans, 1979), page 491.

30. Hugh Stowell, cited in Spurgeon, *The Treasury of David*, volume 2, part 2, page 244.

31. Calvin, *Commentary on the Book of Psalms*, volume 3, part 1, page 95.

The Cross
and the Kingdom
PSALM 22

W hen Romanian pastor Joseph Ton completed studies in theology at Oxford University in England in 1972 and decided to return to Romania to preach the gospel, his Christian friends warned him that the Communist government would restrict his activities and—if necessary—kill him. He asked God how he should respond, and God reminded him of Mt. 10:16: "I am sending you out like sheep among wolves." He had a vision of a circle of wolves with a sheep trembling in the center, and the Lord said, "Tell Me, what chances of success does that sheep have of surviving five minutes, let alone converting the wolves? Now, Joseph, that's how I send you—totally defenseless. If you accept that, then go. If you don't accept that position, don't go."

Joseph Ton returned to Romania and studied the Bible's teaching on martyrdom. When he became convinced that martyrdom was one of the chief means God uses for converting people to Christ, he determined that he would preach and write openly regardless of government persecution, because even his death would only multiply his effectiveness. Soon arrests began, and one day an interrogating officer threatened to kill him. "Sir," Ton said, "let me explain that issue to you. Your supreme weapon is killing.

243

My supreme weapon is dying! Sir, you know my sermons are all over the country on tapes. When you kill me, I just sprinkle them with my blood. Whoever listens to them after that will say, 'Well! I'd better listen! This man sealed it with his blood!' They will speak ten times louder than before, Sir. So go on and kill me! I win the supreme victory then!" The officer sent him home.

Ton preached freely from then on. He later learned that officials had told another pastor, "We know that Joseph would love to be a martyr, but we are not such big fools as to fulfill his wish." They wouldn't kill him, even if he wanted them to.

"Wait a minute!" he thought. "For twenty or twenty-five years I wanted to be a low-key Christian because I wanted to survive. I accepted all the limitations and restrictions and interdictions they put on me, because I wanted to live. Now I want to die, and they won't oblige. Now I can do whatever I want in this country, because they won't kill me even if I require it! For twenty-five years I wanted to save my life, and I was losing it. Now that I want to lose it, I am winning it." His bold preaching became a key element in the beginning of a great revival in Romania.

Because Ton was willing to pay any price for the sake of the gospel, he defeated the strategies of Satan. He learned that death is the way to life, surrender is the way to victory, defeat is the way to triumph. He learned the key to powerful, fruitful witness: taking up the cross and following Jesus. "As the Father has sent me," Jesus said to the disciples, "I am sending you" (Jn. 20:21). He was sent as the Lamb of God, and in Lk. 10:3 He said, "Go! I am sending you out like lambs among wolves." We are sent into the world as Jesus was sent; if we will go as He went, we will bear fruit as He bore fruit.

Psalm 22 vividly portrays both aspects of Jesus' ministry—death and life, surrender and victory, defeat and triumph. It describes both the terror of the Crucifixion and the joyful expectation of the fruit that sacrifice would bear. In the process, it tells us much about how we can endure tribulations and remain steadfast

in our faith while we look expectantly to victories ahead.

The title of Psalm 22 ascribes authorship to David, and that surely is true. But the suffering described is beyond anything David ever endured, and the descriptions are so clearly tied to crucifixion that Christian scholarship through the ages has overwhelmingly understood the psalm as prophetic of Christ's passion and resurrection. While some interesting applications may be made to David's own life, I will in this chapter ignore those in order to focus on its description of the work of Christ.

The psalm has two clearly distinct sections, with no transition between them. The dark description of Christ's seemingly hopeless sufferings (verses 1-21) gives way suddenly to a triumphant description of their results (verses 22-31)—as if in the midst of Jesus' cries for help He had died, and His next words had come after the Resurrection. In the first section, where the writing seems heavy and laborious, there are five divisions: the opening cry of despair (verses 1-2); an effort at self-encouragement by appeal to God's former dealings with Israel (verses 3-5); a fall into deeper despair upon comparing Himself with His ancestors (verses 6-8); a new and stronger effort at self-encouragement by appeal to God's former dealings with Jesus Himself (verses 9-10); and an extended appeal to God for His presence and help (verses 11-21). The light, almost dancing second section stands in bright contrast. Nothing is labored here. Everything is expectant exultation. There are only two divisions: a call for all God's people to praise Him (verses 22-25), and a description of the thanksgiving and celebration that would accompany the coming realization of God's rule over the world (verses 26-31).

We will miss the drama and power of this psalm if we forget that while He suffered Jesus was God and man perfectly united in a single Person. This psalm reveals feelings that we cannot believe belonged to God—feelings of doubt and despair that don't fit well with facts of omniscience and omnipotence. If, when we read of the intense emotions He suffered, we think of Jesus as God only,

we will shake our heads in idle curiosity but never really believe. But these emotions are just what we should expect in any man in such a situation, and we must remember that it was there on the cross, if anywhere, that Jesus' manhood was most powerfully displayed. There He represented all men, there He substituted Himself for us, there the Last Adam did what the first Adam could not. So we must read Psalm 22 while constantly reminding ourselves, "The Word became *flesh*" (Jn. 1:14); He was "made in *human* likeness" (Phil. 2:7); He was made "perfect through suffering" and "shared in [our] humanity" (Heb. 2:10,14); He is "not . . . a high priest who is unable to sympathize with our weaknesses, but . . . has been tempted in every way, just as we are—yet was without sin" (Heb. 4:15).

Christ on the Cross

My God, my God, why have you forsaken me?
> Why are you so far from saving me,
> so far from the words of my groaning?
O my God, I cry out by day, but you do not answer,
> by night, and am not silent. (Ps. 22:1-2)

Christ uttered the opening cry while on the cross (Mt. 27:46, Mk. 15:34), and everything from Ps. 22:1 through verse 21 can be understood as revealing His thoughts during His hours of agony. While the Gospels tell the story of the Crucifixion from the point of view of onlookers, here Jesus Himself bares His mind to us, and we are made privy to the most dreadful torment imaginable.

A Cry of Despair

It is easy to jump directly to the arresting words, ". . . why have you forsaken me?" Coming from the lips of God-in-flesh, such words shock and puzzle us. Immediately we begin to speculate. We ignore the agony expressed in "why?" and ask instead, "*How*

can God have forsaken God?" Doubtless that's a good question. But by running straight to it we rob this cry of more powerful lessons.

First, the question begins not with "why . . ." but with "My God, my God" It is almost as if Jesus said to His Father, "You might have forsaken Me, but I have not forsaken You. You are *My* God. Suffer what I may, I will still claim You as Mine!" What a great demonstration of faith this is, and how much strength we can gain to bear our sufferings if we follow Jesus' example!

Second, Jesus doesn't wonder whether God has forsaken Him, but assumes it. Amazing that the confidence He expressed in "My God, my God," should collapse instantly into such resignation! The strongest faith and the deepest anxiety can be bound up together in the same heart, and that the heart of God's Son!

Third, Jesus doesn't ask *how* His Father can have forsaken Him, but *why*. Why would the Father forsake His beloved Son, in whom He was well pleased? Why would He abandon to death this One who did all that the Father told Him to do? The answer to that question lays open the mystery of redemption—but it is hidden from us for the moment.

The parable of the importunate widow comes to life during the Crucifixion. Jesus sees no sign of God's favor, feels nothing of His presence, hears no voice from Heaven saying, "This is my Son, whom I love; with him I am well pleased" (Mt. 3:17). Can we feel the passion in His words, "O my God, I cry out by day, but you do not answer, by night, and am not silent"? All is darkness. He feels Himself utterly abandoned by God. He cannot say, as He once did, ". . . *I am not alone*. I stand with the Father who sent me" (Jn. 8:16, emphasis added)—His Father stands aloof.

Still Jesus again calls God "*my* God," and though He says little aloud while He hangs on the cross, His silent prayers never cease. Despite His Father's awful, condemning silence, Jesus persists in prayer.

An Appeal to the Covenant

> Yet you are enthroned as the Holy One;
>> you are the praise of Israel.
> In you our fathers put their trust;
>> they trusted and you delivered them.
> They cried to you and were saved;
>> in you they trusted and were not disappointed.
> (Ps. 22:3-5)

Now Jesus, perhaps feeling the surging doubts about to overwhelm Him, bravely struggles to bolster His faith. He follows a pattern common to the faithful of Israel (see Ps. 105:7-44): He recalls to His mind God's holy nature and the deliverances He wrought in fulfillment of His promises to the people of the Covenant. These cannot be reconciled with the idea that He would finally and everlastingly abandon one of His own, and so they provide reassurance to the Sufferer.

Three times in four lines the Savior points to the fathers' trust. They trusted, He trusts; they were delivered, He must be delivered. Surely the Holy One, who remembered His Covenant in the past, will remember it again now! Surely the King enthroned is the King faithful and powerful to deliver! If the Patriarchs were saved when they cried to the Lord, surely this Son of the Covenant can hope for similar mercy.

Long before, when a man had asked Jesus whether He could do anything to help his demonized child, Jesus had said, "Everything is possible for him who believes," and the man had responded, "I do believe; help me overcome my unbelief!" (Mk. 9:23-24). How can there be this mixture—belief and unbelief, unbelief and belief—tangled up in the same heart? Because faith is not only a matter of knowing but also of feeling. Sometimes we can know and feel together; but there are times when we can know but not feel. Sometimes we doubt because, like the father of the

demonized boy, our hopes are so high we hardly dare believe, even when we know. At other times we doubt because our suffering mocks everything we know.

I think Jesus experienced that on the cross. He *knew* that God would answer, that He would not be forsaken forever; He *knew* that God was His God; He *knew* that God was "enthroned as the Holy One" and that He had always proved Himself faithful to answer the prayers of His people. But the torture He suffered was so deep, so strong, so awful that He could not feel what He knew. He *felt* the wrath of God directed against the sin of all mankind bundled in the one Man on the cross; He *felt* the scorn of the people; He *felt* the nails and the lacerations of the whip and the excruciating thirst and the sore muscles and the dislocated bones. So when He appealed to what He knew of God's nature and past record, He drew upon His knowledge to strengthen His feelings.

Despair Returns

> But I am a worm and not a man,
>> scorned by men and despised by the people.
> All who see me mock me;
>> they hurl insults, shaking their heads:
> "He trusts in the LORD;
>> let the LORD rescue him.
> Let him deliver him,
>> since he delights in him." (Ps. 22:6-8)

Anyone who has swum in heavy surf knows what it is to be overwhelmed by great, surging waves and suddenly fear for his life. He knows what it is to struggle to the surface and be filled with hope—almost with exhilaration—only to be struck immediately from behind by another wave more violent than the first, a wave that plunges him down, down, deep into the turbulent water, perhaps pressing him helpless into the churning bottom. Panic

strikes, and he fights to reach the surface again for one sweet breath of air, where for a moment thrill displaces terror. But then comes another wave, more massive and violent than the last, and he thinks himself lost forever.

Such sudden and violent turns of emotion must have gripped our Savior on the cross. For a while He would find strength in what He knew of God and His promises and His gracious dealings with men. And then a twist of the body, a gasp for breath, a mock from the crowd would come upon Him like a snarling wave, crushing His hope. So it is now. Fighting to the surface, He breathes the sweet air of God's covenant faithfulness. But suddenly He is crushed by a wave of mockery. It isn't enough that His own body screams, "Forsaken! Forsaken!" Its insistent voice, once suppressed by knowing faith, is joined by a new choir, chanting again and again, "Stricken by God! Smitten by God! Afflicted by God! Ha! Stricken by God! Smitten by God! Afflicted by God! Ha!" The tender shoot of faith is crushed (Is. 53:1-4).

Jesus feels Himself utterly contemptible, no more than a worm that people crush under the heel without a second thought. And the crowd agrees. His faith—the one thing that can support Him in His torment—becomes the object of their ridicule and scorn: "He claims to have faith, but God could not let the faithful suffer so. He is a sham!" He has appealed to God on the basis that He was one of God's people (Ps. 22:4-5), but now they disown Him. And who is He to argue? He cannot cling to the Covenant, resting on God's protection of His ancestors! Anyone with eyes can see that He writhes under the stern judgment of God. Where can He find the strength to overcome this wave?

An Appeal to His Past

> Yet you brought me out of the womb;
> you made me trust in you
> even at my mother's breast.

From birth I was cast upon you;
>from my mother's womb you have been my God.
(verse 9)

Being rejected by His people, Jesus finds strength in His own past. God has protected Him before, He will do it again—won't He? In the womb, during birth, in His infancy: always God has upheld Him. It must be no different now. Perhaps Jesus remembers the stories Joseph and Mary told Him years ago, about His birth in a cold stable, the flight into Egypt, the horrible reports of hundreds of babies butchered by Herod's soldiers, the dream by which God had warned Joseph to go to Nazareth to avoid Archelaus. Jesus remembers His battle with the Adversary in the desert, His confrontations with the rulers, and the times when He had just escaped stoning. "Always, Father, You have protected Me. Will You not do it now?"

Prayer for Deliverance

His faith bolstered once more, Jesus changes course. No more does He cry out, "Why have you forsaken me?" Now He asks for a remedy (verses 11-21). He begs God to rescue Him (verse 11), describing His miserable condition to stir up pity in His Father's heart (verses 12-18), and finally reaching a climax in a sustained call for help (verses 19-21).

Do not be far from me,
>for trouble is near
>and there is no one to help.

Many bulls surround me;
>strong bulls of Bashan encircle me.
Roaring lions tearing their prey
>open their mouths wide against me.
I am poured out like water,

and all my bones are out of joint.
My heart has turned to wax;
 it has melted away within me.
My strength is dried up like a potsherd,
 and my tongue sticks to the roof of my mouth;
 you lay me in the dust of death.
Dogs have surrounded me;
 a band of evil men has encircled me,
 they have pierced my hands and my feet.
I can count all my bones;
 people stare and gloat over me.
They divide my garments among them
 and cast lots for my clothing.

But you, O LORD, be not far off;
 O my Strength, come quickly to help me.
Deliver my life from the sword,
 my precious life from the power of the dogs.
Rescue me from the mouth of the lions;
 save me from the horns of the wild oxen.
(verses 11-21)

To the God who seems to have forsaken Him, Jesus prays, "Do not be far from me." Initially He prays not so much for life or comfort as for the presence of God. All else—the mocking crowds, the tortured body, even death—He can endure if He but knows that God is with Him. "Whom have I in heaven but you?" He seems to say. "And being with you, I desire nothing on earth. My flesh and my heart may fail, but God is the strength of my heart and my portion forever" (Ps. 73:25-26).

Having already raised God's holy nature, His faithfulness to His covenant promises, and His prior protection as arguments for why God ought to respond to His cries, Jesus now appeals directly to God's pity by describing His miserable circumstances. He

may be but a worm in the sight of the crowd, but the people are
hardly human themselves. They are like angry bulls, "roaring lions
tearing their prey," a pack of crazed dogs slobbering around Him,
wild oxen bent on goring Him. How can anyone with the slight-
est mercy not be moved by such a picture? Surely this will win
God's pity.

And look at the Sufferer Himself: He is utterly spent. His
blood is no more to be retrieved than water poured out on parched
soil. The hours on the cross have dislocated His bones. His heart
has lost its strength. He hangs there, emaciated, as brittle as a bit of
old broken pottery in a trash heap, ready to crumble into dust at
the slightest pressure. Every touch, every twist of His body, every
breath wrings groans of agony from Him. Was anyone ever so
needy before? Surely God must be moved by such a spectacle!

And now look! His torturers see the end coming. They lay
claim to His clothing, knowing He cannot live to use it again.
Seeing this, in one last great effort to surmount the crushing waves,
Jesus calls out for rescue (Ps. 22:19-21). His prayer is akin to
David's in Ps. 69:1-4:[1]

> Save me, O God,
>> for the waters have come up to my neck.
> I sink in the miry depths,
>> where there is no foothold.
> I have come into the deep waters;
>> the floods engulf me.
> I am worn out calling for help;
>> my throat is parched.
> My eyes fail,
>> looking for my God.
> Those who hate me without reason
>> outnumber the hairs of my head;
> many are my enemies without cause,
>> those who seek to destroy me.

I am forced to restore
> what I did not steal.

But it is too late. Death overwhelms Him. We hear no more prayer for rescue. The forsaking is complete. *But it is not forever!*

From Cross to Crown

A new day dawns, and we see Jesus risen in triumph. He has restored what He did not steal. His sacrifice has been accepted. No more forsaken is He, no more torn His flesh or disjointed His bones. He is Victor over the grave, and He sings a new song:

I will declare your name to my brothers;
> in the congregation I will praise you.
You who fear the LORD, praise him!
> All you descendants of Jacob, honor him!
> Revere him, all you descendants of Israel!
For he has not despised or disdained
> the suffering of the afflicted one;
he has not hidden his face from him
> but has listened to his cry for help.
From you comes my praise in the great assembly;
> before those who fear you will I fulfill my vows.
(Ps. 22:22-25)

Jesus' complaints are gone, His once frightened eyes blaze with joy as He praises the God who forsook Him not forever. Jesus calls His brothers to Him and declares to them the greatness of God. He builds for Himself a congregation in which to praise His Father, and calls on all who fear Jehovah, the God of the Covenant that was sealed in His blood, to join Him in praise. "For he has not despised or disdained the suffering of the afflicted one; he has not hidden his face from him but has listened to his cry for

help" (verse 24).

Here at last is the answer to that plaintive cry with which the psalm began: "My God, my God, why have you forsaken me?" His suffering was not despised, but accepted! He was forsaken that His brethren might be welcomed. The price is paid, the jealous God appeased. In a few hours, the infinite Worm has suffered what billions of finite bulls and lions, dogs and oxen could not have suffered in eternity.

Praise reverberates between Father and Son: ". . . in the congregation will I praise you. . . . From you comes my praise in the great assembly" (verses 22,25). No more forsaken, the Crucified is the object of His Father's praise. And to this festival, this celebratory feast of praise, Father and Son call all the world to eat the Bread and drink the Blood so that they will never hunger or thirst again:[2]

> The poor will eat and be satisfied;
>> they who seek the LORD will praise him—
>> may your hearts live forever!
> All the ends of the earth
>> will remember and turn to the LORD,
> and all the families of the nations
>> will bow down before him,
> for dominion belongs to the LORD
>> and he rules over the nations.
>
> All the rich of the earth will feast and worship;
>> all who go down to the dust will kneel before him—
>> those who cannot keep themselves alive.
> Posterity will serve him;
>> future generations will be told about the Lord.
> They will proclaim his righteousness
>> to a people yet unborn—
>> for he has done it. (verses 26-31)

Poor and rich Jesus calls to His Feast, the Supper He shared with His disciples before He suffered and now shares again in its "fulfillment in the kingdom of God" (Lk. 22:16). The King upon the throne says to everyone, "Come, for everything is now ready" (Lk. 14:17), and when those on the guest list make excuses He sends His servant "into the streets and alleys of the town [to] bring in the poor, the crippled, the blind and the lame," and into "the roads and country lanes [to] make them come in," for He insists that His house be full (Lk. 14:21,23).

To that banquet come "all the ends of the earth . . . and all the families of the nations," and they "bow down before him," acknowledging His dominion "over the nations" (Ps. 22:27-28). The poor rejoice in their exaltation and the rich in their humiliation (Jas. 1:9-10), for as one undivided Body they praise the Lord. And as they come from all the ends of the earth, so they come from every generation, one after another, till time is no more. All serve Him whom, on the cross, they jeered—"for He has done it" (Ps. 22:31); "It is finished" (Jn. 19:30). Jehovah has made Him a guilt offering for all the sins of men, but now He sees His offspring (Is. 53:10), and, "because he poured out his life unto death, and was numbered with the transgressors," He has received His portion among the great and divides the spoils with the strong (Is. 53:12). The righteous King for whom David prayed in Psalm 101 has come to His throne!

Take Up Your Cross

"[A]nyone who does not carry his cross and follow me cannot be my disciple," Jesus said (Lk. 14:27). Following Him means self-sacrifice—perhaps to the point of death, like the martyrs, but at least to the point of sorrow. If we are to take up the cross and follow Jesus, we first must learn from Him how to bear it. Psalm 22 shows us several helpful examples we can learn from and follow.

Cling to God Despite All

Jesus introduced His question, ". . . why have you forsaken me?" with the words, "My God, my God." Despite the circumstances, He clung to God and to the knowledge that God was His God no matter what happened.

We must learn to do the same. We must learn to pray, as Asaph prayed and as Jesus demonstrated not only on the cross but throughout His ministry, "Whom have I in heaven but you? And being with you, I desire nothing on earth" (Ps. 73:25).

Lose Your Life for Christ

"If anyone would come after me, he must deny himself and take up his cross daily and follow me," Jesus said. "For whoever wants to save his life will lose it, but whoever loses his life for me will save it. What good is it for a man to gain the whole world, and yet lose or forfeit his very self?" (Lk. 9:23-25).

Everything in this life we may lose—including life itself. We, like Jesus, may someday be stripped naked, beaten, tortured, mocked, and finally killed. So long as this body and this world are our chief delights, we will shrink from the challenge of such persecution. But He teaches us to fear not those who can kill the body but him who can destroy both body and soul in hell (Mt. 10:28).

William Shakespeare put beautifully the attitude Christians must have toward our mortal lives:[3]

Poor soul, the center of my sinful earth,
[Fool'd by] these rebel powers that thee array,
Why dost thou pine within and suffer dearth,
Painting thy outward walls so costly gay?
Why so large cost, having so short a lease,
Dost thou upon thy fading mansion spend?
Shall worms, inheritors of this excess,
Eat up thy charge? Is this thy body's end?

Then, soul, live thou upon thy servant's loss,
And let that pine to aggravate thy store.
Buy terms divine in selling hours of dross,
Within be fed, without be rich no more.
So shalt thou feed on Death, that feeds on men,
And Death once dead, there's no more dying then.

You Are Not Alone

Nothing intensifies suffering more than the idea that no one else
has suffered as we do. But when we feel abandoned by God, we
can take comfort from the fact that Jesus has been there. He has
felt the same way—indeed, however we might feel, we will never
be forsaken by God as Jesus was, for He was forsaken that we
might be accepted.

It is tempting to think, when in the midst of a "dark night of
the soul," that we have made ourselves so filthy that God can no
longer bear our presence. But that thought, too, can be overcome if
we remember that Jesus took all our sin on Himself when He went
to the cross—and afterward God received Him into glory, declar-
ing His acceptance of the sacrifice. Because Jesus died for us, there
is no more sin left to separate us from God. He has paid what we
owed, and our debt is wiped out.

Let Knowledge Strengthen Emotions

While on the cross, Jesus appealed repeatedly to what He knew of
God's holy nature, His promises, His Covenant, His past dealings
with others and with Himself, all to counterbalance His otherwise
uncontrollable feelings of despair. We can do that, too.

We must not think that because we, like Joseph Ton, have
decided—firmly decided—that we will willingly lose ourselves
for Christ's sake, we will never fear persecution. Far from it! What
we feel may overwhelm what we know, and then we will have to
battle to restore our faith. Jesus knew from the moment He was
born—indeed, from before Creation—that He would lay down

His life for us. But He still quaked with fear in the Garden of Gethsemane and agonized on the cross. We may well experience similar fear, and when we do, the great test will be whether we will live by faith or by feeling.

When we feel forsaken, we can recall Christ's promise, ". . . surely I will be with you always, to the very end of the age" (Mt. 28:20). We can take comfort from the same promise God gave to Joshua: "As I was with Moses, so I will be with you; I will never leave you or forsake you" (Josh. 1:5). We can recite to ourselves the great acts of deliverance God performed on behalf of the Patriarchs of Israel, the nation itself, David and others of His chosen ones, and the greatest deliverance of all, the Resurrection of Christ from the dead. Such knowledge can strengthen our weak emotions.

Focus on the Glory to Come

Psalm 22 shows us how glory followed disgrace for Christ. Because the Lamb of God died, God raised Him to new life and confirmed Him on the throne of His Kingdom, "that at the name of Jesus every knee should bow, in heaven and on earth and under the earth, and every tongue confess that Jesus Christ is Lord, to the glory of God the Father" (Phil. 2:10-11).

He sends us forth, too, as sheep among wolves. Yet for us, too, there is a glory to come. Even martyrdom is but a doorway to the presence of God (Rev. 6:9-11). And we must remember that if "a kernel of wheat falls to the ground and dies . . . it produces many seeds," and the Father honors those who serve the Son (Jn. 12:24,26).

It was their focus on the glory to come that enabled all the giants of faith to endure persecutions (Hebrews 11).

> Therefore, since we are surrounded by such a great cloud of witnesses, let *us* throw off everything that hinders and the sin that so easily entangles, and let *us* run with perseverance

the race marked out for us. Let *us* fix our eyes on Jesus, the author and perfecter of our faith, who for the joy set before him endured the cross, scorning its shame, and sat down at the right hand of the throne of God. Consider him who endured such opposition from sinful men, so that you will not grow weary and lose heart. (Heb. 12:1-3, emphasis added)

NOTES:

1. Psalm 69 is itself a Messianic prophecy.

2. See also Jn. 6:32-35.

3. Sonnet No. 146. The bracketed words are one editor's guess at what Shakespeare originally intended. The original text is lost and the words placed there by the earliest known compiler, "My sinful earth," almost surely are not original since they contain too many syllables.

Thy Kingdom Come

PSALM 145

Have you ever stopped to think what a profound faith is expressed in the words, "God is great, God is good, let us thank Him for this food"? God not only is great, He also is good; God not only is good, He also is great. Great alone, He might be only a terror; good alone, He might mean well but lack the ability to be "an ever-present help in trouble" (Ps. 46:1). But He is both great and good; therefore we thank Him for everything we enjoy, for all comes by His grace. We look to Him, He opens His hand and gives us everything we need.

Here in this simple child's prayer are three key elements of biblical faith: the greatness of God, the goodness of God, and the providence of God—the third a combination, or application, of the first two. "God is great, God is good, let us thank Him for this food" sums up, in three simple phrases that every child can understand, God's nature and behavior. It presents God's nature under the two categories of greatness and goodness. And it describes His behavior in terms of His intimate involvement in providing for His creatures' needs.

Theologians call God's greatness His immensity or transcendence; His goodness His beneficence; and His providence His

261

immanence. They speak of the first as His natural attributes, the second as His moral attributes, and the third as His governmental supervision of the world. Ha! Children know better! Such big words, at first blush anyway, do not express faith; they smother it. Children don't pray, "God is transcendent, God is beneficent, let us thank Him for His immanence." No, they are satisfied with the simple words, "God is great, God is good, let us thank Him for this food." And in these words they express all the longings of men for the Kingdom of God: for a great and good King who, in ruling over all, meets all His children's needs.

Not that technical theological words are useless. They bring precision to our thoughts about God. But faith grows from the general and simple to the precise and complex, and we need precision more as complexity increases.[1] We will see that David drew on a wide array of words, sometimes with fine distinctions, to express the rich concepts of his faith. But like children, we all find it easier to start with simplicity and graduate to complexity.

A Psalm of Praise to God the King

When David, writing Psalm 145, pondered the hoped for Kingdom of God, he expressed himself in categories like those found in the child's prayer. He wrote of the character of the King under the two heads of His greatness and His goodness, and of the character of the King's reign expressed in His providential care for His subjects.

David prefaced his psalm with his personal commitment to praise Jehovah his King: "I will exalt you, my God the King; I will praise your name for ever and ever. Every day I will praise you and extol your name for ever and ever" (Ps. 145:1-2).

Next he wrote of God's greatness:

Great is the LORD and most worthy of praise; his greatness no one can fathom. One generation will commend your

works to another; they will tell of your mighty acts. They will speak of the glorious splendor of your majesty, and I will meditate on your wonderful works. They will tell of the power of your awesome works, and I will proclaim your great deeds. (verses 3-6)

Then he proclaimed God's goodness:

They will celebrate your abundant goodness and joyfully sing of your righteousness. The LORD is gracious and compassionate, slow to anger and rich in love. The LORD is good to all; he has compassion on all he has made. All you have made will praise you, O LORD; your saints will extol you. (verses 7-10).

Then—like a child who thanks God for his food—David exclaimed over the wonders of God's provisions for men, provisions by which He demonstrated His greatness and His goodness:

They will tell of the glory of your kingdom and speak of your might, so that all men may know of your mighty acts and the glorious splendor of your kingdom. Your kingdom is an everlasting kingdom, and your dominion endures through all generations.

The LORD is faithful to all his promises and loving toward all he has made. The LORD upholds all those who fall and lifts up all who are bowed down. The eyes of all look to you, and you give them their food at the proper time. You open your hand and satisfy the desires of every living thing.

The LORD is righteous in all his ways and loving toward all he has made. The LORD is near to all who call on him, to all who call on him in truth. He fulfills the desires of those who fear him; he hears their cry and saves

them. The LORD watches over all who love him, but all the
wicked he will destroy. (verses 11-20)

Finally, his mind full of the glories of Jehovah, David reiter-
ated his commitment to praise God and expressed his longing for
the whole creation to join him: "My mouth will speak in praise of
the LORD. Let every creature praise his holy name for ever and
ever" (verse 21).

How did David express God's greatness, God's goodness,
and God's providential care for His creatures? The words he chose
are filled with rich meaning.

The Character of the King: God Is Great

"Great is the LORD," David wrote, "and most worthy of praise;
his greatness no one can fathom," (Ps. 145:3) or, more literally,
"his greatness is unsearchable" (NASB). David used two related
terms to speak of God's greatness. God is "great," *gadowl*, and His
"greatness," *geduwlah* (the noun from which *gadowl* is formed), is
unsearchable. The word *great* might be used to indicate the
magnitude or extent of something, a vast number of things, the
intensity of some feeling (such as fear), the loudness of a sound,
someone's age, or the importance of some person or thing. God is
great especially in the first and last of these senses: He is immense,
or omnipresent, and He is more important than anything else. He
is so great that man cannot begin to search out the extent of His
greatness, so important that we cannot begin to imagine how
utterly we depend on Him.

Jesus claimed this kind of importance in the lives of His
disciples when He told them, "No branch can bear fruit by itself; it
must remain in the vine. Neither can you bear fruit unless you
remain in me. I am the vine; you are the branches. If a man
remains in me and I in him, he will bear much fruit; *apart from me
you can do nothing*" (Jn. 15:4-5, emphasis added). Christ is so

great that all things were created by Him: "things in heaven and on earth, visible and invisible, whether thrones or powers or rulers or authorities; all things were created by him and for him. He is before all things, and in him all things hold together" (Col. 1:16-17). Imagine that! All things hold together only because Christ wills them to do so! And everything in Heaven and on earth was created and is sustained by Him.

In portraying God as great, David wrote of His majesty, which he described as glorious and splendid (Ps. 145:5) and of His might (verse 11). Each of those terms helps us understand what he meant when he wrote, "Great is the LORD."

God's Majesty

Generations of God's people, David wrote, "will speak of the glorious splendor of your majesty" (verse 5). What ideas did David mean to convey by these words?

"Majesty," the Hebrew word *howd*, conveys the ideas of splendor and vigor. When a son of Korah composed a wedding song, perhaps for Solomon, he wrote, "Gird your sword upon your side, O mighty one; clothe yourself with splendor and majesty. In your majesty ride forth victoriously in behalf of truth, humility and righteousness; let your right hand display awesome deeds" (Ps. 45:3-4).[2] If we get pictures in our minds of knights in shining armor riding into battle on great war horses, we're getting the idea behind "majesty"! Indeed, when God contrasts His greatness with Job's frailty, He asks, "Do you give the horse his strength or clothe his neck with a flowing mane? Do you make him leap like a locust, striking terror with his proud [literally, "majestic"] snorting? He paws fiercely, rejoicing in his strength, and charges into the fray. He laughs at fear, afraid of nothing . . ." (Job 39:19-22).

When "majesty" describes God or His acts, it refers to the light and glory that He wears as King. Thus one psalmist wrote, "O LORD my God, you are very great; you are clothed with

splendor and majesty. He wraps himself in light as with a garment; he stretches out the heavens like a tent and lays the beams of his upper chambers on their waters. He makes the clouds his chariot and rides on the wings of the wind" (Ps. 104:1-3). Even God's voice is majestic: "The LORD will cause men to hear his majestic voice and will make them see his arm coming down with raging anger and consuming fire, with cloudburst, thunderstorm and hail. The voice of the LORD will shatter Assyria; with his scepter he will strike them down" (Is. 30:30-31). Does God's majesty fill us with awe? Or do we forget to reflect on it?

God's Majesty Is Glorious

David wrote of the "glorious splendor" of God's majesty. Each of those words multiplies the effect of the word *majesty,* as if by itself it couldn't convey the whole idea he had in mind.

"Glorious," the Hebrew *kabowd,* refers to abundance and honor. When Joseph was put in charge of Egypt and Pharaoh had put his signet ring on his finger, dressed him in robes of fine linen and put a gold chain around his neck, and made him ride in a chariot as second-in-command (Gen. 41:41-43), Joseph could say to his brothers, "Tell my father about all the honor [literally, "glory"] accorded me in Egypt . . ." (Gen. 45:13). The idea is someone whose huge wealth and power make everyone admire and even fear him.

When Moses asked to see God's "glory," God responded, "I will cause all my goodness to pass in front of you, and I will proclaim my name, the LORD, in your presence. . . . But . . . you cannot see my face, for no one may see me and live. . . . There is a place near me where you may stand on a rock. When my *glory* passes by, I will put you in a cleft in the rock and cover you with my hand until I have passed by. Then I will remove my hand and you will see my back; but my face must not be seen" (Ex. 33:19-23). For God's majesty to be glorious, then, is for it to be so weighty and brilliant that the mere glimpse of it might kill a man.

God's Majesty Is Splendid

The word David used for "splendor" is the Hebrew *hadar*, which refers to an ornament that signifies the honor or dignity of one who wears it. Proverbs 20:29 says, "Gray hair [is] the splendor of the old." Ezekiel said that Tyre once had "splendor" because soldiers from other mighty nations served her and "hung their shields and helmets" on her walls, bringing the city's "beauty to perfection" (Ezk. 27:10-11). When Isaiah prophesied the coming of the Suffering Servant, he wrote that Messiah would have "no beauty or majesty [literally, "splendor"] to attract us to him, nothing in his appearance that we should desire him" (Is. 53:2), but when David prophesied of Messiah's coming to claim His Kingdom he pictured Him "arrayed in holy majesty [literally, "splendor of holiness"]"—sacred, festal garments denoting His kingly honor and authority (Ps. 110:3).

What a picture this gives us of David's conception of the great God his King! No wonder he wrote, "I will exalt you, my God the King; I will praise your name for ever and ever. Every day I will praise you and extol your name for ever and ever" (Ps. 145:1-2).

God's Might

The other aspect of God's greatness that David lauded in Psalm 145 is His might, or power. He predicted that God's people would "tell of the glory of your kingdom, and speak of your *might*" (verse 11). This word, *gebuwrah*, refers to strength or valor. The horse, the most powerful creature with which Israelites had regular contact, was a model of strength. At the same time that God challenged Job regarding the majestic snorting of a war horse, He also said, "Do you give the horse his strength or clothe his neck with a flowing mane?" (Job 39:19). When Gideon avenged his brothers' deaths by striking down their killers, he showed his valor, or strength, as a warrior (Jdg. 8:20).

God Himself is the paradigm of strength, demonstrating His

power in creation and the government of the world. "Death is naked before God," said Job; "Destruction lies uncovered. He spreads out the northern skies over empty space; he suspends the earth over nothing. He wraps up the waters in his clouds, yet the clouds do not burst under their weight. . . . The pillars of the heavens quake, aghast at his rebuke. By his power he churned up the sea; by his wisdom he cut Rahab to pieces. By his breath the skies became fair; his hand pierced the gliding serpent. And these are but the outer fringe of his works; how faint the whisper we hear of him! Who then can understand the thunder of his power [Hebrew: *gebuwrah*]!" (Job 26:6-14).

The word *gebuwrah* is related to one of the names of Jehovah: *El Gibbor*, "Mighty God" (Is. 10:21). The word means "hero," and when Isaiah called the coming Messiah "the Mighty God" (Is. 9:6), he meant that Messiah would come as "'a God of a hero,' a hero whose chief characteristic is that he is God."[3] With His strength the Mighty God overcomes the enemies of His people, delivers them from danger, and establishes His Kingdom. Jesus represented Himself as Hero of His followers when He said, ". . . a time is coming, and has come, when you will be scattered, each to his own home. You will leave me all alone. Yet I am not alone, for my Father is with me. I have told you these things, so that in me you may have peace. In this world you will have trouble. But take heart! I have overcome the world" (Jn. 16:32-33).

As the King is mighty so are His deeds, and so David takes it upon himself to tell of them (Ps. 145:4), for he wants all men to know of them (verse 12) and of "the glorious splendor of [God's] kingdom" (verse 12). That is the chief theme of Psalm 145: that all might know of the coming Kingdom, a Kingdom that outshines all the kingdoms of men, with a King who outshines all kings. The glorious, splendid, majestic King (verse 5) will have a glorious, splendid Kingdom (verse 12). In this psalm David looks beyond himself and his faulty reign to the perfect reign of Jehovah the

King. That will be the perfect fulfillment of the hopes he once vainly held for himself (Psalm 101).

The Character of the King: God Is Good

The second chief idea David had of the character of God was that God is *good*. "The LORD is good to all," he wrote (Ps. 145:9), predicting that God's people would celebrate His abundant goodness (verse 7). Again David chose words closely related to each other: "goodness" (Hebrew: *tuwb*) and "good" (Hebrew: *towb*).

The word *tuwb* might refer to good things, property, or ethical goodness, depending on the context in which it was used. When Pharaoh heard that Joseph's brothers had come to Egypt, he promised them "the best [literally, "goodness"] of the land of Egypt" (Gen. 45:18,20,23)—that is, the good produce of the land to relieve them from the famine they suffered in Canaan. The servant sent by Abraham to find a wife for Isaac took with him "all kinds of good things [literally, "goodness"]" to lavish on the bride's father (Gen. 24:10). And God promised Israel that it would enjoy in the Promised Land "flourishing cities you did not build, houses filled with all kinds of good things [literally, "goodness"] you did not provide" (Dt. 6:10-11). Goodness could also connote beauty, or fairness; this was the "goodness" God permitted Moses to see on Mount Sinai (Ex. 33:19). And it could connote the joy of heart with which God's servants sing in His Kingdom (Is. 65:14). Clearly one of the leading ideas of "goodness" was something pleasant, enjoyable, or agreeable.

When the Old Testament speaks of God's "goodness" it usually has in mind one of three things: His goodness in bestowing good things to His people (Neh. 9:25), His goodness in saving His people despite their rebellion (Ps. 25:7, Is. 63:7), and His goodness stored up for His saints to enjoy while they take refuge in His presence (Ps. 31:19-20). It is the idea of God's saving goodness that comes to the fore in Ps. 145:7, for David goes on to declare

that God "is gracious and compassionate, slow to anger and rich in love [or "mercy," Hebrew: *hesed*]" (verse 8). It is the same goodness of which David rejoiced when he wrote, "Surely goodness and love [or "mercy," Hebrew: *hesed*] will follow me all the days of my life, and I will dwell in the house of the LORD forever" (Ps. 23:6).

Two Categories of God's Goodness

In Psalm 145 David wrote of God's goodness as displayed in two primary ways: His truthfulness and His love. Each of these ideas David brought out in several ways. God's truthfulness is seen in His righteousness (verses 7,17), faithfulness (verse 13), and holiness (verse 21). His love is seen in His mercy (verses 8,13), graciousness (verse 8), compassion (verses 8-9), and nearness (verse 18).

God's Truthfulness

The people of Jehovah the King, David wrote, will "joyfully sing of [His] righteousness" (Hebrew: *tsedaqah*, verse 7). Jehovah "is righteous" (Hebrew: *tsaddiyq*, an adjective derived from *tsedaqah*); He is "faithful (Hebrew: *aman*) to all His promises" (verse 13); every creature should "praise his holy [Hebrew: *qodesh*] name" (verse 21). Each of these attributes tells us of the goodness of God as expressed in His truthfulness, or His incorruptible fidelity to what is true, right, and pure.

 God Is Righteous. Tsedaqah, righteousness, denotes rectitude, or rightness judged by the perfect standard of God's Law. When Jacob assured Laban of his fairness in tending the flocks, he said, ". . . my honesty [*tsedaqah*] will testify for me in the future, whenever you check on the wages you have paid me" (Gen. 30:33). The righteous man "speaks what is right . . . rejects gain from extortion and keeps his hand from accepting bribes . . . stops his ears against plots of murder and shuts his eyes against contemplating evil—this is the man who will dwell on the heights, whose

refuge will be the mountain fortress" (Is. 33:15-16).

God's "righteousness is like the mighty mountains, [His] justice like the great deep" (Ps. 36:6)—immovable and unfathomable, so that He is beyond reproach or even accusation. Or, as Elihu put it, "The Almighty is beyond our reach and exalted in power; in his justice and great righteousness, he does not oppress" (Job 37:23). "He is the Rock, his works are perfect, and all his ways are just. A faithful God who does no wrong, upright and just is he" (Dt. 32:4). His government is just, equitable, and right (Ps. 99:4)—the ideal government David longed for (Psalm 101). In righteousness God redeems the "penitent" but punishes "rebels and sinners" (Is. 1:27-28).

God's righteousness can be transferred to His people: "Who may ascend the hill of the LORD?" David asked. "Who may stand in his holy place? He who has clean hands and a pure heart, who does not lift up his soul to an idol or swear by what is false. He will receive blessing from the LORD and vindication [*tsedaqah*] from God his Savior" (Ps. 24:3-5). Isaiah longed for the day when Heaven would "rain down righteousness" so that salvation and righteousness would spring up in return from earth (Is. 45:8; see Ps. 85:10-13). Malachi predicted a time when, for those who revered God's name, God would send Messiah in power, "the sun of righteousness . . . with healing in its wings," who would vindicate them and enable them to crush their enemies (Mal. 4:2). This is what Paul explained when he wrote, "The righteousness from God comes through faith in Jesus Christ to all who believe." These people, he said, "are justified freely by his grace through the redemption that came by Christ Jesus" (Ro. 3:22-24). When David wrote that the people of the great King Jehovah would celebrate His abundant goodness and "joyfully sing of [His] righteousness" (Ps. 145:7), he had this idea in mind: God's vindicating righteousness by which He saves those who trust in Him.[4]

The ultimate fulfillment of David's longing for the Kingdom of righteousness is what Isaiah prophesied regarding the coming

Messiah: "Of the increase of his government and peace there will
be no end. He will reign on David's throne and over his kingdom,
establishing and upholding it with justice and righteousness from
that time on and forever. The zeal of the LORD Almighty will
accomplish this" (Is. 9:7).

God Is Faithful. To express God's faithfulness David chose
the word *aman*, an adjective derived from a verb meaning "to
confirm" or "to support" (Ps. 145:13).[5] *Aman* is the word God
used when He promised David, ". . . your throne will be estab-
lished forever" (2 Sam. 7:16). Samuel was confirmed (*aman*) as a
prophet of God (1 Sam. 3:20).

Used of moral character, *aman* describes someone as reliable
or trusty. David desired trusty men as his royal counselors (Ps.
101:6)—people as reliable in their advice as the moon is a "faith-
ful witness in the sky" (Ps. 89:37).

Just as God is the paradigm of strength, so He is the paradigm
of faithfulness. His unwavering trustworthiness is seen preemi-
nently in His upholding the Covenant: ". . . he is the faithful God,
keeping his covenant of love to a thousand generations of those
who love him and keep his commands" (Dt. 7:9). God's reliability
will ensure and preserve the glorious reign of Messiah, the Servant
of Jehovah: "Kings will see you and arise, princes will see and bow
down, because of the LORD, who is faithful, the Holy One of
Israel, who has chosen you" (Is. 49:7). And Messiah Himself is the
very Incarnation of faithfulness: "These are the words of the
Amen, the faithful and true witness, the ruler of God's creation"
(Rev. 3:14; see also 19:11, 21:5, 22:6)—"Amen" is a translitera-
tion of *aman*, and both "faithful" (Greek: *pistos*) and "true"
(Greek: *alethinos*) are words used to translate *aman* in the
Septuagint.

God Is Holy. At the close of his song of praise David writes,
"Let every creature praise [Jehovah's] holy name for ever and
ever" (Ps. 145:21). Here is yet another term emphasizing the
truthfulness, or purity, of God.

The Hebrew *qodesh* emphasizes sacredness, separation from anything that would defile or profane. God required that His priests and all that they handled in ceremonies be set apart: "You must distinguish between the holy [*qodesh*] and the profane, between the unclean and the clean" (Lev. 10:10, NIV 1978); grain left over from offerings was to be eaten "without yeast [typifying incorruption] beside the altar, for it is most holy" (Lev. 10:12).

God's holiness is closely related to His majesty: "Who among the gods is like you, O LORD? Who is like you—majestic in holiness, awesome in glory, working wonders?" (Ex. 15:11). It is also related to His greatness (Ps. 77:13). His holiness, power, righteousness, love, and faithfulness are all bound up in the work of salvation: "Sing to the LORD a new song, for he has done marvelous things; his right hand and his holy arm have worked salvation for him. The LORD has made his salvation known and revealed his righteousness to the nations. He has remembered his love and his faithfulness to the house of Israel; all the ends of the earth have seen the salvation of our God" (Ps. 98:1-3).

When God's word or promise is described as holy, it is to emphasize its inviolability: "Once for all, I have sworn by my holiness—and I will not lie to David—that his line will continue forever and his throne endure before me like the sun; it will be established forever like the moon, the faithful witness in the sky" (Ps. 89:35-37, a promise ultimately fulfilled in Jesus the Messiah). God's holiness guarantees His immutable faithfulness to His promises. When—as in Ps. 145:21—God's name is called holy, the point is that God's reputation must never be sullied by man (compare Lev. 20:3; 22:2,32)—and will never be profaned by God Himself.

God's Love

The second category of God's goodness is His love, or mercy. The Hebrew noun *hesed* (Ps. 145:8) and the adjective formed from it, *hasid* (verses 13,17), convey the idea of rich, condescending

lovingkindness.

God demonstrates *hesed* in redeeming His people from ene-
mies and trouble (Gen. 19:19, Ex. 15:13). For this lovingkindness—
the motive behind God's redeeming men from homelessness,
rebellion, foolishness, and pride—men should thank the Lord (Ps.
107:8,15,21,31). *Hesed* is also the reason for God's preserving
men from death: "I will praise you, O Lord my God, with all my
heart; I will glorify your name forever. For great is your love
[*hesed*] toward me; you have delivered me from the depths of the
grave" (Ps. 86:12-13). When overwhelmed with sorrow for sin,
David prayed, "Have mercy on me, O God, according to your
unfailing love [*hesed*]; according to your great compassion blot
out my transgressions" (Ps. 51:1). So *hesed* is the ground of God's
forgiving us and giving us spiritual life (Ps. 109:26).

The Covenant that contains all God's promises to Israel is a
Covenant of *hesed* (Dt. 7:12; 1 K. 8:23; Neh. 1:5, 9:32; Dan. 9:4),
and He upholds it according to His mercy (Mic. 7:20). Because of
its intimate connection with the Covenant, *hesed* also has the sense
of fidelity.[6]

God's merciful love is shown in His being gracious (*chan-
nuwn*) (Ps. 145:8), compassionate (*rachuwm* or *racham*) (verses
8-9), and near (*qarowb*) to all who call on Him in truth (verse 18).

God Is Gracious. *Channuwn* is an adjective used almost
exclusively of God. It denotes His tender care for those in need.
When, for instance, God instructed Israelites to take security when
they made loans, He foresaw the plight of some extremely poor
borrowers. This is how He protected them: "If you ever take your
neighbor's cloak as a pledge, you are to return it to him before the
sun sets, for that is his only covering; it is his cloak for his body.
What else shall he sleep in? And it shall come about that when he
cries out to Me, I will hear him, for I am gracious" (*channuwn*, Ex.
22:26-27, NASB). This text, part of the "Law of the Covenant" that
comprises Ex. 21-23,[7] shows beautifully what it means for God to
be "gracious." He looks after those in need; He helps them. David

might even have had this passage in mind when he wrote, "The LORD upholds all those who fall and lifts up all who are bowed down" (Ps. 145:14).

God's graciousness works together with His righteousness and compassion when He "protects the simplehearted"; these three attributes of God led to the saving of one "in great need," who could then say, "Be at rest once more, O my soul, for the LORD has been good to you" (Ps. 116:6-7). It is one of the preeminent attributes God claimed when He revealed Himself to Moses, saying, "The LORD, the LORD, the compassionate and gracious God, slow to anger, abounding in love and faithfulness, maintaining love to thousands, and forgiving wickedness, rebellion and sin" (Ex. 34:6-7)—a passage that echoes all through the Old Testament (2 Chron. 30:9; Neh. 9:17,31; Joel 2:13; Jon. 4:2), all through the Psalms (Ps. 86:15, 103:8, 111:4, 112:4), and especially all through Ps. 145:7-9.

God Is Compassionate. Closely associated with God's graciousness is His compassion. The noun *racham*, stemming from a word for the womb, apparently is rooted in the idea of either brotherly or motherly feeling. It normally describes God's tender mercies toward men, though once (Ps. 112:4) it is attributed to a man—an ideal man who fears God and delights in His Law.

Jeremiah celebrated God's love (*hesed*) and compassion (*racham*) together with His faithfulness when he wrote, "Because of the LORD's great love we are not consumed, for his compassions never fail. They are new every morning; great is your faithfulness" (Lam. 3:22-23). David cast the fate of his people into the hands of God rather than the hands of men, reasoning, "his mercy [literally, "compassions," plural of *racham*] is great" (2 Sam. 24:14). When Asaph saw the nation in "desperate need" because of invading armies, he prayed, "Do not hold against us the sins of the fathers; may your mercy [*racham*] come quickly to meet us" (Ps. 79:8).

God Is Near. A powerful proof of God's love is that He is

"near [*qarowb*] to all who call on him, to all who call on him in truth" (Ps. 145:18). God's nearness to Israel was a clear sign of His favor (Dt. 4:7). Lest the people think His Law was too difficult, Moses assured them, "No, the word is very near you; it is in your mouth and in your heart so you may obey it" (Dt. 30:14). It is God's nearness to those who call on Him in truth and fear Him that assures them that their desires will be fulfilled and they will be saved when they cry out for His help (Ps. 145:18-19).

In one sense God's nearness balances His holiness—His separateness. (Just as His love, grace, and compassion balance His righteousness and faithfulness.) Were He holy but not near, we could not approach Him or expect Him to respond when we cried. But He is near, and so we can have confidence that this intimate relationship will comfort troubled souls.

God's Truth and Love in Salvation

Yet His nearness is no excuse for us to presume on that relationship—to forget His holiness. "'Am I only a God nearby,' declares the LORD, 'and not a God far away? Can anyone hide in secret places so that I cannot see him?' declares the LORD. 'Do not I fill heaven and earth?' declares the LORD" (Jer. 23:23-24). Those who call on God in truth, or sincerity, fearing Him, may expect His salvation; but those who profane Him by violating His Word can expect His judgment.

Just so, while God's grace, compassion, and love balance His righteousness and faithfulness, they are no excuse for us to continue in rebellion. They, too, are only for those—however imperfect they may be—who love and fear Him and genuinely desire to forsake sin: "None of those condemned things shall be found in your hands, so that the LORD will turn from his fierce anger; he will show you mercy, have compassion on you, and increase your numbers, as he promised on oath to your forefathers, because you obey the LORD your God, keeping all his commands that I am giving you today and doing what is right in his eyes"

(Dt. 13:17-18; see also Romans 6).

What is the practical effect of God's goodness, love, and compassion on His people? Isaiah tells us:

> I will tell of the kindnesses [*hesed*] of the LORD, the deeds for which he is to be praised, according to all the LORD has done for us—yes, the many good things [*tuwb*] he has done for the house of Israel, according to his compassion [*racham*] and many kindnesses [*hesed*]. He said, "Surely they are my people, sons who will not be false to me"; and so he became their Savior. In all their distress he too was distressed, and the angel of his presence saved them. In his love and mercy he redeemed them; he lifted them up and carried them all the days of old. (Is. 63:7-9)

The Character of the Kingdom:
The King's Providential Care for His Subjects

What an amazing God we have! Splendid, glorious, majestic in His greatness. Righteous and faithful and holy, yet full of loving mercy, grace, and compassion. A God who, from His vantage point far away, sees our every rebellious act, yet a God near and ready to comfort and help. Truly God is great and God is good! No wonder David was so intent on praising Him!

All of these marvelous attributes of God, these elements of His greatness and goodness, determine the kind of Kingdom He rules. The glorious, splendid, majestic King has a glorious and splendid Kingdom (Ps. 145:5,11-12). The God who is forever faithful to His promises rules a Kingdom that endures forever (verse 13). And in that Kingdom of love Jehovah the King "upholds all those who fall and lifts up all who are bowed down" (verse 14). He meets all His subjects' needs—and even more, all their desires (verses 15-16). Righteous in all His ways and loving toward all He has made, He draws near to those who call on Him

and fear Him, and He saves them (verses 17-19). And then, that His saints might endure as long as His Kingdom endures, He "watches over all who love him, but all the wicked he will destroy" (verse 20).

What Shall We Do as Citizens of the Kingdom?

What does one do in the presence of a king? He bows, he speaks courteously, he obeys. In all three he honors the king.

What ought God's people to do in His presence? The prophet Micah says, "He has showed you, O man, what is good. And what does the LORD require of you? To act justly and to love mercy and to walk humbly with your God" (Mic. 6:8). In all three we honor the King. By acting justly and loving mercy we follow His example, and by walking humbly we acknowledge His majesty. "I am the LORD who brought you up out of Egypt to be your God," God said to Israel; "therefore be holy, because I am holy" (Lev. 11:45). "Love your enemies and pray for those who persecute you," said Jesus to His followers, "that you may be sons of your Father in heaven. . . . Be perfect, therefore, as your heavenly Father is perfect" (Mt. 5:44,48).

There are five things we, as citizens of the Kingdom of God, can do in response to the message of Psalm 145: we can strive to reflect God's goodness in our lives; we can exalt the King; we can trust our King to provide for our needs; we can share David's longing for the fullness of the Kingdom; and we can proclaim the good news of the Kingdom to others.

Be a Mirror of God's Goodness

Do I, in my daily life, try to reflect the two sides of God's goodness—His truth and His love? Do I share in God's righteousness by living according to His Word? If I do, I will help others to share in it by telling them of the righteousness from God that they can receive if they will believe in Jesus. I will be faithful to my

word, living up to my commitments to God and others. And I will be holy, avoiding sin and striving to be pure and clean in thought, word, and deed.

Do I, in my daily life, try to reflect God's love by showing mercy to those in need? If I do, I will be gracious to those who offend me. I will be compassionate to those who cannot help themselves, or who suffer because others oppress them. And I will draw near to the needy so that they will know that they can find help when they ask for it.

Exalt God as King

Am I, like David, bubbling over with the desire to praise God? If I am, then I probably will find myself so overcome with admiration for Him that when I begin to describe Him a multitude of wonderful words will come tumbling out of my mouth in a torrent of praise—words like great and mighty, majestic and splendid and glorious; righteous, faithful, and holy; loving, gracious, and compassionate. Or do I find it difficult to say anything about the great Lord my God, who saved me?

Am I as eager to praise God as David was—so eager that I say, "I will praise your name for ever and ever. Every day I will praise you and extol your name for ever and ever" (Ps. 145:1-2)? Does my mouth "speak in praise of the LORD" (verse 21) so that everyone can know of His mighty acts and of the glorious splendor of His Kingdom (verse 12)?

Trust the King to Provide

"The eyes of all look to you," David wrote, "and you give them their food at the proper time. You open your hand and satisfy the desires of every living thing" (Ps. 145:15-16). When I worry and fret about money—even for such essential things as food, clothing, and shelter—I testify by my actions, even if not by my words, that I don't really believe that a great and good God looks out for my welfare. I have not then learned the lesson of the child's prayer,

"God is great, God is good, let us thank Him for this food."
Practically, I have embraced the foolishness of atheism.

If I am to witness every day to the love, grace, and compassion of my King, if I am to let people know that He is righteous and faithful to fulfill His holy promises, then I must learn to trust Him. And that means learning to live without worry, for to live otherwise is to live like a pagan who knows not God (Mt. 6:32). Do I really seek God's Kingdom and God's righteousness above and beyond all the material things of this world? Or when I pray, "Give us this day our daily bread," am I mouthing words that I don't believe?

Long for the Fulfillment of the Kingdom

The first two petitions Jesus taught us in the Lord's Prayer are these: ". . . your kingdom come, your will be done on earth as it is in heaven" (Mt. 6:10). King David longed for his own reign to be just and loving (Psalm 101), but he fell far short. Yet that didn't stop him from looking forward to the fulfillment of the reign of God on earth, when righteousness and love would rule over all.

Am I as filled with that longing as David was? Or am I content to let the world stumble along without God and without Christ and without hope? Do I do what I can to see justice and righteousness, love and compassion done on earth? Or have I given it up for lost? Do I, in short, perjure myself when I pray the first two petitions of the Lord's Prayer? Let's hope that instead I will be known as someone who strove to help those around me to know God's love and receive His righteousness.

Proclaim the Good News

In the middle of Psalm 145 David revealed his great hope: that as God's people told of His glory and might, all men might come to know of Him, of His mighty acts, and of the glorious splendor of His Kingdom (verse 12). David had a missionary's heart—so much so that in the midst of a prayer of penitence he could

promise that if God would only restore to him the joy of His salvation he would teach transgressors His ways so that sinners would be turned back to God (Ps. 51:12-13).

When Jesus walked this earth, He preached the good news of the Kingdom (Mt. 4:23, 9:35). He urged His disciples to pray for the coming of that Kingdom and to seek that Kingdom above and before everything else (Mt. 6:10,33). He instructed His disciples to preach this message: "The kingdom of heaven is near" (Mt. 10:7), and said the gospel of the Kingdom must be "preached in the whole world" (Mt. 24:14). After His resurrection, He claimed authority as King (Mt. 28:18), and commissioned His disciples, saying, "Therefore go and make disciples of all nations, baptizing them in the name of the Father and of the Son and of the Holy Spirit, and teaching them to obey everything I have commanded you" (Mt. 28:19-20). The Lord's desire is that all of His followers would be engaged in the constant work of enlarging His Kingdom by making disciples, introducing them to His Church, and teaching them to obey Him.

The Apostle Paul took this commission to heart. Knowing that everyone must appear one day before the judgment seat of Christ the King, and fearing the Lord, he worked to persuade men (2 Cor. 5:10-11). "For Christ's love compels us," he wrote, "because we are convinced that one died for all, and therefore all died. And he died for all, that those who live should no longer live for themselves but for him who died for them and was raised again" (verses 14-15). And what did that love of Christ compel him to do? To act as an ambassador. Paul claimed that God had given him "the ministry of reconciliation: that God was reconciling the world to himself in Christ, not counting men's sins against them. And he has committed to us the message of reconciliation. We are therefore Christ's ambassadors, as though God were making his appeal through us. We implore you on Christ's behalf: Be reconciled to God" (verses 18-20).

Am I compelled by the love of Christ? Do I perform the

work of an ambassador of the King, pleading with people to be reconciled to Him? May God help me—may God help all of His people—to do that. Thy Kingdom come. Thy will be done in earth, as it is in Heaven. Amen.

NOTES:

1. Precision distinguishes truth from plausible error. We use "omniscience" rather than "greatness" to say that God not only knows a lot but knows everything. We speak of God's "transcendence" to say that He is distinct from creation. His "immanence" reminds us that God did not, as deists claim, leave the world to itself.

2. The Epistle to the Hebrews tells us that the real focus of this psalm is King Jesus. Compare Ps. 45:6-7 with Heb. 1:8ff.

3. Edward J. Young, *The Book of Isaiah*, 3 volumes (Grand Rapids: Eerdmans, 1979), volume 1, page 337.

4. Francis Brown, S.R. Driver, and Charles Briggs, edd., *A Hebrew and English Lexicon of the Old Testament*, trans. Edward Robinson (Oxford, England: Clarendon Press, [1907] 1978), page 842.

5. The last two lines of Ps. 145:13 in the NIV translate a clause found only in one manuscript of the Masoretic Text, the Dead Sea Scrolls, the Septuagint, and the Syriac version. Most Hebrew manuscripts do not have it. Yet it seems likely that the clause is original, both because of the early attestation in the Dead Sea Scrolls and the Septuagint, and because the clause begins with a word starting with the letter *nun*, which otherwise would be the only letter not used to begin a strophe in this alphabetically arranged psalm.

6. For more on the meaning of *hesed*, see the section "A Merciful Rule" in Chapter Sixteen.

7. For an excellent study of these crucial Old Testament chapters, see James B. Jordan, *The Law of the Covenant: An Exposition of Exodus 21-23* (Tyler, Tex.: Institute for Christian Economics, 1974).